RETURN TO ISLE OF MAN TRANSPORT

Front Cover: This highly evocative view of the old horse car terminus at Victoria Pier was taken on 20 July 1957. Having just disembarked from one of the Isle of Man Steam Packet vessels, an orderly queue of visitors, complete with luggage, waits to board No. 43. On busy days during the height of the season, up to 25 trams provided a 1½ minute service. What a wonderful way to begin a holiday! *Foster M. Palmer, Seashore Trolley Museum*

Title Page: The Isle of Man changes character dramatically during motorcycle TT (Tourist Trophy) Week. Thousands of motor sport enthusiasts descend on the island and the normal way of life is interrupted during the two weeks of disruption. Public transport is affected, most notably the Snaefell Mountain Railway, which operates in two sections either side of the level crossing at Bungalow that forms part of the mountain section of the TT course. Car No. 3 is seen here during the 1975 event, with the summit of the mountain in the background.
Nicholas Britton

Rear Cover Top: A typical early morning scene from the late 1950s. Car No. 43 is passing the Hydro Hotel heading for Derby Castle as one of the island's many Bedford OBs pauses at the foot of Switzerland Road before joining the cavalcade of coaches touting for that day's custom on the promenade. With the exception of the OB, this scene is little changed today.
Charles Firminger, courtesy Bob Bridger

Rear Cover Bottom 1: Douglas Corporation buses had a distinctive deep yellow and red livery. Shortly before nationalisation, a more simplified version was adopted, eliminating the Corporation title and distinctive shaded fleet numerals, as shown here on No. 2, a Metro-Cammell-bodied AEC Regent V of 1964. Some years after this view was taken on 28 June 1975, this area would be redeveloped with the loss of buildings such as the Royalty Cinema seen in the background.
Michael J. Russell

Rear Cover Bottom 2: For most of the history of the Manx Electric Railway, its rolling stock has been painted in a red, white and teak livery. The principal exception was in the era immediately after the line was nationalised in 1957 when a number of cars – including 'Winter Saloon' No. 22 – received a plain green and white livery, which was to prove short-lived. The Austin A40 Devon van on the right was operated by well-known Manx ice cream supplier Felice's.
Marcus Eavis/Online Transport Archive

RETURN TO ISLE OF MAN TRANSPORT

MANX ELECTRIC, SNAEFELL & AND THE BUSES AND TRAMS OF DOUGLAS CORPORATION

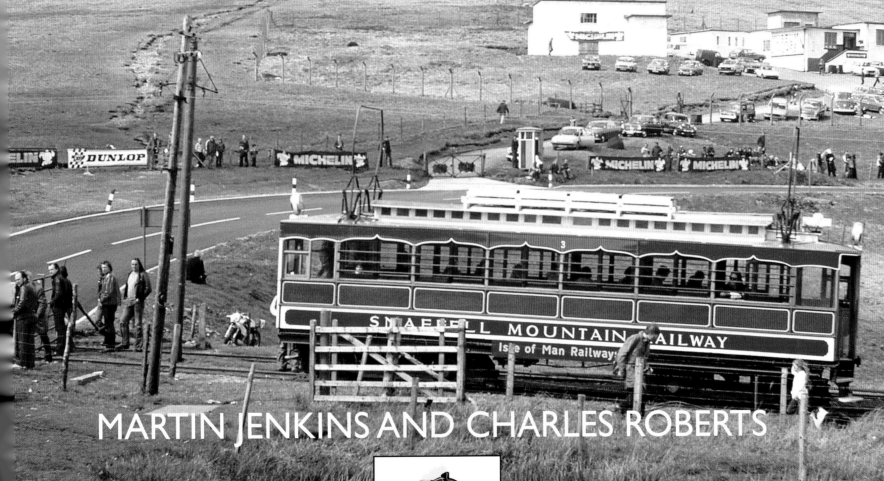

MARTIN JENKINS AND CHARLES ROBERTS

PEN & SWORD
TRANSPORT
AN IMPRINT OF PEN & SWORD BOOKS LTD.
YORKSHIRE – PHILADELPHIA

First published in Great Britain in 2018 by
Pen & Sword Transport
An imprint of Pen & Sword Books Ltd
Yorkshire - Philadelphia

Copyright © Martin Jenkins and Charles Roberts, 2018

ISBN 978 1 4738 6243 2

Typeset by Aura Technology and Software Services, India
Printed and bound in India by Replika Press Pvt. Ltd.

Pen & Sword Books Ltd incorporates the Imprints of Aviation, Atlas, Family History, Fiction, Maritime, Military, Discovery, Politics, History, Archaeology, Select, Wharncliffe Local History, Wharncliffe True Crime, Military Classics, Wharncliffe Transport, Leo Cooper, The Praetorian Press, Remember When, Seaforth Publishing and Frontline Publishing.

For a complete list of Pen & Sword titles please contact

PEN & SWORD BOOKS LTD
47 Church Street, Barnsley, South Yorkshire, S70 2AS, England
E-mail: enquiries@pen-and-sword.co.uk
Website: www.pen-and-sword.co.uk

Or

PEN AND SWORD BOOKS
1950 Lawrence Rd, Havertown, PA 19083, USA
E-mail: Uspen-and-sword@casematepublishers.com
Website: www.penandswordbooks.com

Introduction

This book is dedicated to Brian Faragher, who was born and raised on the Isle of Man. Like both of us, he was a member of the Liverpool University Public Transport Society. Over the years, he has taken hours of ciné film and many hundreds of high quality colour slides, of which a significant number appear in this book. Today, he maintains his passion for all forms of Manx transport.

Complementing our previous book, *Isle of Man Transport: A Colour Journey in Time* which is devoted to the steam railways, shipping and Road Services buses, the colour photographs in this book have also been taken during the same period (late 1940s to late 1970s). After a post-war boom in visitor numbers, the growth in car ownership and overseas holidays had a profound effect upon the island's economy. Also, the cost of operating the many forms of transport continued to rise as ridership plummeted leading to some being faced with permanent closure. Several once-popular sea crossings operated by the Isle of Man Steam Packet Company were discontinued and the number of vessels greatly reduced. The network of lines operated by the Isle of Man Railway was reduced to a seasonal operation on a single line whilst the island-wide bus routes run by the associated Isle of Man Road Services suffered some cutbacks, both eventually being nationalised. Even though the Manx Electric Railway (MER) and Snaefell Mountain Railway (SMR) were taken into Government control in 1957, this did not prevent closure of the Laxey-Ramsey section in 1975. However, following a fiercely-fought campaign, the whole line was running again in 1977. After its loss-making bus services were nationalised in 1976, Douglas Corporation continued to operate its legendary promenade tramway but with ever decreasing enthusiasm until it too was nationalised in 2016. On the credit side, many more people now use a variety of airlines to access the island and the rich mix of vintage transport still attracts visitors from all over the world.

As many books have been published providing comprehensive coverage of the island's various forms of transport, our volume does not go into major historical detail, although some background information is embedded in various captions. In the case of the MER and SMR, we offer a colour view of each of the vehicles operated on both lines, including motor cars, trailers and, where possible, goods wagons, vans and works equipment. The selected scenes also cover different aspects of the diverse nature of the two lines. With the legendary horse trams, we have adopted the same approach in offering a view of nearly all the cars operating after 1953. In the case of the Douglas Corporation buses, our earliest view dates from 1949. We have opted to show each of the major post-war classes with particular focus on the long-serving AEC Regents and the Utility Daimlers, although we were unable to locate any colour views of the two wartime Bedford OWBs. Frustratingly, they are probably out there somewhere! To complete the picture there are scenes of non-tram horses at work, steamrollers, the Falcon Cliff lift, aircraft, MER vans and buses and a selection of vehicles operated by the island's many private coach operators.

Martin: 'I first visited the island shortly after the end of the war, probably in 1948. I remember coming off the steamer after a somewhat boisterous crossing and going to our hotel by horse tram. During our week's stay, we went everywhere by 'Shanks's Pony' or else on board public transport. We used the horse trams to reach the town, theatres, cinemas and Derby Castle. I also remember a couple of Corporation bus trips especially to Douglas Head and I have a clear memory of riding on one of the Vulcans and thinking it very unusual. I don't remember if we walked or took a bus to the railway station, but we certainly made 'the round trip', as my mother called it, at least twice. This involved taking the train to Ramsey and returning to Douglas on the Manx Electric or vice versa. We also creaked our way up Snaefell and walked up to the blustery summit. I recall a couple of coach

trips to various beauty spots on the island including one on a fairly clapped-out Bedford, with its big gear stick being worked vigorously by the driver on some of the steeper roads. However, it was the Manx Electric that really caught my imagination. A fantastic country ride with superb scenery which just seemed to go on for ever. Furthermore, the trams and the route bore no resemblance to those in my home system of Liverpool. During the holiday, I spent many hours at Derby Castle watching the comings and goings whilst my mother went to explore the shops. On one occasion, I was allowed into the depot for a look around after being warned to 'mind the pits'. It really was love at first sight and I have remained fascinated by the MER ever since, making a number of trips over the years. In the 1980s, I was privileged to have made a documentary for BBC Radio 4 entitled 'Trams and Tramcar Enthusiasts' during which I was allowed to drive No. 1 on a very windy day for nearly the entire length of the line – something I have never forgotten. For me, the MER offers one of the greatest tram rides in the world and the rolling stock is nothing short of magnificent. It has been a pleasure to co-author this book and to unearth so many previously unpublished views.'

Charles: 'My memories of the island's aircraft were limited to the familiar sight and sound of Cambrian Airways' Viscounts as they passed over our Wirral home flying between Speke and Ronaldsway. Sadly, travel by that mode was beyond our pockets and we had to resort to the occasionally rough crossing of the Irish Sea on the Steam Packet. Once disembarked at Douglas, there was always a horse tram waiting to take us on, but that was for a later day as we usually went to catch the bus up to Onchan. In those days, it was always one of the Mark V Regents – the earlier Regents would have still been around, but I don't remember seeing them. I do remember a couple of journeys on the Guy Otters with their ridiculously oversized destination screens – we travelled on those round to Douglas Head on the 25. From our hosts' bungalow, it was a short walk down to Derby Castle. A ride on the horse tram was a must. On one occasion I was lucky enough to sit up front, but I didn't think so at the time as my hands were blue with cold by the time we reached journey's end. Similarly, there is a picture of me at the top of a windswept Snaefell in 1972, the look on my face showing clearly that all I wanted was to get back on the car and travel back down to Laxey. This might have been the same occasion when, getting a shot on my Box Brownie at Laxey, I was suddenly aware that the tram I intended to catch back to Derby Castle – and on which my aunt was quietly sitting – had started to pull away. Thinking quickly, I jumped onto the running board and walked down the outside of the moving trailer in the same way that the conductors used to do, and sat down next to my aunt as if nothing untoward had happened. Nearly 40 years later, to mark my 50th birthday, I was treated to the Ultimate Driving Experience and spent a very enjoyable day at the controls of cross-bench motor No. 33 along the whole length of the line. Something I can highly recommend to birthday present buyers!'

This book is dedicated to Brian Faragher who is seen here – cameras at the ready – on the occasion of the LUPTS Mersey Docks Railtour on 8 May 1965. (*B.D. Pyne/Online Transport Archive*)

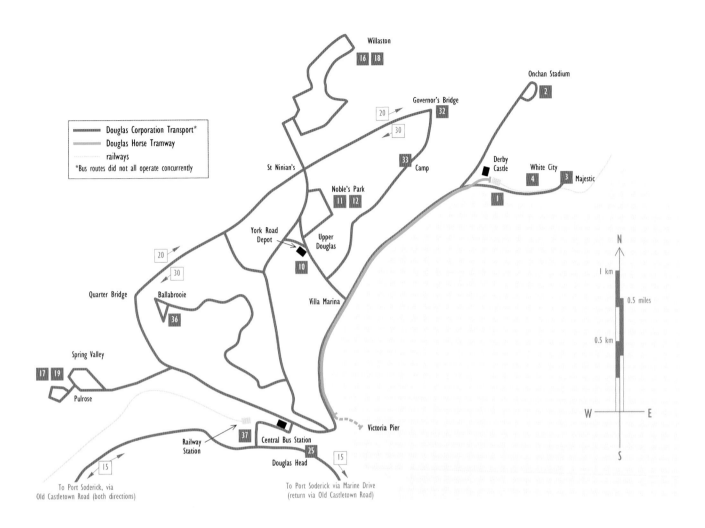

Willaston 16 18

Onchan Stadium 2

Governor's Bridge 20 32 30

St Ninian's

33 Camp

Derby Castle

White City 4

Majestic 3

1

Noble's Park 11 12

York Road Depot

Upper Douglas

10

Quarter Bridge

Ballabrooie

20 30

Villa Marina

36

Spring Valley

17 19

Pulrose

Railway Station

37

Central Bus Station 25

Douglas Head 15

Victoria Pier

To Port Soderick, via Old Castletown Road (both directions) 15

To Port Soderick via Marine Drive (return via Old Castletown Road)

Douglas Corporation Transport*
Douglas Horse Tramway
railways
*Bus routes did not all operate concurrently

N
1 km
0.5 miles
0.5 km
W E
S

Acknowledgements

The authors wish to thank all those who have provided photographs for this book. Particular thanks are due to Leo Sullivan of Boston, USA, who helped to make the Donald Nevin collection available; Jim Schantz of the Seashore Trolley Museum who provided access to the Foster M. Palmer collection; Malcolm King and Geoff Price for access to the Jim Copland and Peter Deegan collections respectively; Tony Wilson of Travel Lens Photographic; aviation expert Ken Ellis for his detailed knowledge of aircraft; Ray Hulock for personal insight into the steamroller fleet; and Chris Poole for preparing the maps. Significant help in identifying locations and checking caption detail has been given by Bill Barlow, Jonathan Cadwallader, Rob McCaffery and Geoff Price. As with the authors' other transport-related books, this volume has been compiled in conjunction with Online Transport Archive (OTA), a UK registered charity dedicated to the preservation and conservation of transport images and to which the authors' fees have been donated. For further detailed information about the archive, please contact the Secretary at 25, Monkmoor Road, Shrewsbury, SY2 5AG (email secretary@onlinetransportarchive.org).

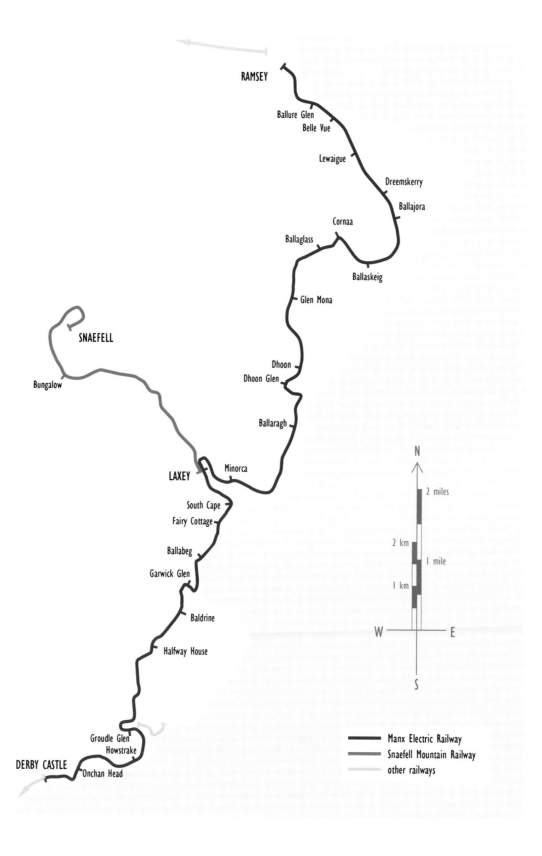

RAMSEY

Ballure Glen
Belle Vue

Lewaigue

Dreemskerry
Ballajora

Cornaa

Ballaglass

Ballaskeig

Glen Mona

SNAEFELL

Bungalow

Dhoon
Dhoon Glen

Ballaragh

Minorca

LAXEY

South Cape
Fairy Cottage

Ballabeg

Garwick Glen

Baldrine

Halfway House

N

2 miles

2 km
1 mile

1 km

W ——————— E

S

Groudle Glen
Howstrake

DERBY CASTLE
Onchan Head

━━━ Manx Electric Railway
━━━ Snaefell Mountain Railway
┈┈┈ other railways

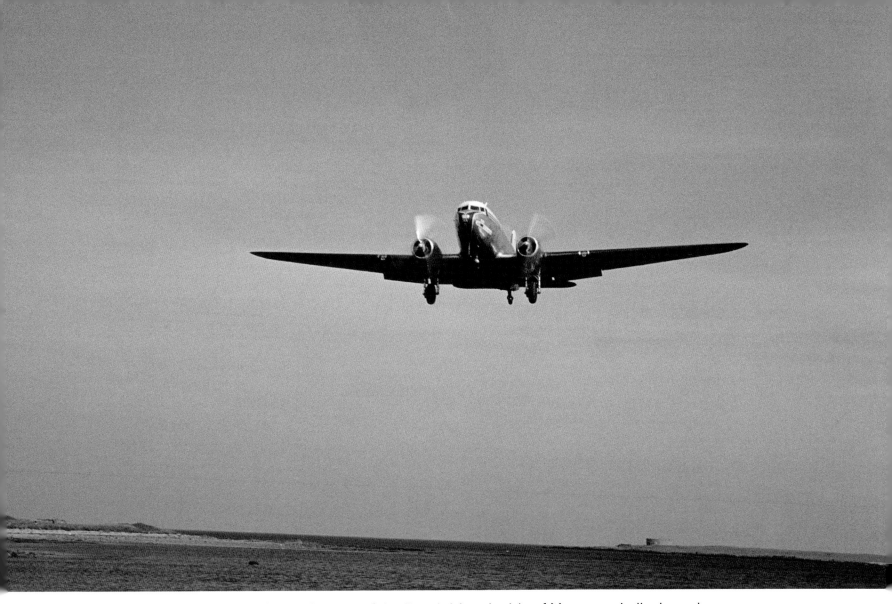

Physically separate from the rest of the British Isles, the Isle of Man was wholly dependent on sea transport for its connections with the UK and Ireland until the development of commercial air services to and from the island in the 1930s. Although an airfield near Ramsey was operational in the period 1935-7, a site at Ronaldsway, some seven miles south west of Douglas, became the centre for aviation operations and this remains the location of Isle of Man Airport. It is not a good place for the nervous flyer. Owing to its coastal location the approach and take-off paths usually involve low flying over Castletown Bay. A perimeter road provides a good vantage point for photography of incoming aircraft, in this case an unidentified BEA red and silver-liveried Douglas Dakota DC-3. Developed initially in the 1930s, but improved significantly during the Second World War, the Dakota was the workhorse of many airlines in the 1950s and examples would still occasionally visit the island as late as the 1990s. This view was taken by Marcus Eavis during his visit in late May 1959, which had begun with flight BE040 from Liverpool, the journey time being just 30 minutes. (*Marcus Eavis/Online Transport Archive*)

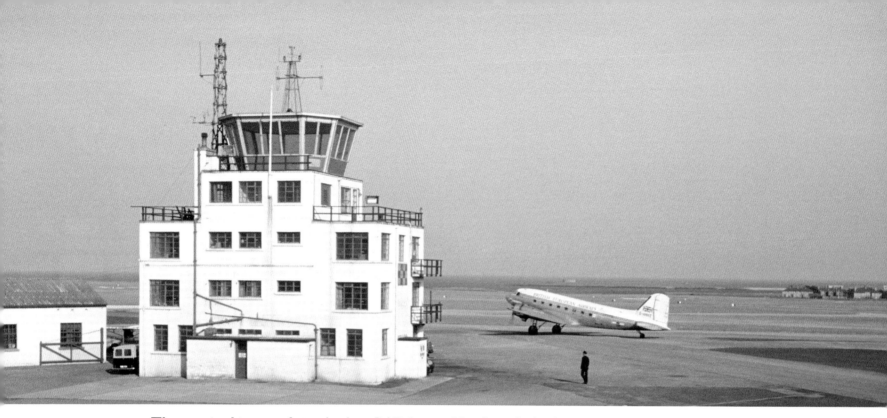

The control tower dates back to RAF days and has been little altered for its subsequent peacetime role. The bleak and windswept nature of the airfield can be gleaned from this picture, which also features a BEA Dakota DC-3, this time identifiable as G-AMKE. Aircraft such as the Dakota provided a vital lifeline, particularly ensuring that the daily papers arrived in time for islanders to read every morning. (*Marcus Eavis/Online Transport Archive*)

British United was another airline associated with the Isle of Man for some years. Formed in 1960 through the merger of a number of smaller companies, it was at one time the largest independent airline in Britain, operating from hubs at Gatwick and Stansted. It ceased operations in 1970 when it merged with Caledonian Airways. In its attractive white, blue and silver livery, with gold lining out, DC-3 G-AKNB is about to start taxiing prior to take-off. This aircraft was new to the RAF in 1943 and transferred to civilian use in 1947. It operated for a number of airlines during its commercial career and, in semi-retirement, has appeared in several feature films. It is believed to still exist. (*Marcus Eavis/Online Transport Archive*)

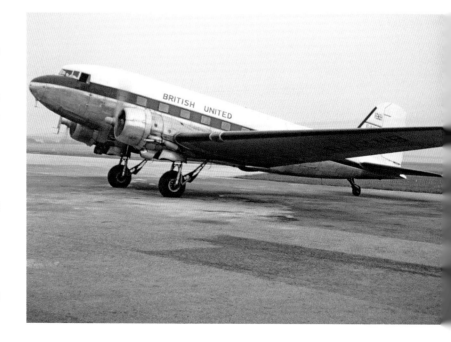

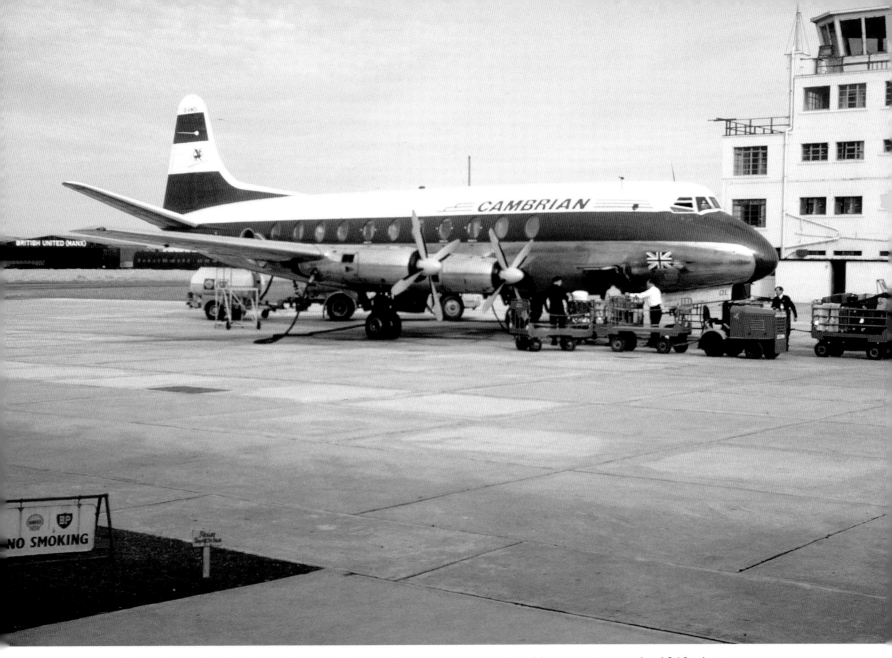

This view of a Cambrian Airways Vickers Viscount characterises Manx aviation in the 1960s, having taken over BEA's Isle of Man routes. The airline, based in Cardiff, was founded in 1935 and, although operations were suspended during the Second World War, it became the first British airline to restart after the war. Through a series of mergers, the Cambrian name gradually began to disappear in the early 1970s and the company was formally dissolved in 1976 as its operations were fully merged into British Airways. The medium-range Viscount was the world's first turboprop aircraft. It entered service in 1953 and remained in production until 1963. G-AMOL, pictured here, was new in 1953 but met a tragic end when it crashed on approach to Liverpool Speke Airport on 20 July 1965. There were no passengers on board, but the crew of two were killed as well as two people on the ground. (*Marcus Eavis/Online Transport Archive*)

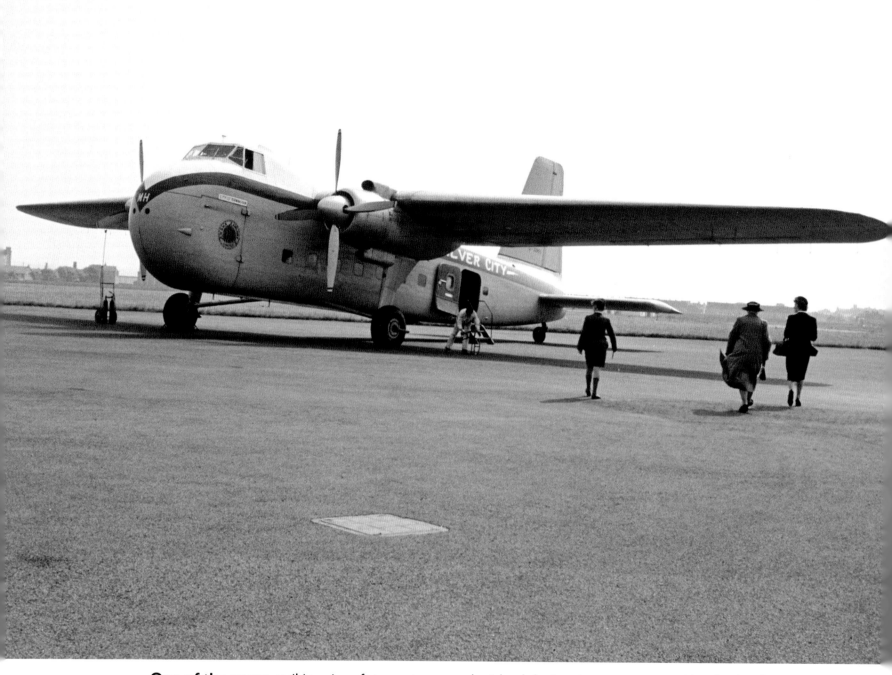

One of the more striking aircraft types to serve the island during the years covered by this book was the Bristol 170 Freighter. This featured a bulbous front end with hinged doors which allowed it to operate as an 'air ferry' to transport cars and small numbers of passengers over relatively short distances, although cars were never carried on Isle of Man routes. 214 were built between 1945 and 1958. New to a French Airline, G-AIMH was bought by Silver City Airways in 1952 and named 'City of Birmingham'. For part of the time, it was leased to Manx Airlines Limited and it carries branding for both companies when seen on the tarmac in May 1959. It was sold in 1962 and broken up in 1963. (*Marcus Eavis/Online Transport Archive*)

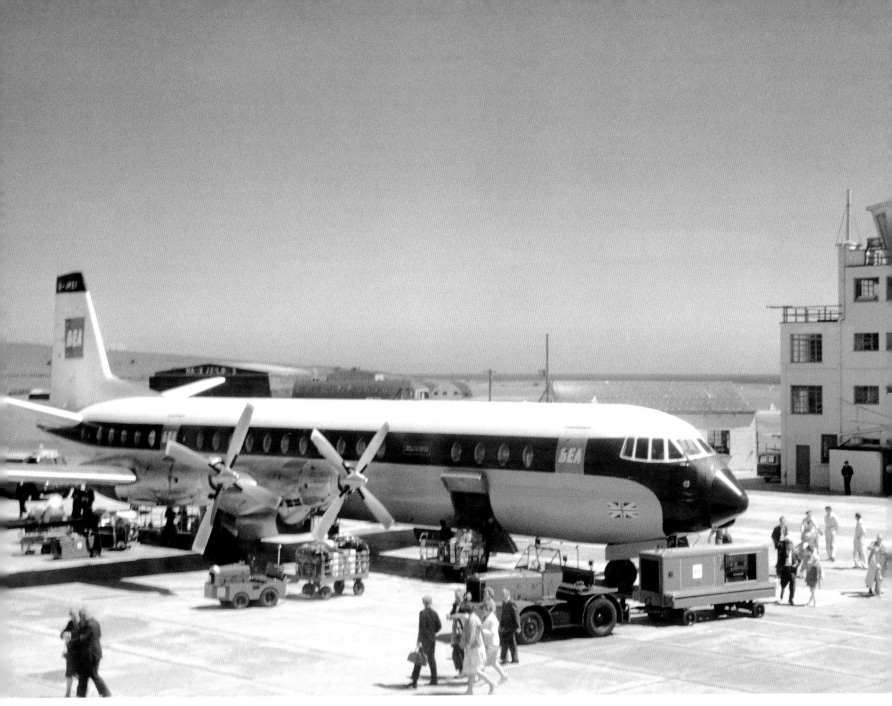

Passengers disembarking from this BEA Vickers Vanguard 953 four-engine aircraft seem to be wandering across the apron at will as they make their way to the terminal building, a far cry from today's high security. First entering service in 1960, the Vanguard was a development of the Viscount, featuring four turboprop engines. It appeared just as the industry was moving towards jet-powered aircraft so only 44 were built by the time production ceased, with BEA being one of only two customers. The type was used to and from the island only on London routes. G-APEI was new in 1961 and was with BEA until 1973. (*J N. Barlow/Online Transport Archive*)

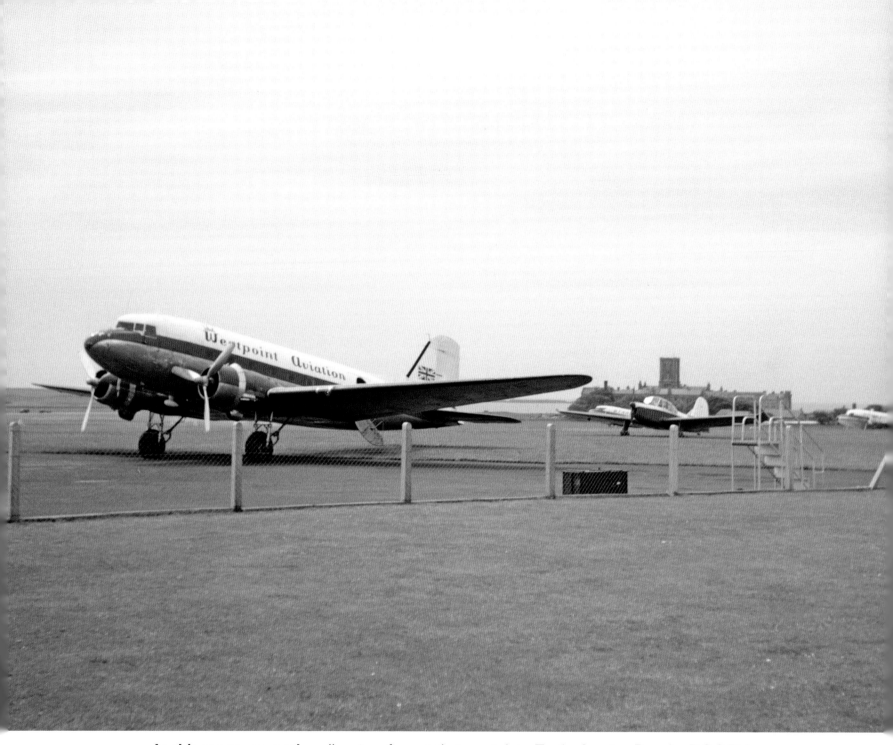

In this scene, several smaller aircraft await their next duty. To the fore is a Douglas DC-3 Dakota of short-lived airline British Westpoint Airlines. From a base in Exeter, it ran a mix of scheduled services between 1962 and 1967 when financial problems forced the closure of the operation. The buildings in the background are those of the independent boarding school King William's College. (*J.N. Barlow/Online Transport Archive*)

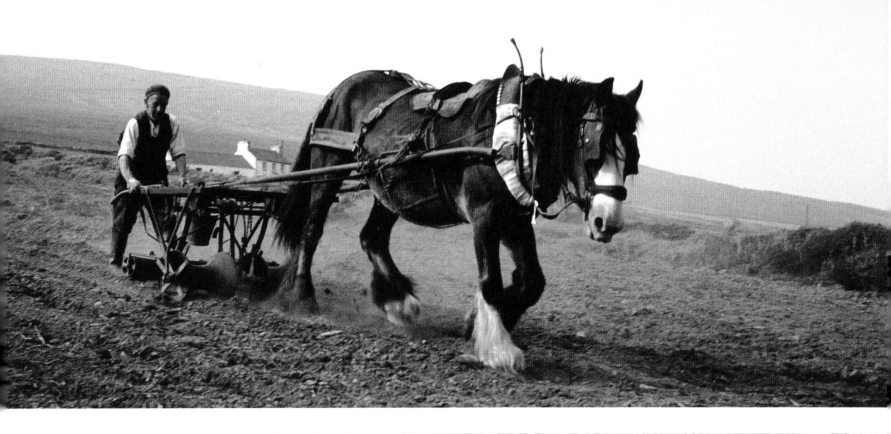

The horse tramway along Douglas promenade is world-famous. Despite several closure scares plus a shut down during the Second World War, the 1¾ mile, three-foot gauge line celebrated its 140th anniversary in 2016. However, too many residents now regard the horse cars plodding down the middle of the road as an anachronism and until recently insufficient visitors were using them as a prime means of transport. During the years covered by this book, the horse still played a prominent role in the island's economy. For example, in two views taken in late May 1959, a 28-year-old ploughs a field at South Barrule whilst in Douglas another is in charge of a dray owned by Heron & Brearley Ltd, the island-based drinks company nowadays best known for brewing Okell's beer. (*Marcus Eavis/Online Transport Archive (both)*)

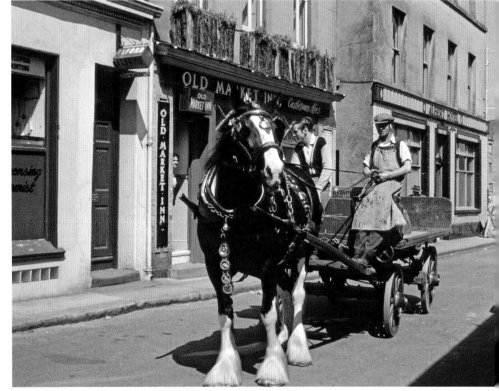

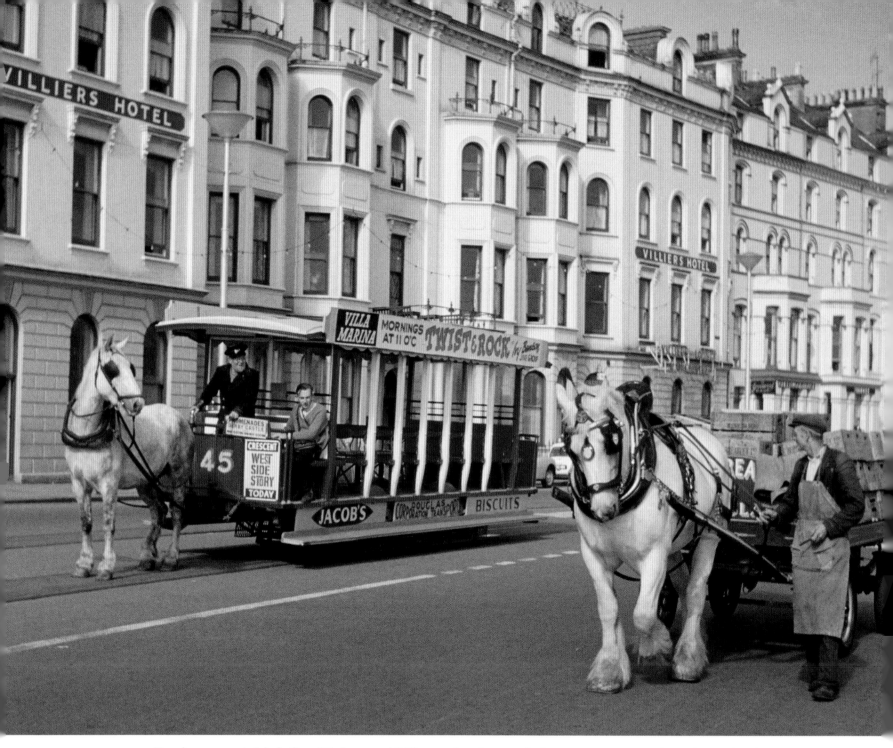

Equine courtship? On 17 August 1962, another brewer's horse seems to reject the seductive advances from a passing 'trammer'. For many years, the latter have mostly come from Ireland. Working hours are strictly limited to a number of daily trips. Each carries its name and daily supervision is undertaken by a veterinary surgeon. Ultimately, many retire to a special home outside Douglas. (*F.W. Ivey*)

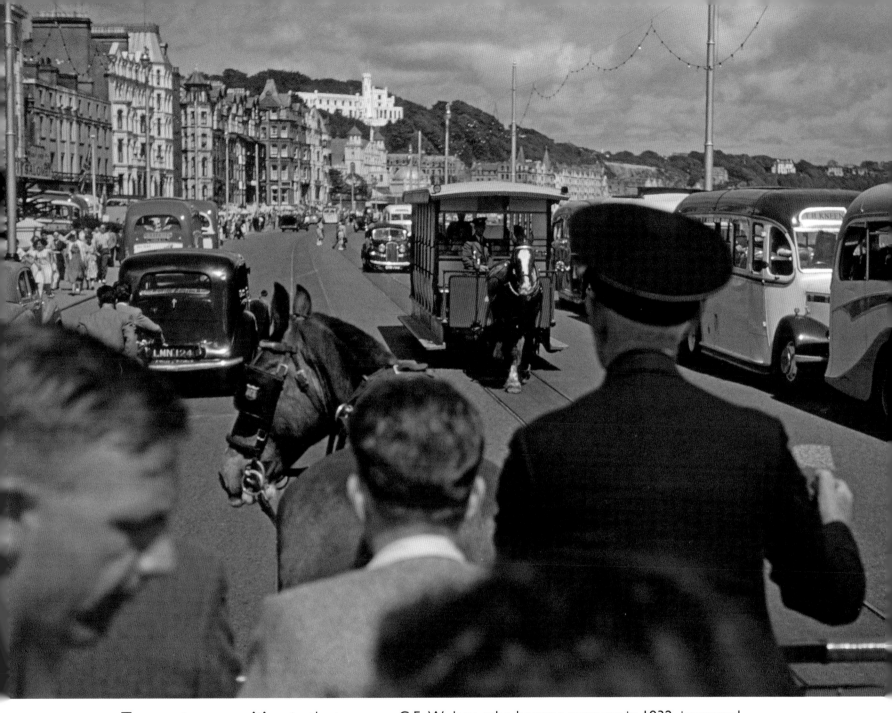

To counter opposition to the tramway, C.F. Wolsey, who became manager in 1932, increased seating capacity on selected cars and also installed improved running gear and axles boxes to ease the load for the horses. After the war, he overcame further calls for closure by streamlining the operation. This scene, taken on 3 August 1953, revives memories of the post-war hustle and bustle when 'no vacancy' signs abounded, 'big names' topped the bill at local theatres, beaches were crowded, private coach operators offered island tours, horse trams ran every few minutes and the sun shone – at least some of the time! (*John McCann/Online Transport Archive*)

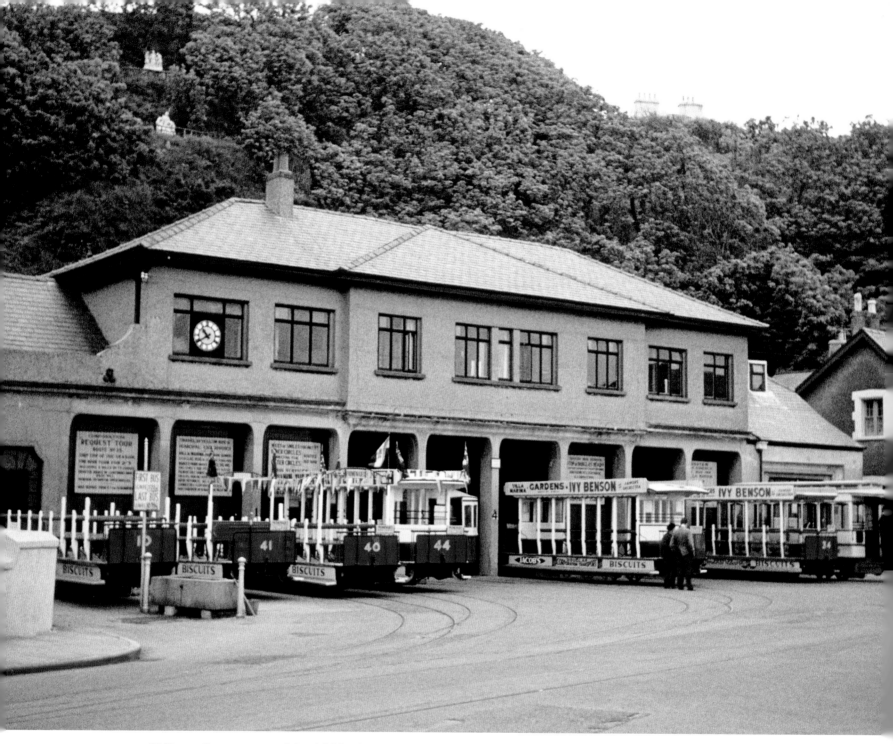

When first opened in 1896, the depot and offices at Derby Castle had 12 tracks for 36 cars. This capacity was gradually reduced with some cars stored off-site especially following loss of the winter service in 1927. After a suite of offices was built above the depot in 1935, 27 trams could be housed on nine tracks, of which five were connected to the running lines and four were accessed by a traverser. This view dates from Whitsun 1961. (*Phil Tatt/Online Transport Archive*)

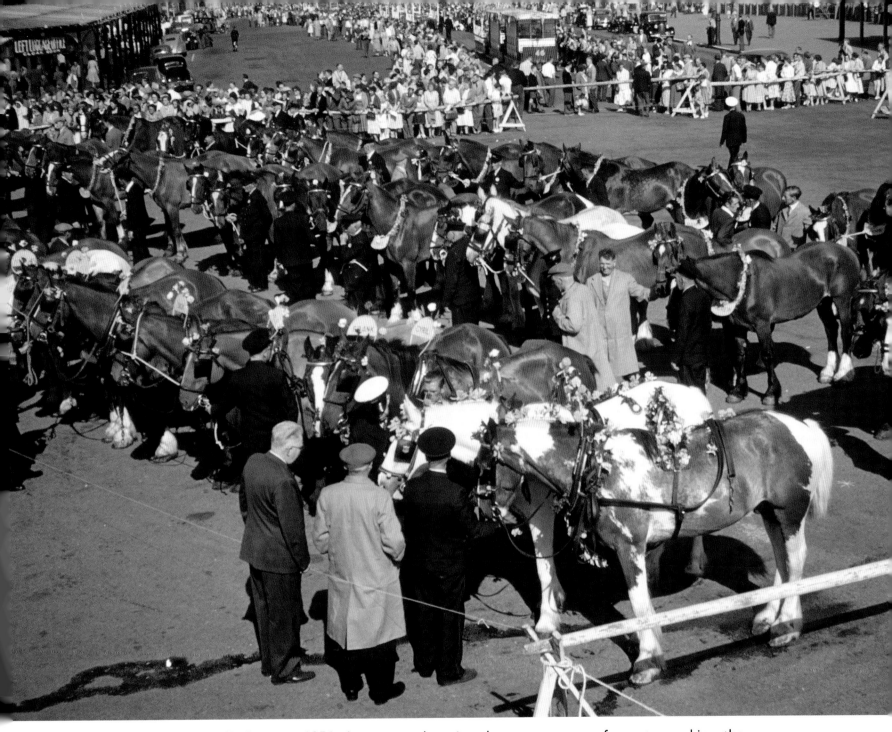

On Tuesday 7 August 1956, large crowds enjoyed a programme of events marking the 80th anniversary of the tramway. The day began with a 'Grand Assembly of Decorated Horses and Trams' when over 80 animals were on display at Victoria Pier, each with its own name board. Such a significant stud required 100 tons of hay, 4500 bushels of oats and 30 tons of straw a year despite spending seven months 'out to grass'. Some of the animals seen here were later involved in the actual celebratory parade whilst others returned to the stables. (*John McCann/Online Transport Archive*)

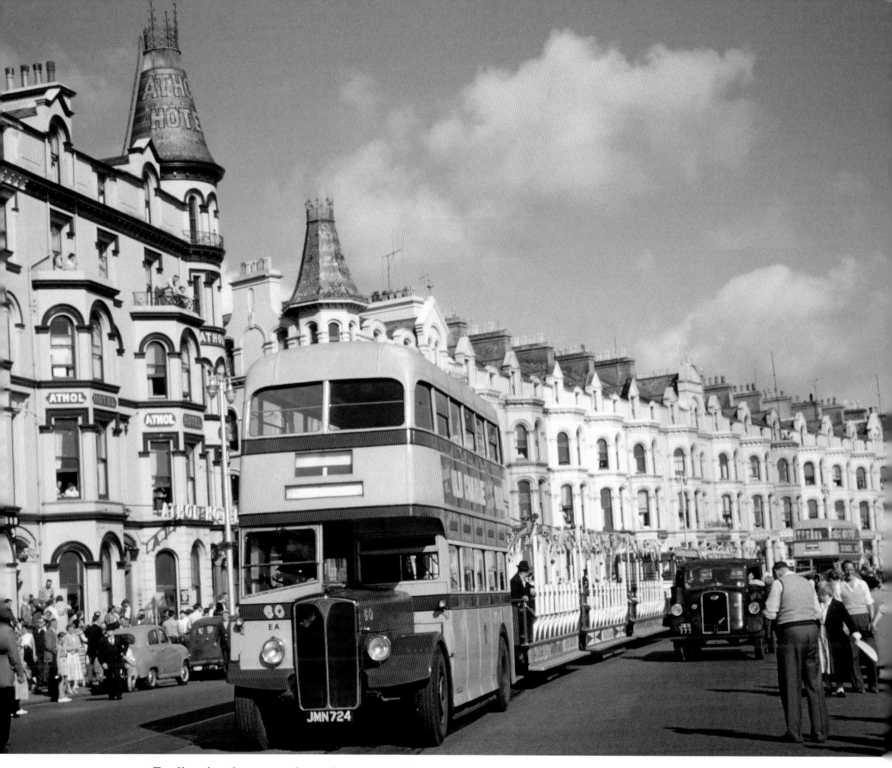

Earlier in the morning, the trams taking part in the parade were towed behind Corporation buses from Derby Castle in three linked groups of six. In this view, Northern Counties bodied AEC Regent III No. 60 of 1948 is in charge of the first sextet as they progress past the Athol Hotel bound for Victoria Pier. The hotel was demolished in 1994. (*John McCann/Online Transport Archive*)

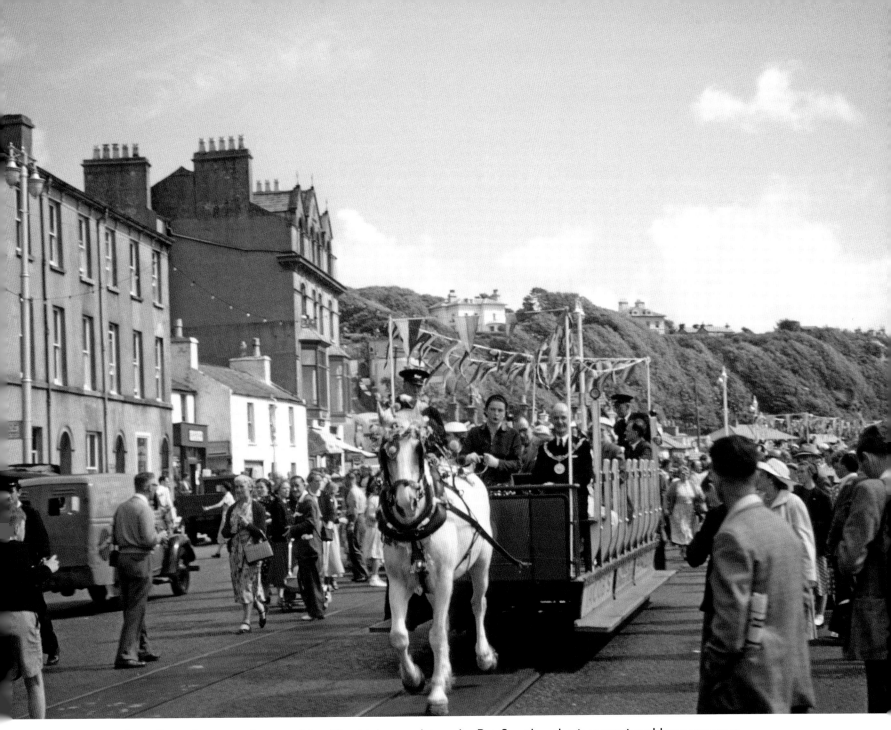

Leading the parade was No. 40 which was driven by Pat Smythe, the international horsewoman. Also on the platform were Driver Cowin and the Mayor, W.B. Kaneen. Watched by cheering crowds, the official procession plodded slowly from Victoria Pier to Derby Castle and then back to the Villa Marina. Here, No. 40 is passing the stables at the start of its return journey. Souvenir tickets and an illustrated programme were available. The whole event was masterminded by long-serving manager C.F. Wolsey, who retired in 1961. (*John McCann/Online Transport Archive*)

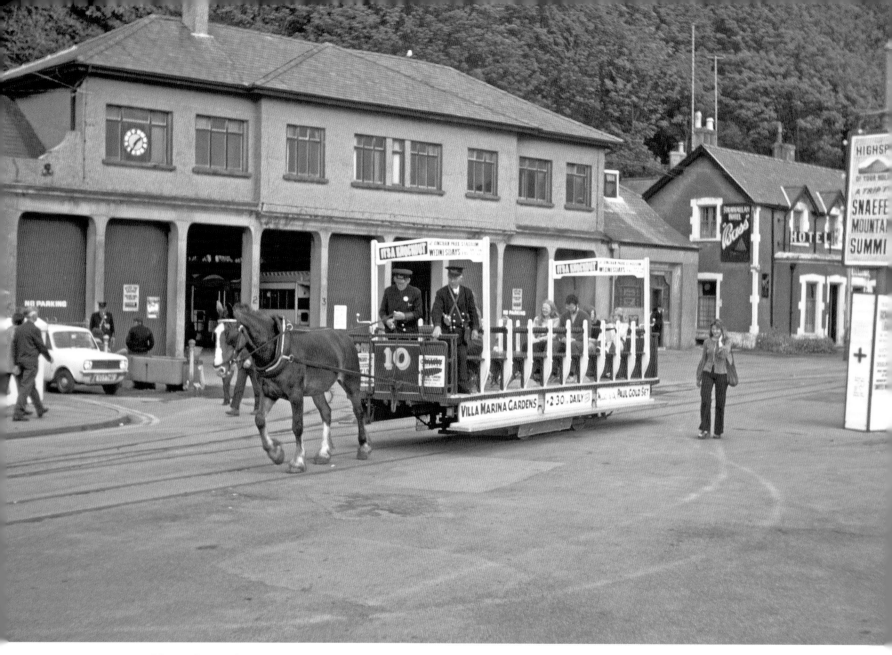

No colour views appear to exist of double deckers Nos. 1-8 built by the Starbuck Car & Wagon Company between 1876 and 1884. All were withdrawn and broken up by 1949 due in part to those opposed to a single horse pulling a fully laden double-decker. Nos. 9-10 were lightweight toastracks built by Starbuck in 1884. No. 9 was sold for scrap in 1952 but 10 was among the cars upgraded by Wolsey when it was converted from an eight-bench 32-seat 'small toastrack' into a 40 seat 'lengthened toastrack' with shorter platforms, narrower spaced seats and Maley & Taunton (M&T) roller bearing axle boxes. During the rebuilding, the hooped iron arches which supported the lamphouses were removed. It is seen leaving Derby Castle in July 1974. The advertising boards were carried on the four end posts which had been raised in 1963/4. No. 10 was withdrawn in 1979 and broken up in 1983. (*Martin Jenkins/Online Transport Archive*)

Virtually identical to the first two toastracks, No. II was ordered from Starbuck but may have been completed by G.F. Milnes. Delivered in 1886, it was in almost original condition when withdrawn in the late 1970s. It is seen behind No. 33 in July 1956. This historic vehicle is now preserved at the Jurby Transport Museum. (*Alex Hamilton, courtesy Leo Sullivan/Online Transport Archive*)

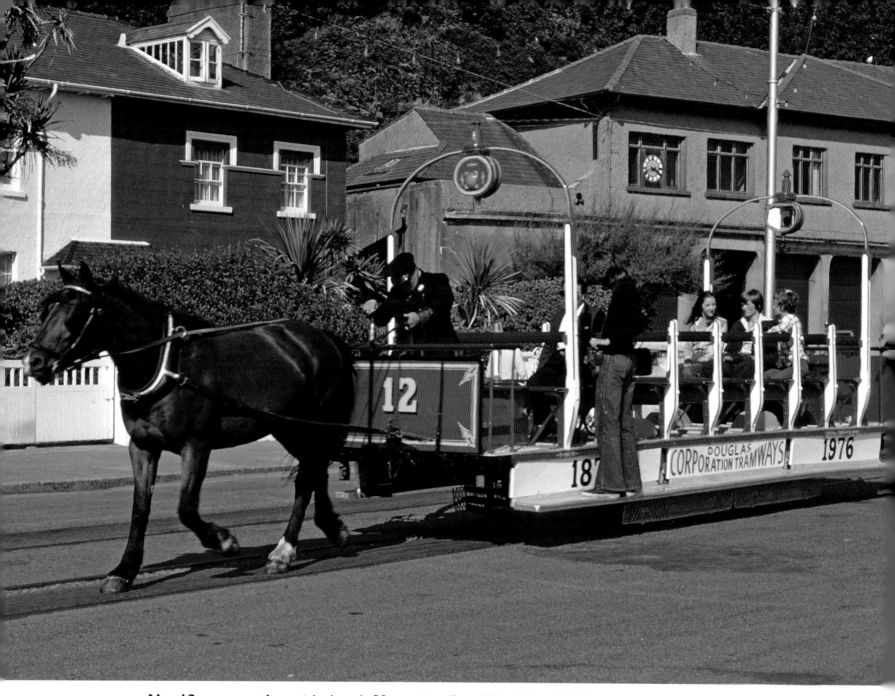

No. 12 was another eight-bench 32-seat 'small rack', built by G. F. Milnes in 1888. The hooped arches and lamphouses removed in 1949 were reinstated when the car was returned to its 1934 condition ready for the centenary celebrations. On 28 August 1976, it carries the special centenary livery with decorated white posts, flashes on the dash, florid fleet numerals and the inscription on the underframe. The driver wears the traditional heavy blue serge uniform whilst his more casually-dressed conductor is probably a local student hired for the summer 'rush'. Today, this is probably the oldest tram in the world still working on the line for which it was built. (*G.W. Morant/Online Transport Archive*)

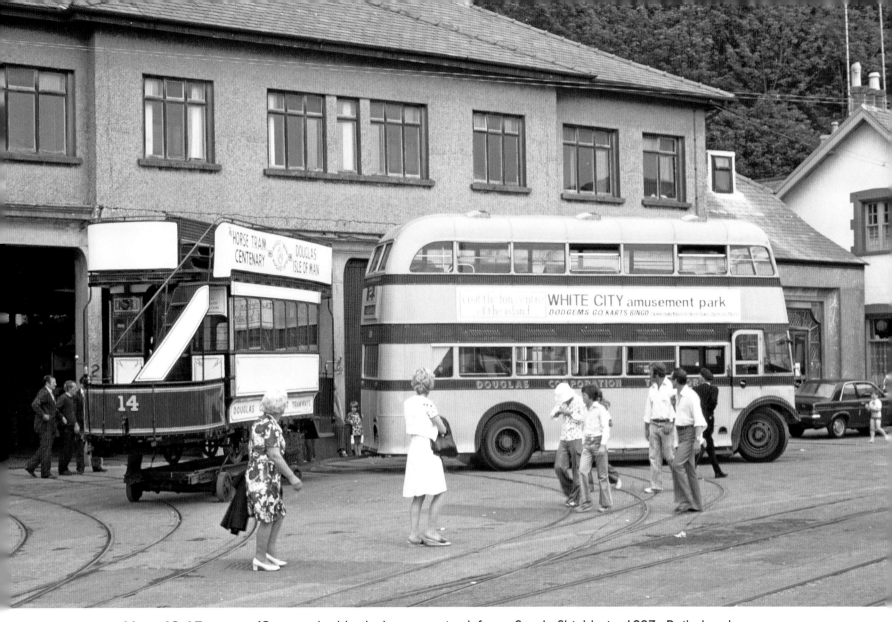

Nos. 13-17 were 42-seat double-deckers acquired from South Shields in 1887. Built by the Metropolitan Railway Carriage & Wagon Company in 1883, they had upper deck knife-board seating, quarter turn stairs, offset bulkhead doors and seven elliptical headed windows. After No. 14 suffered irreparable damage during a rockfall at Derby Castle, No. 13 took its number. No. 16 was scrapped during the First World War, whilst 17 became a single-decker prior to being scrapped at about the same time. This left 14 and 15 which were upgraded in 1935 with M&T running gear and Hoffman roller bearings. Stored during the war, it is believed they never ran again. No. 15 was scrapped in 1949 whilst 14 returned to England in March 1955. Eventually it was restored and put on display at the Museum of British Transport at Clapham. When this closed, it spent time at the Science Museum before returning to the island to star in the centenary parade in August 1976. In this view taken on Friday 6 August 1976, No. 14 has just arrived at the depot after being towed on a special low-loader from York Road works. (*G.W. Price/Online Transport Archive*)

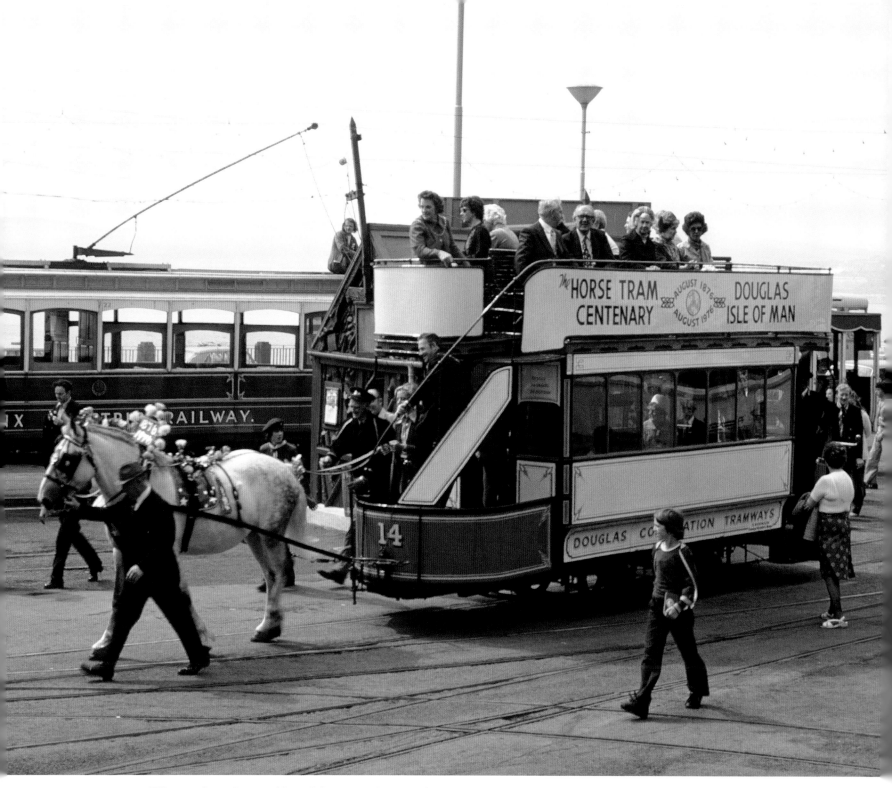

Three days later, 'Sarah' was in charge of No. 14 as it arrived at Derby Castle, the parade having left Victoria Pier at 11.15am. At the reins were Stevie Stricketts, the long-serving stable foreman, and Anne Moore, the show jumper. (*G.W. Price/Online Transport Archive*)

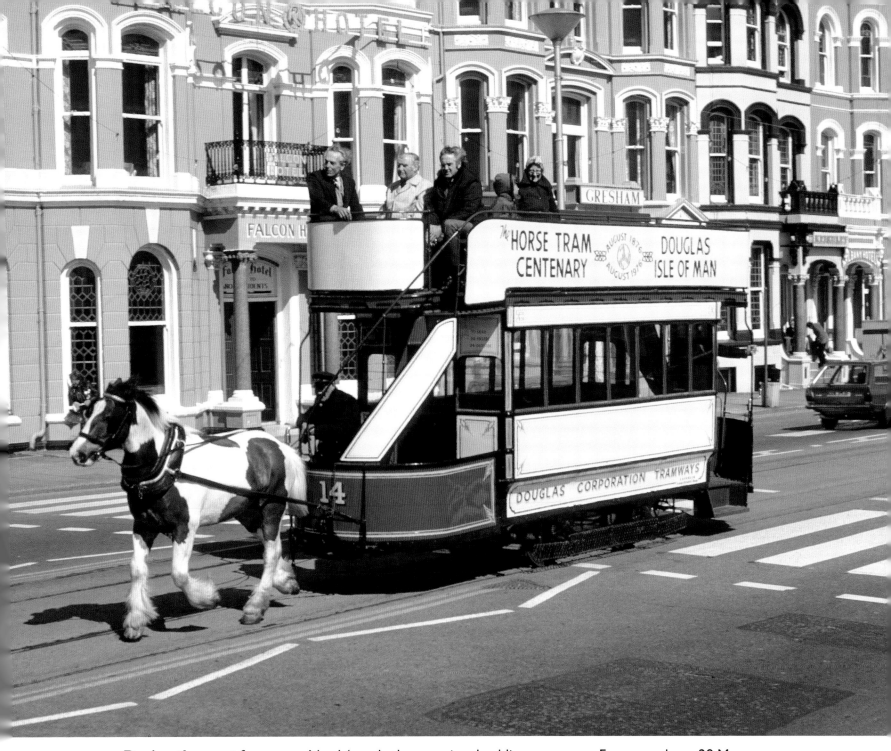

During the next few years, No. 14 made the occasional public appearance. For example on 29 May 1979, it heads south past the Falcon Hotel still in its centenary livery complete with inscriptions. However, these outings ended when it was moved to the Manx Museum in Douglas during the winter of 1990/1. Today this 44-seater provides a remarkable link with the past. (*R.L. Wilson/Online Transport Archive*)

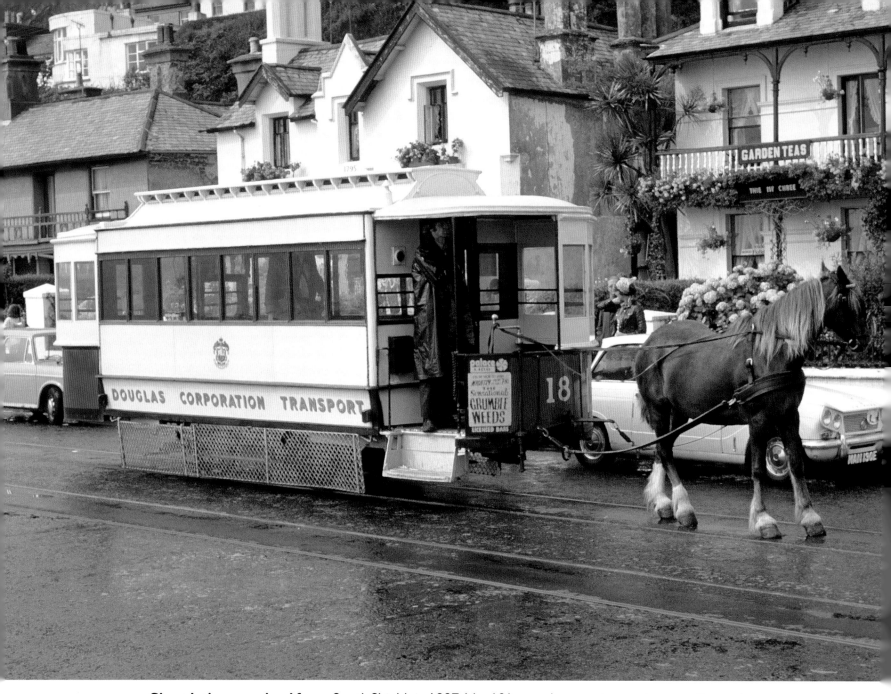

Since being acquired from South Shields in 1887, No. 18 has undergone two major transformations. Probably built by the Falcon Engine & Car Works for a line linking Ramsgate and Margate, it was diverted to South Shields. During the winter of 1903/4, it was converted into an eight window, 28-seater single-decker with clerestory roof, half windscreens and metal truck guards. For a period after the Second World War, it did not display the Douglas coat of arms but it was among the last to carry the title 'Douglas Corporation Tramways' on the rocker panels. Wrapped in his waterproof, the driver is approaching Derby Castle in August 1979. No. 18 remains part of the current fleet although reconverted into a double decker since the 1980s. (*G.W. Morant/Online Transport Archive*)

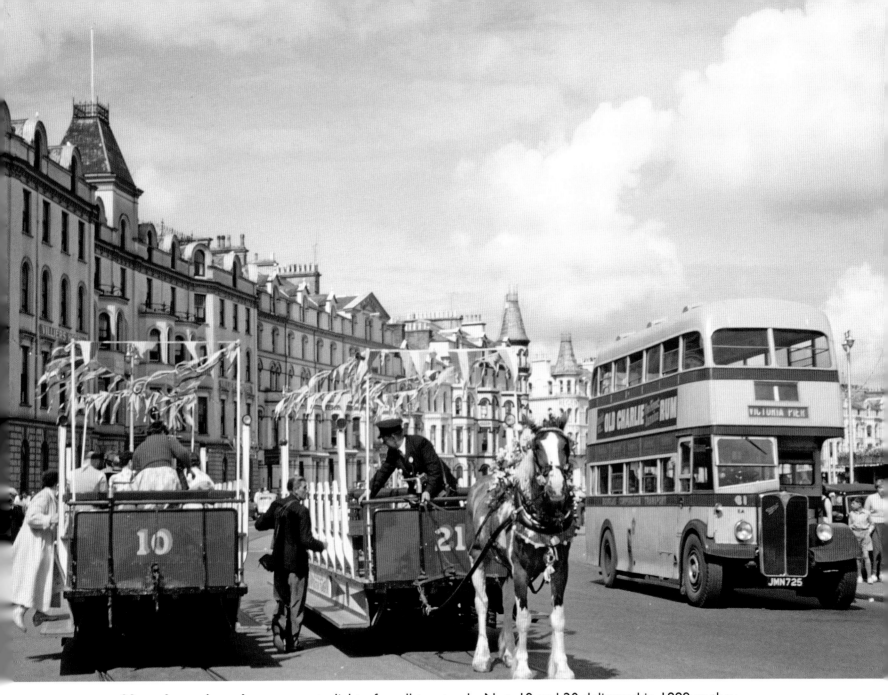

No colour views have come to light of small toastracks Nos. 19 and 20 delivered in 1889 as they were withdrawn and scrapped by 1952. However, views do exist of No. 21, which was one of a pair of small Milnes-built toastracks delivered in 1890. During the winter of 1935/6, it was converted into another 'lengthened' 40-seater with improved running gear. On 7 August 1956, it is seen at Victoria Pier in a patriotic red, white and blue paint scheme alongside No. 10, both being dressed overall to mark the tramway's 80th anniversary. During 1963/4, the end posts on both would be lengthened to provide support for advertising boards. No. 21 remains operational today. (*John McCann/Online Transport Archive*)

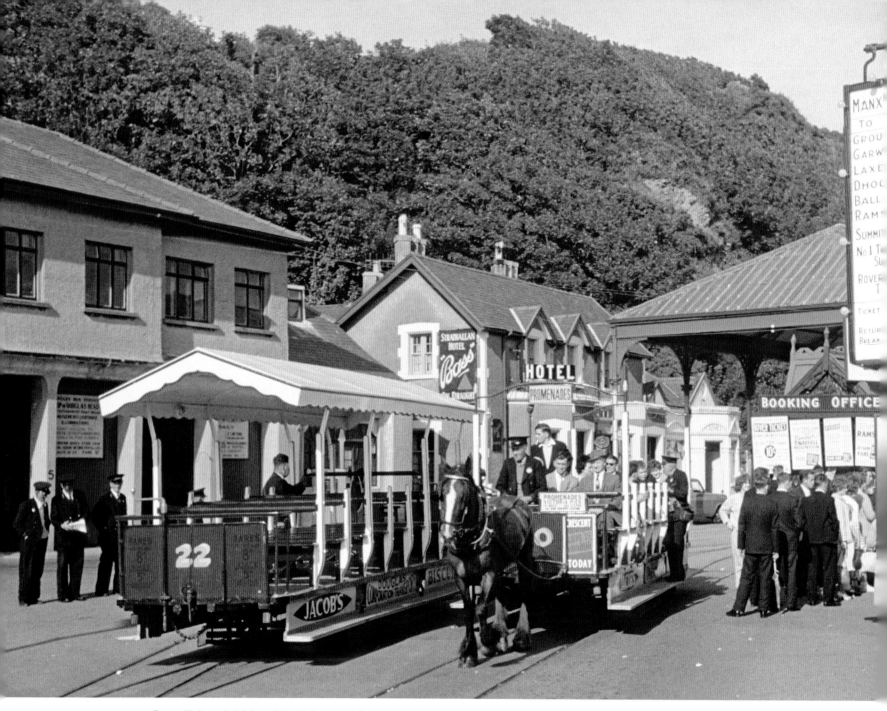

Small 'rack' No. 22 delivered from G.F. Milnes in 1890 was fitted with a V-shaped ridged roof and retractable canvas blinds in 1908. Later, the roof was permanently fixed and from 1935 it received improved running gear and axle boxes. In the summer of 1958, the 'umbrella car' is seen at Derby Castle alongside No. 10. The staff all wear uniforms and the passengers queueing for the next MER departure are in their 'summer best'. Following its withdrawal in 1976, 22 served as a mobile shop at Derby Castle, a role it now fulfils at the Jurby Transport Museum. (*E.C. Bennett/ Online Transport Archive*)

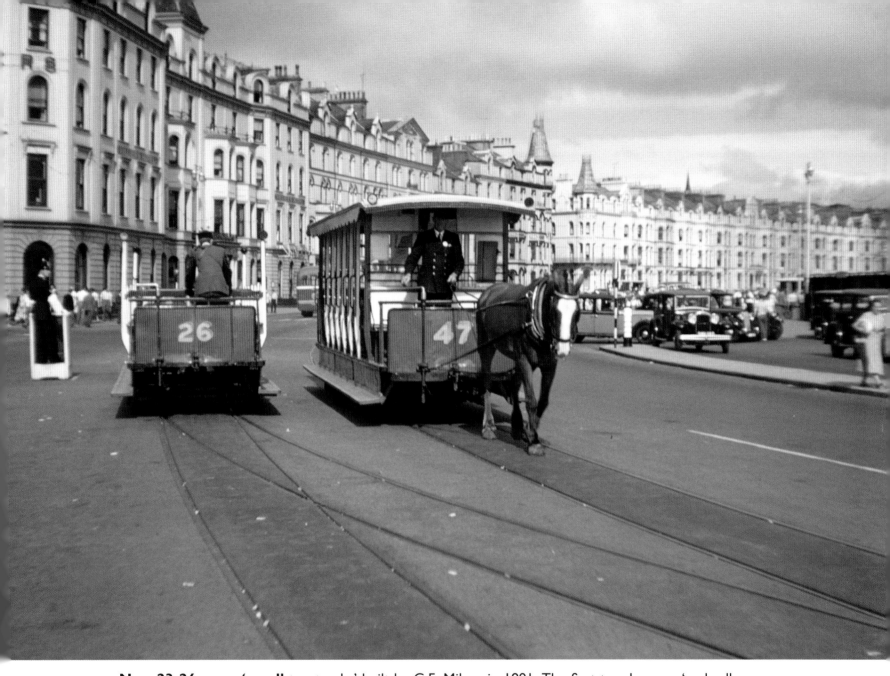

Nos. 23-26 were 'small toastracks' built by G.F. Milnes in 1891. The first two became 'umbrella cars', whilst 25 was in almost original condition when the trio were disposed of in 1952. Only No. 26 survived the purges. On 1 August 1955, the 32-seater is seen at Victoria Pier with No. 47. On a good day, up to 25 cars could be used with extra staff drafted in to drive, conduct, change the horses, clean and maintain the stables and check the trams seeing the least use. As the service then ran late into the evening, small electric side lights were displayed. These are visible on top of the end pillars on No. 26 and on the four roof corners of No. 47. This busy junction has since been redesigned and some background buildings demolished. Latterly, 26 saw little use before being officially withdrawn in 1974. (*David G. Clarke*)

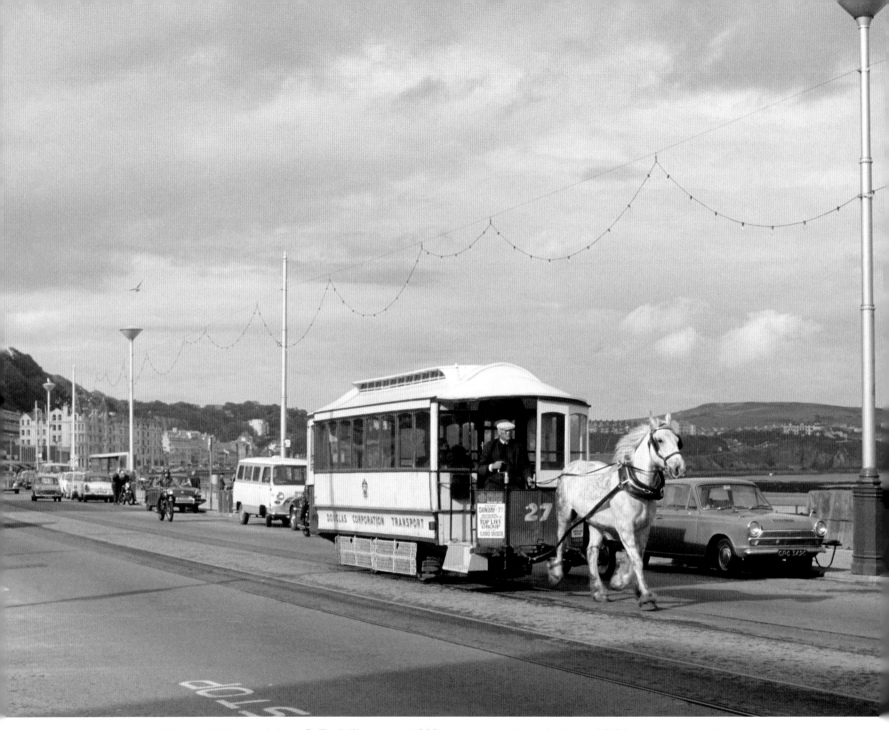

When delivered by G.F. Milnes in 1892, 'winter saloons' Nos. 27-29 with their distinctive turtle-back roofs had longitudinal seats for 24. However, when vestibules were added, capacity was increased to 30. Then, in the mid-1930s, they were equipped with improved running gear and roller bearing axle boxes. In later years, these classic cars appeared in different versions of the basic livery. Normally photographed in dull or wet conditions, lightly-loaded No. 27 is bathed in sunshine as it plods south on 5 June 1974. (W. Ryan)

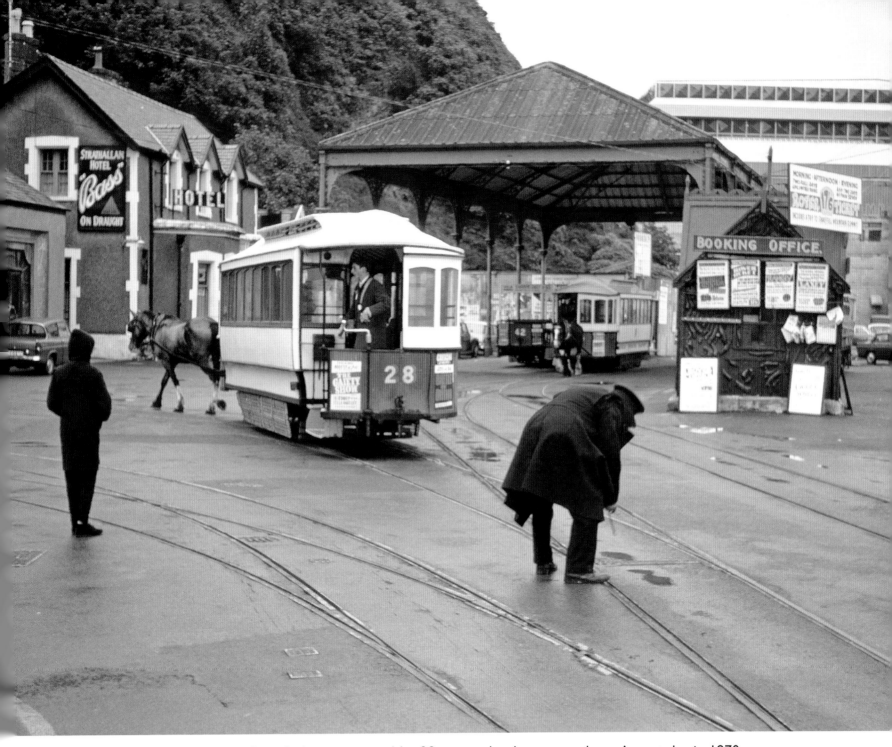

The points have already been reset as No. 28 enters the depot on a damp August day in 1970. It is displaying neither the coat of arms nor the title. When the cast iron canopy covering the sidings at Derby Castle was first completed in 1896 it was far more elaborate, featuring a clock tower and high gables, but these were removed when it was rebuilt after the Second World War. (*E.J. McWatt/ Online Transport Archive*)

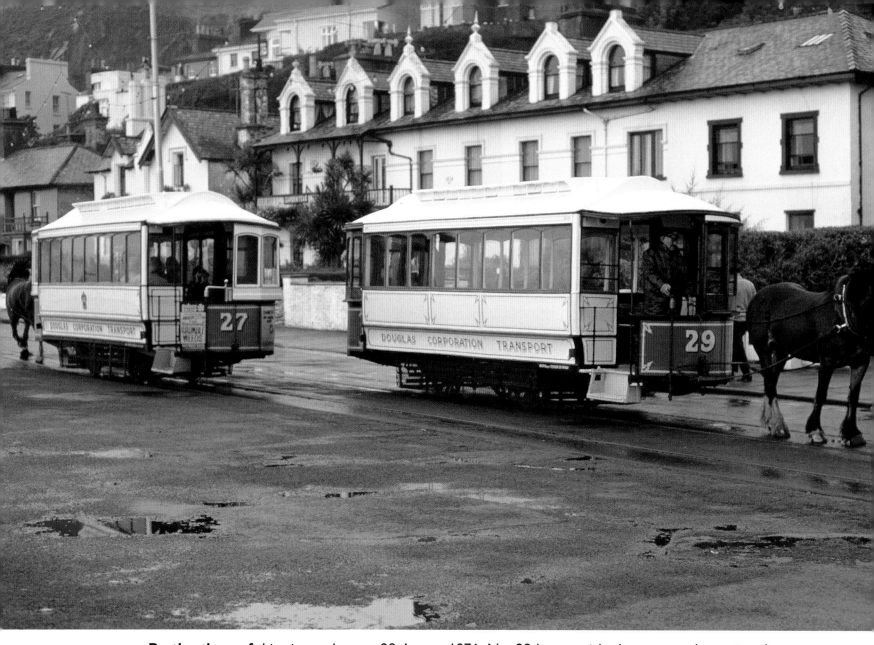

By the time of this view, taken on 29 August 1976, No. 29 has varnished as opposed to painted platform vestibules and there were variations to the lining out on the three cars. Nos. 27 and 29 form part of the current fleet, whilst 28 was among six cars sold in 2016. (*G.W. Morant/Online Transport Archive*)

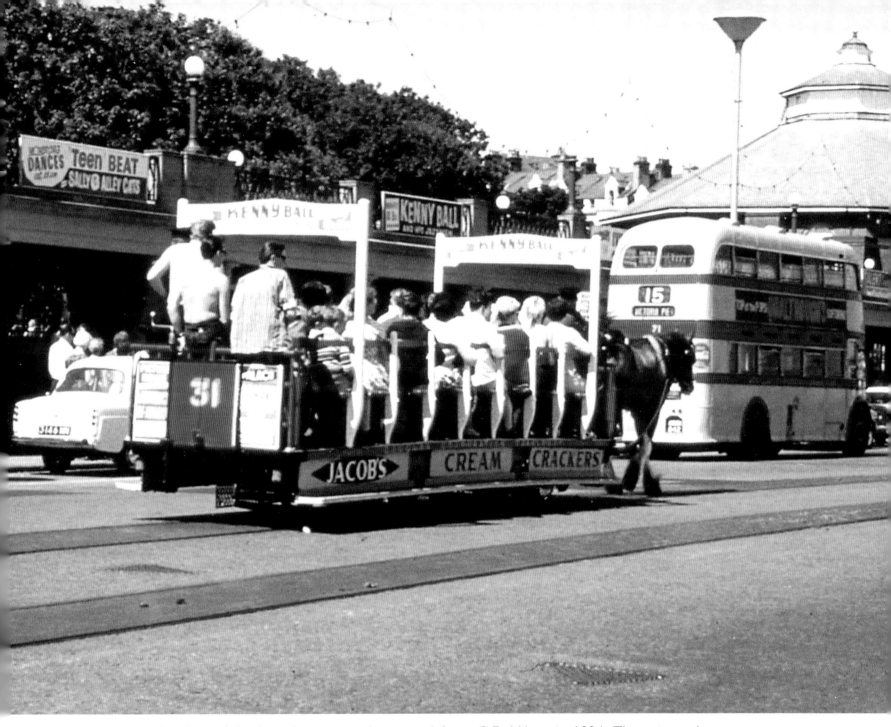

Two further eight-bench toastracks arrived from G.F. Milnes in 1894. There is no known colour view of No. 30 which was sold for scrap in the early 1950s. However, sister car No. 31, which escaped the breakers until 1987, had improved running gear and axle boxes. This photo was taken alongside the Villa Marina shortly after the car had been fitted with extended posts and advertising boards during the winter of 1963/4. Later, it was used to break in new horses and as an overall advertising car. (*Travel Lens Photographic*)

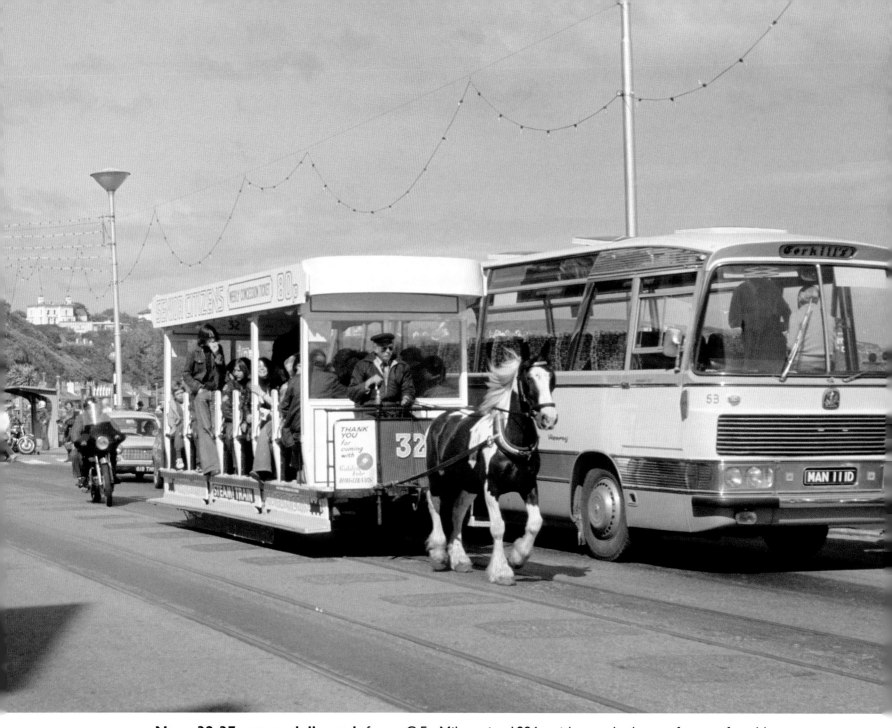

Nos. 32-37 were delivered from G.F. Milnes in 1896 with sunshade roofs, comfortable broad-slatted seat backs, wooden panels at the end of each row, brass grab rails and lamphouses suspended from the roof. The latter were subsequently removed and the seat backs modified. All these 'Sunshades' eventually received improved running gear and axle boxes in the mid-1930s as well as glazed bulkheads starting in 1908. Here, 32 is seen on 12 June 1977 shortly after it had been rebuilt during the previous winter. It remains part of the operational fleet. (*Peter Deegan*)

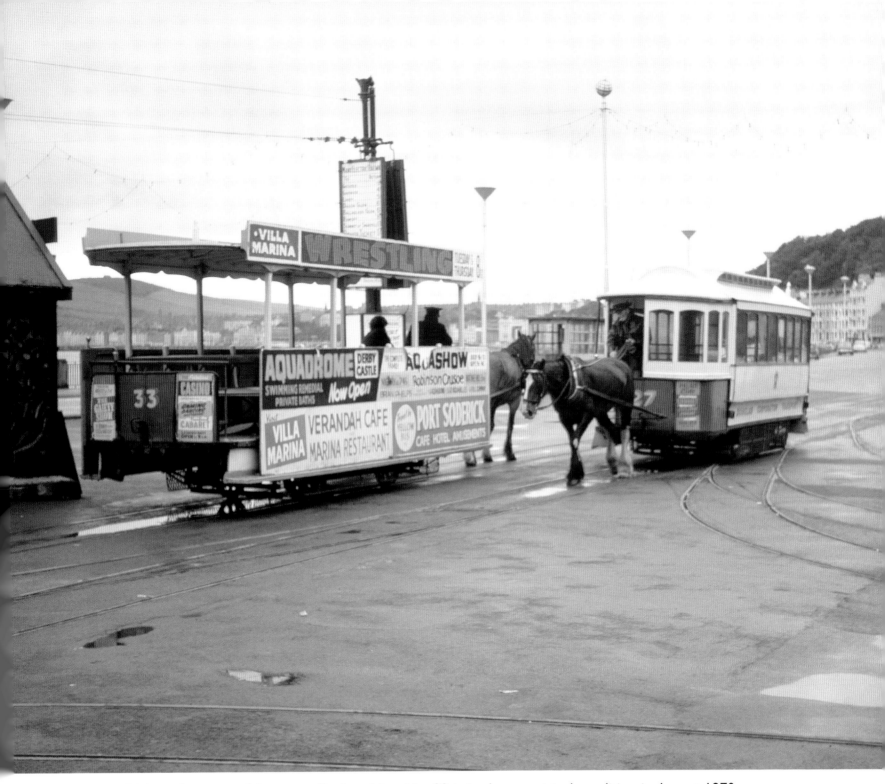

Although covered by overall advertising, No. 33 is in almost original condition in August 1970. Lifeguards and wheel guards had been fitted to all cars in the early 1900s. (*E.J. McWatt/Online Transport Archive*)

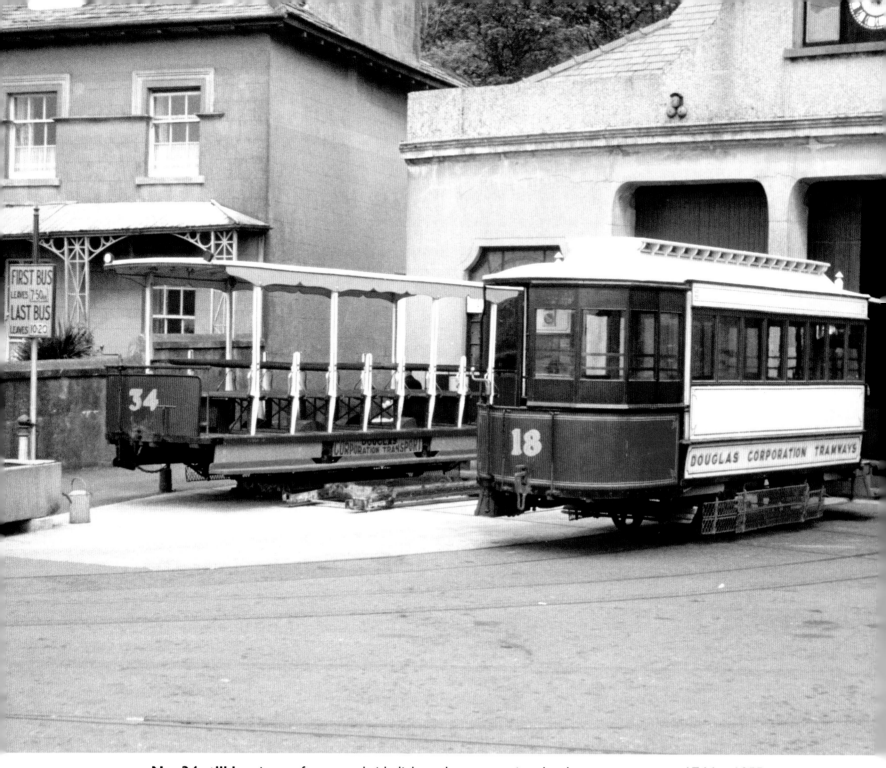

No. 34 still has its roof-mounted side lights when occupying the depot traverser on 17 May 1955. Later, its attractively shaped eaves-boards would be obscured by advert panels and in the 1970s it was rebuilt with glazed bulkheads. It was sold in 2016. At the time this view was taken, No. 18 still carried the title 'Douglas Corporation Tramways'. (*Ray DeGroote/Online Transport Archive*)

In September 1978, No. 35 poses alongside 33 now rebuilt with glazed bulkheads. With the demolition of the 'Great Canopy' in 1980, those trams left out overnight suffered from wet rot, the Wolsey rebuilds proving particularly susceptible due to the amount of unseasoned wood. In 1908, No. 36 was rebuilt with extended platforms, glazed bulkheads and bench seats on either side, thereby increasing overall seating to 40. In the second scene, taken on 17 May 1955, the crew change ends at Victoria Pier. The conductor leads the horse to the front whilst the driver follows with the reins and drawbar. Once the latter has been attached to the drawhook with a link pin, No. 36 can depart. In the background is the old ferry building, demolished in the early 1960s. This car is still operational. (*R. W. A. Jones/Online Transport Archive; Ray DeGroote/Online Transport Archive*)

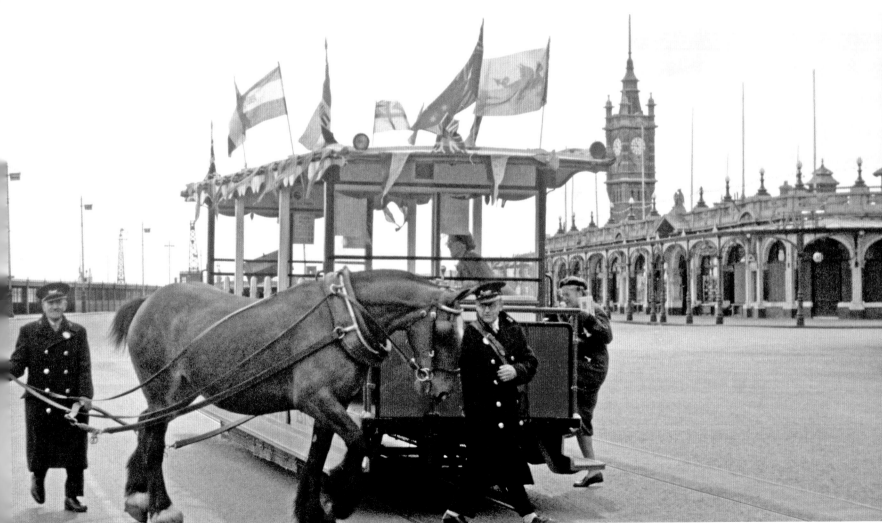

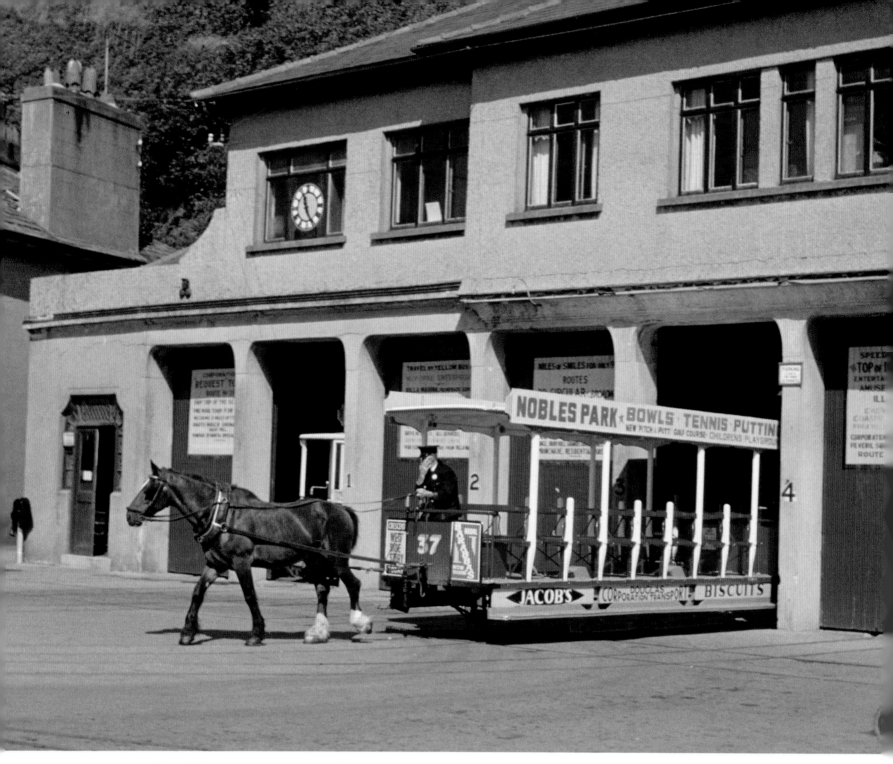

No. 37 is in virtually original condition as it emerges from the depot to take up service in June 1964. The horse trams had always carried adverts but with the loss of nearly a million riders a year between 1946 and 1980, this became an invaluable source of additional income. No. 37 was sold in 2016. (*F. W. Ivey*)

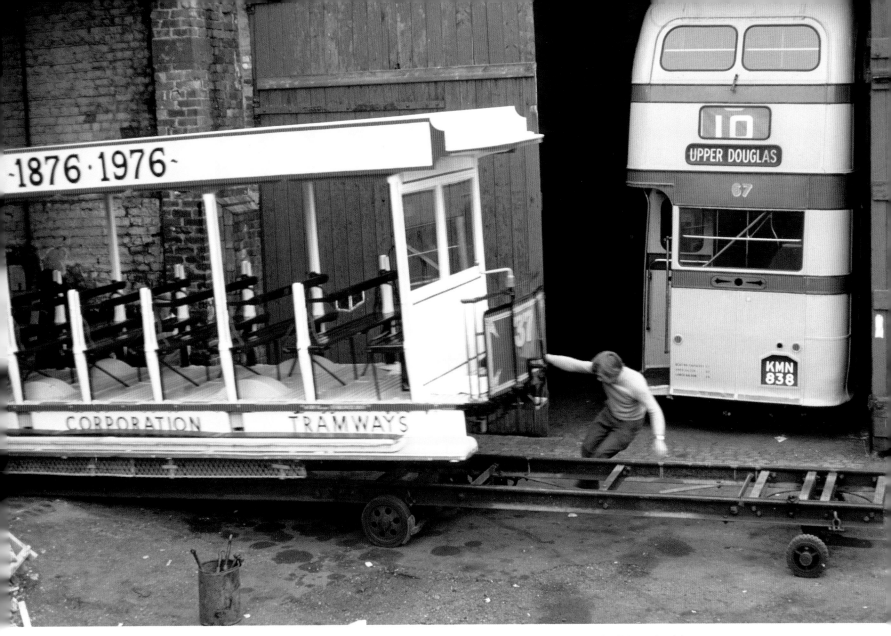

By the time of the 1976 centenary, No. 37 had been rebuilt with glazed bulkheads. Having just been repainted, it is being manoeuvred onto the special low loader to take it from York Road works to Derby Castle depot. After 1976, all repairs, overhauls and repaints would transfer to Derby Castle when York Road ceased to work on the horse cars. (*G.W. Price/Online Transport Archive*)

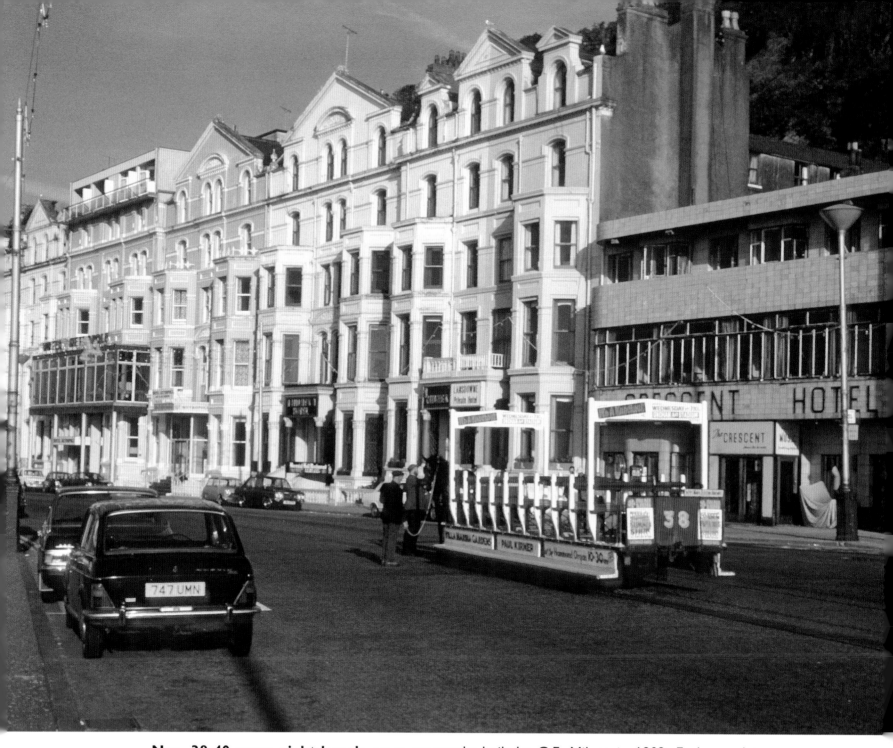

Nos. 38-40 were eight-bench, open toastracks built by G.F. Milnes in 1902. Each was later extended to carry 40 passengers and also fitted with improved running gear and roller bearing axle boxes. The advertising boards were a later addition. On 20 May 1975, No. 38 is being used to break in a new horse, the hardest part of the training being to keep the horse between the rails. A good 'trammer' is expected to work for some 15 years. (*W. C. Janssen/Online Transport Archive*)

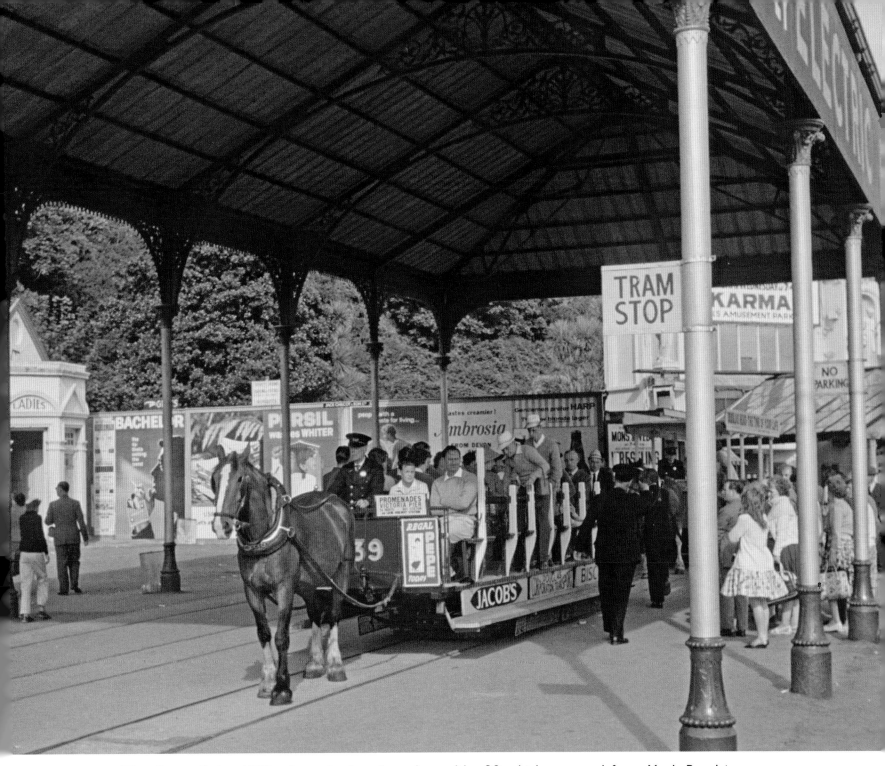

The first of the 1902 trio to be lengthened was No. 39 which emerged from York Road in 1934. Here it is loading at Derby Castle in 1958, the canopy's cast iron pillars and intricate trusses being shown to good effect. Later, 39 had advert boards fitted at either end. (*E. C. Bennett/Online Transport Archive*)

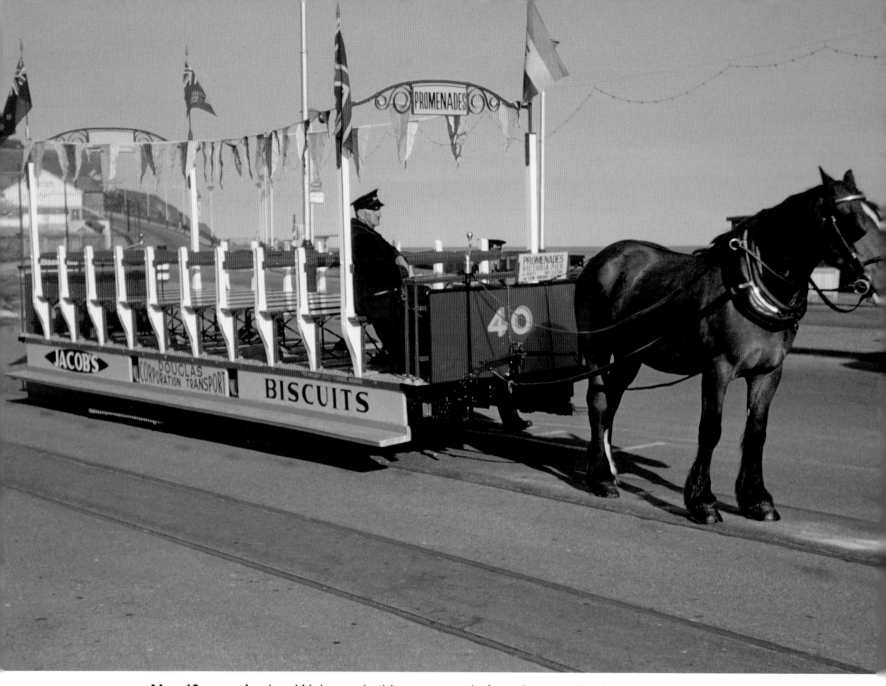

No. 40 was the last Wolsey rebuild to emerge before the war. At the same time, it received extended corner posts and ornate horizontal supports for carrying the destination board 'Promenades', although these were later replaced by the type used on other cars. There is a strong sense of colour coordination in this May 1961 view with the biscuit colour of the destination boards matching the Jacob's advert and the title 'Douglas Corporation Transport'. Only No. 40 now remains, as 38 and 39 were sold by auction in 2016. (*W.J. Wyse/LRTA (London Area)/Online Transport Archive*)

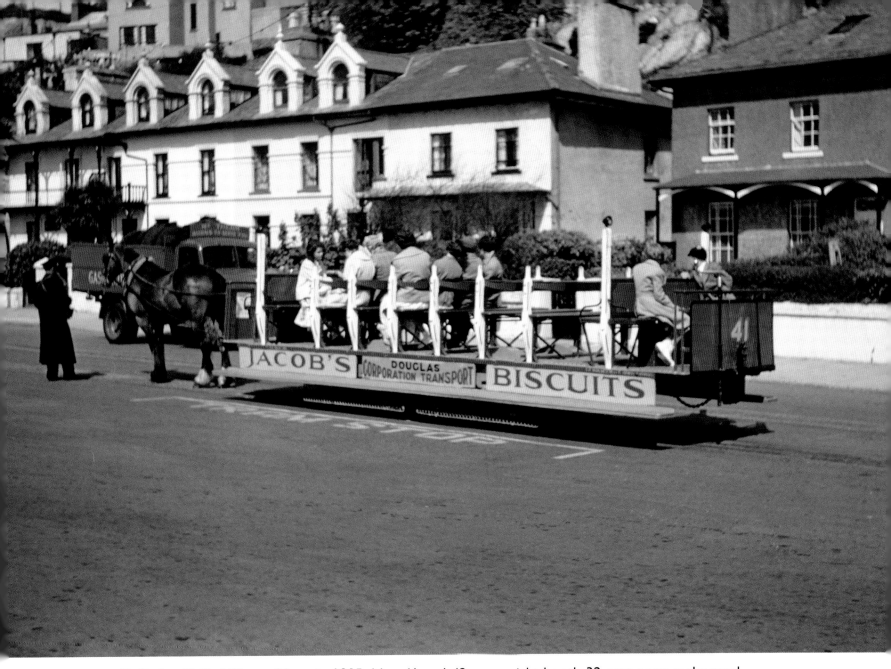

Built by G.C. Milnes, Voss in 1905, Nos 41 and 42 were eight-bench 32-seat open racks used initially on a short-lived shuttle from Victoria Pier to the cable car terminus. No. 41 was lengthened to carry 40 passengers in 1934, followed by No. 42 in 1938. Both also received new running gear and roller bearing axle boxes. In this view, 41 is seen on 19 May 1956 in its post-1934 condition with additional back-to-back bench seats at either end. Note the side lights on the four corner pillars and the 'Jacob's Biscuits' and 'Corporation Transport' in red instead of black. In the background, a lorry delivers coal to the houses on Strathallan Crescent. Having been renumbered 10 in 1985, this 'rack' survived until scrapped by the Corporation in 1988. (*M.J. Lea/LRTA (London Area)/Online Transport Archive*)

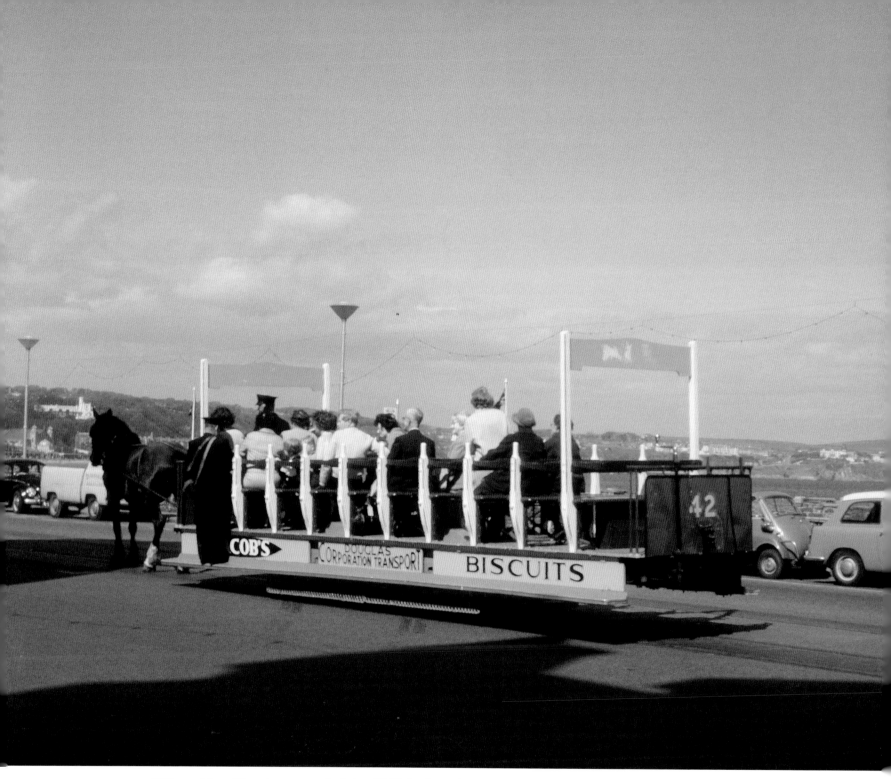

When No. 42 – the second of the 1905-built racks – was lengthened, its dashes were also modified and it was later fitted with extended posts and advertising boards as seen here on 15 May 1964. This car is still active. (*R.L. Wilson/Online Transport Archive*)

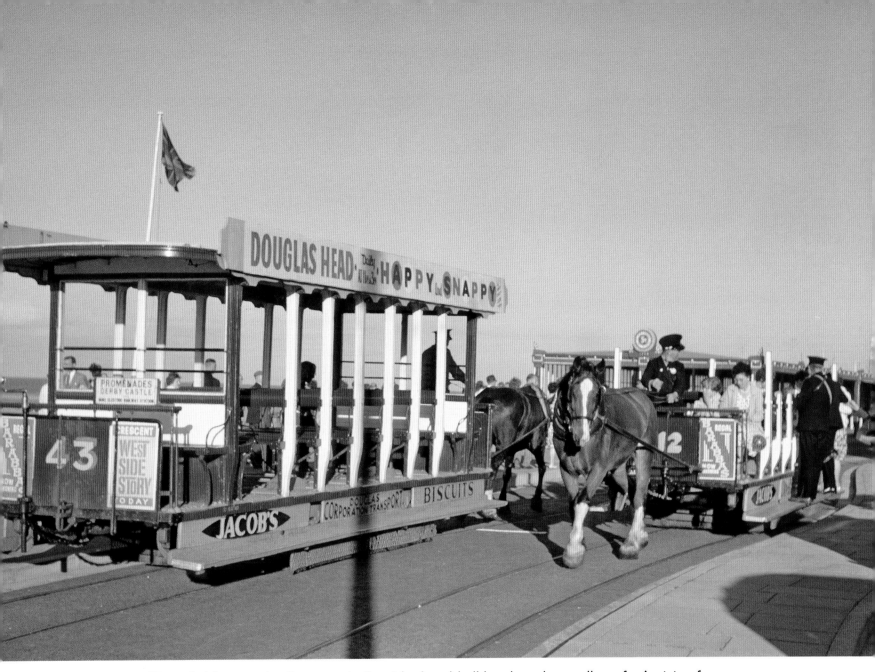

Nos. 43 and 44 were the first cars built with glazed bulkheads and overall roofs. Arriving from the United Electric Car Company in 1907, these 40-seaters were delivered with lamphouses and canvas roller blinds although these were later discarded. No. 43 is seen at the new Victoria Pier tram terminus shortly after it had been formally opened by J.W. Fowler, Chairman of the Light Railway Transport League (LRTL), on 20 May 1961. Facilities included a covered passenger shelter and space for up to four trams. Although serving the new Sea Terminal, it was little used after 1973 as the Corporation were reluctant to pay Douglas Harbour Board for each journey. After the shelter and loading islands had been removed, part of the stub remained accessible until at least 1996 after which the remaining rails were lifted. No. 43 is part of the present fleet. (*F.W. Ivey*)

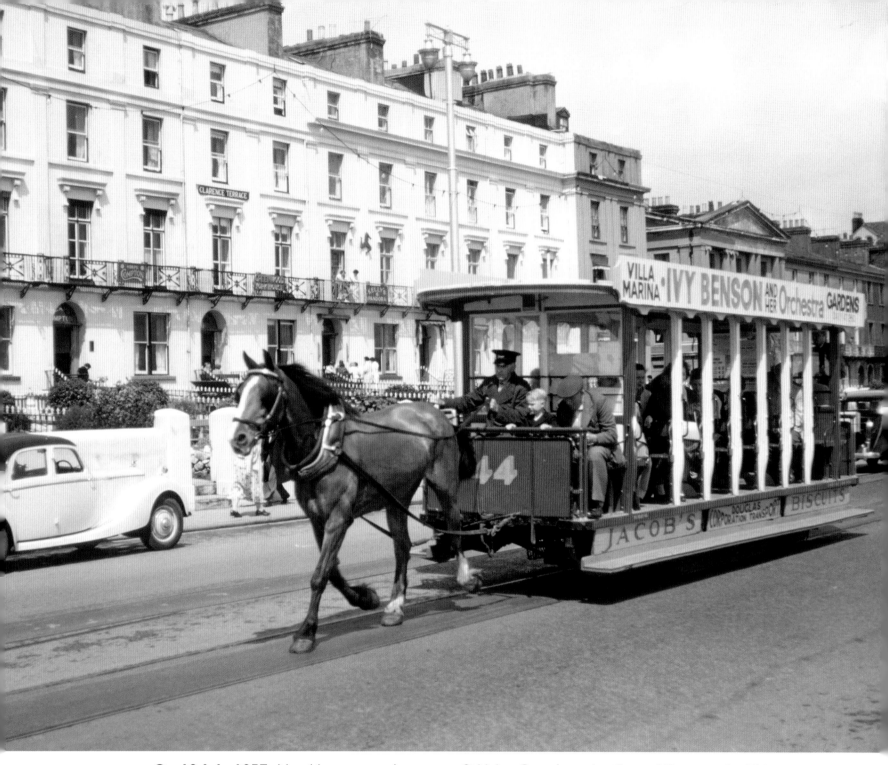

On 18 July 1957, No. 44 passes an Armstrong Siddeley Coupé on the Central Promenade. This was before No. 44 gained fame as the 'Royal Car' after transporting the Queen Mother for a short distance on Friday 5 July 1964. Subsequently it carried other members of the Royal Family, including the Queen and the Duke of Edinburgh. (*Foster M. Palmer/Seashore Trolley Museum*)

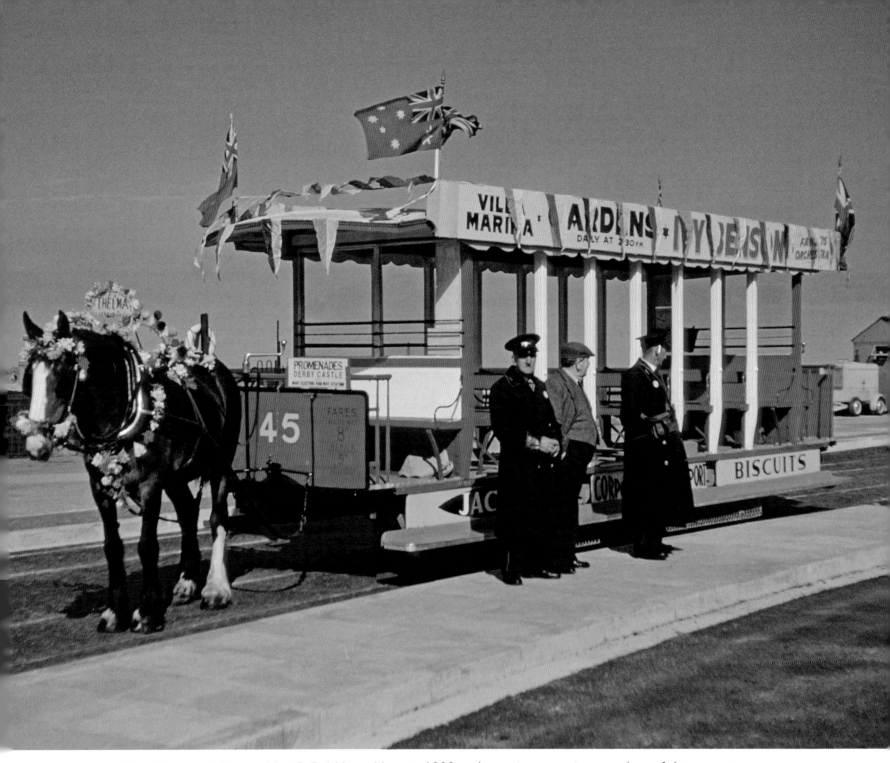

No. 45 was delivered by G.C. Milnes, Voss in 1908 and remains an active member of the current fleet. Here it is paired with 'Thelma' as they pose at the new Sea Terminal tram station on 20 May 1961. For a period after the war, this car carried a patriotic red, white and blue livery. (*A.S. Clayton/ Online Transport Archive*)

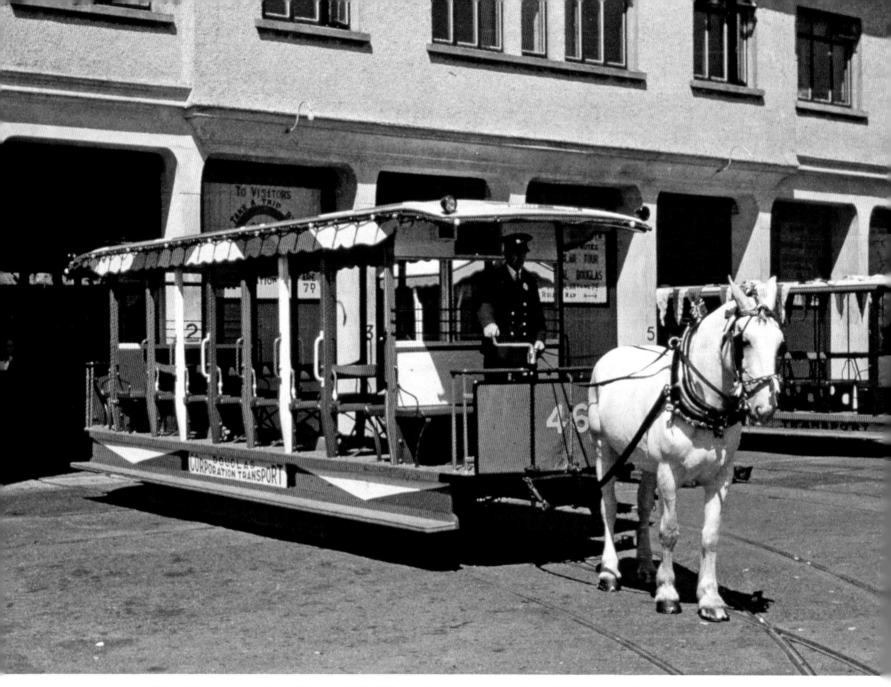

No. 46 was another 40-seat G.C. Milnes, Voss car dating from 1909 but with three as opposed to two glazed bulkhead windows. At some point, it lost its shutters, lamphouses and side lamps. This memorable view, taken on Tuesday 19 June 1951, has 'Gillian' in charge as the car stands outside the depot on the occasion of an LRTL visit. It had been painted in a special livery marking the Festival of Man which coincided with the Festival of Britain. Following its withdrawal, No. 46 became a play tram in 1987 after which it went to its birthplace of Birkenhead where, for some years, it was on public display within the Woodside ferry terminal. It is believed it has been scrapped. (*W.J. Wyse/ LRTA (London Area)/Online Transport Archive*)

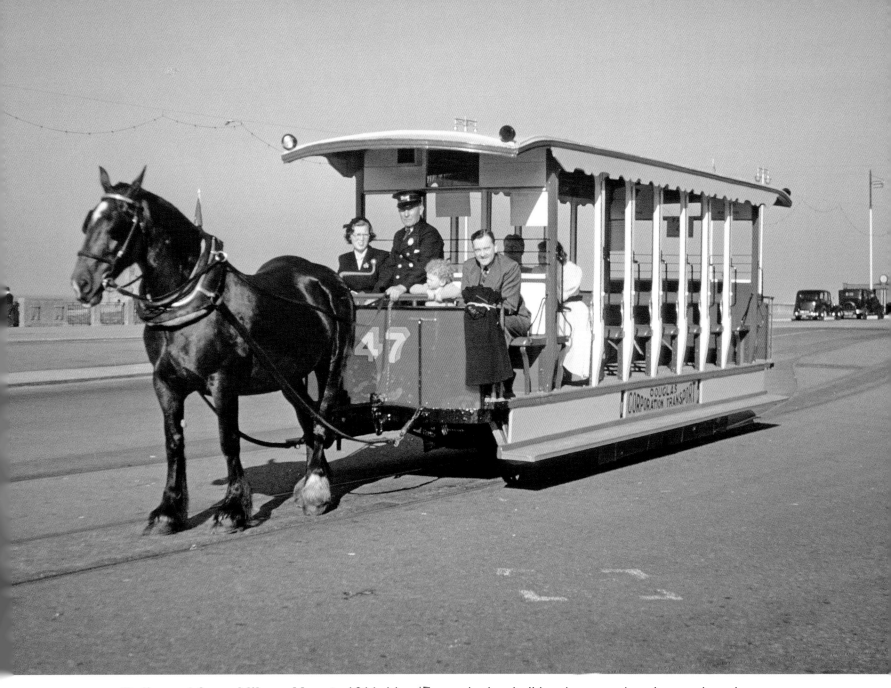

Delivered from Milnes, Voss in 1911, No. 47 was the last bulkhead toastrack to be purchased. Again, it was similar to its predecessors except that it had a steel underframe and a different design of eaves-boards. During its active life, 47 lost its roller shutters, lamphouses and side lights. In May 1953, it is in the economy version of the familiar red and white livery with unlined dash and yellow fleet numbers highlighted in blue. The distinctive white posts first introduced in the early 1900s had replaced the original brown varnish and were subsequently a feature on all new cars. No. 47 was withdrawn in 1976 and is now resident at the Jurby Transport Museum. (*J.M. Jarvis/ Online Transport Archive*)

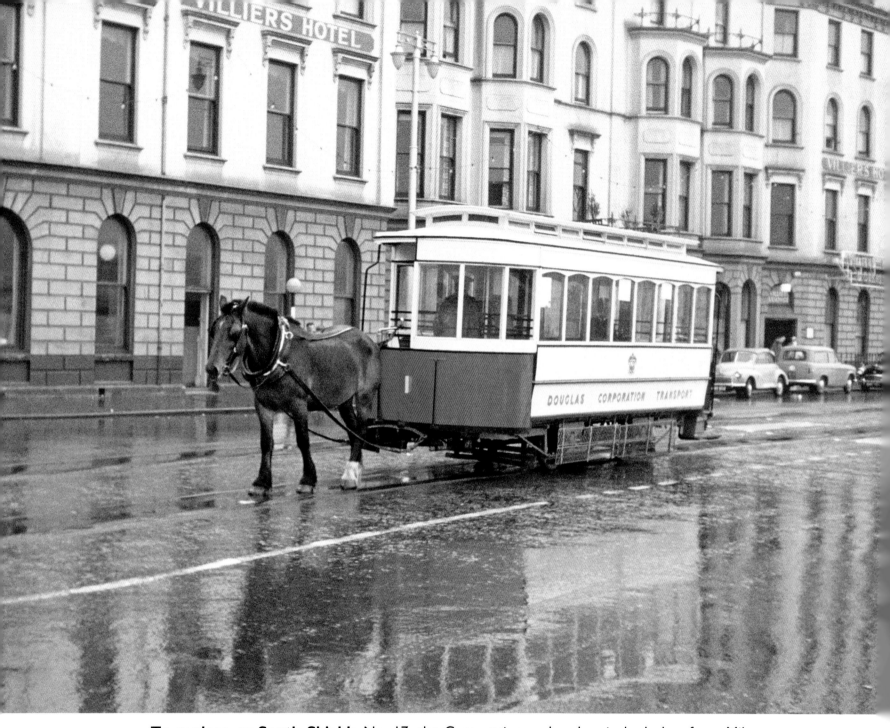

To replace ex-South Shields No. 17, the Corporation ordered a single-decker from Milnes, Voss in 1913. Given the number 1, this eight window car with its clerestory roof, centrally-located bulkheads doors and steel underframe was more akin to a contemporary electric car. In this view, No. 1 is seen in unlined livery against the backdrop of the Villiers Hotel, since demolished. With longitudinal seats for eighteen (plus six on the platforms), it is the youngest member of the current fleet and will be a mere 105 years old in 2018. (*G.W. Morant/Online Transport Archive*)

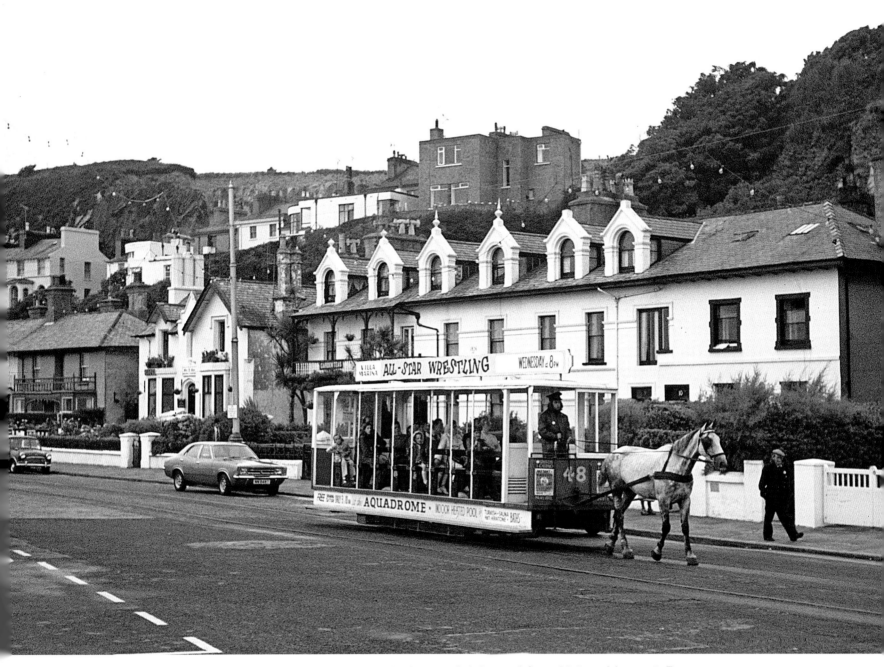

Nos. 48-50 were designed by manager Wolsey and delivered from Vulcan Motor & Engineering Company of Southport in 1935. These were all weather 'convertibles', a series of interlinked side panels allowing the cars to operate in either closed or open condition. When not in use, the panels were stowed on the platforms. The saloon area was accessed by doors at either end which were diametrically opposite each other and the seating was arranged so that loading was normally from the rear on the nearside. When closed, they held twenty-seven but when open seven hinged extension seats were also used. Towards the end of its life, No. 48 approaches the northern terminus on a cold, blustery 23 August 1975. (*Michael J. Russell*)

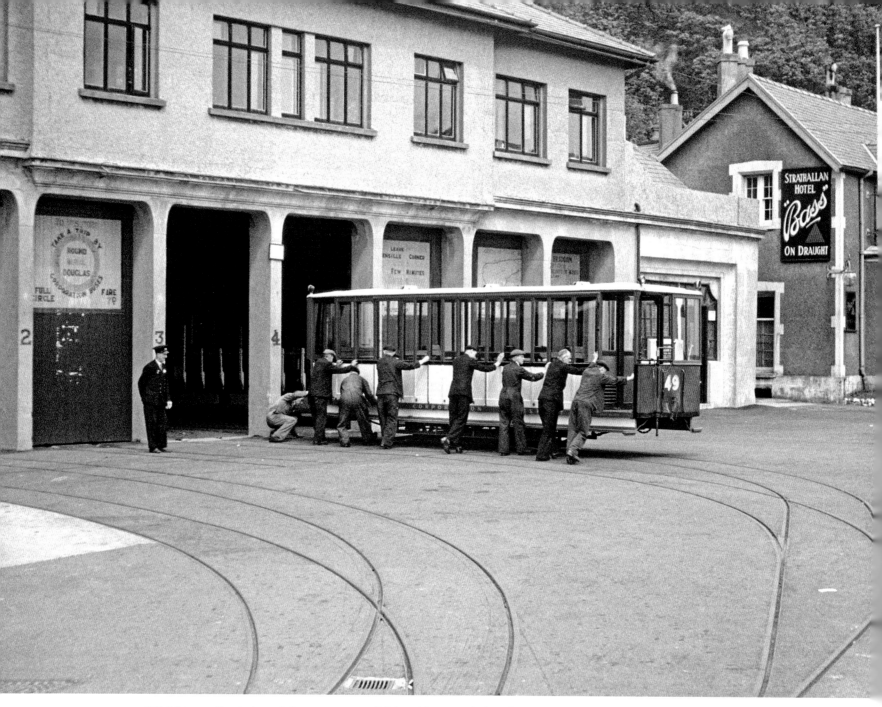

Did it really take eight men to roll No. 49 out of the depot and onto the traverser? This view taken on 17 May 1955 shows the car in closed condition with its panels in situ, varnished interior door, half windscreen, side lights and title 'Douglas Corporation Transport' along the sole bar. In the background are the Transport Offices and to the right the Strathallan Hotel, today renamed the Terminus Tavern. On withdrawal in 1977, all three were sold to the MER for possible use as passenger shelters. They proved unsuitable, with only 49 escaping the scrap man. It now awaits restoration. (*Ray DeGroote/Online Transport Archive*)

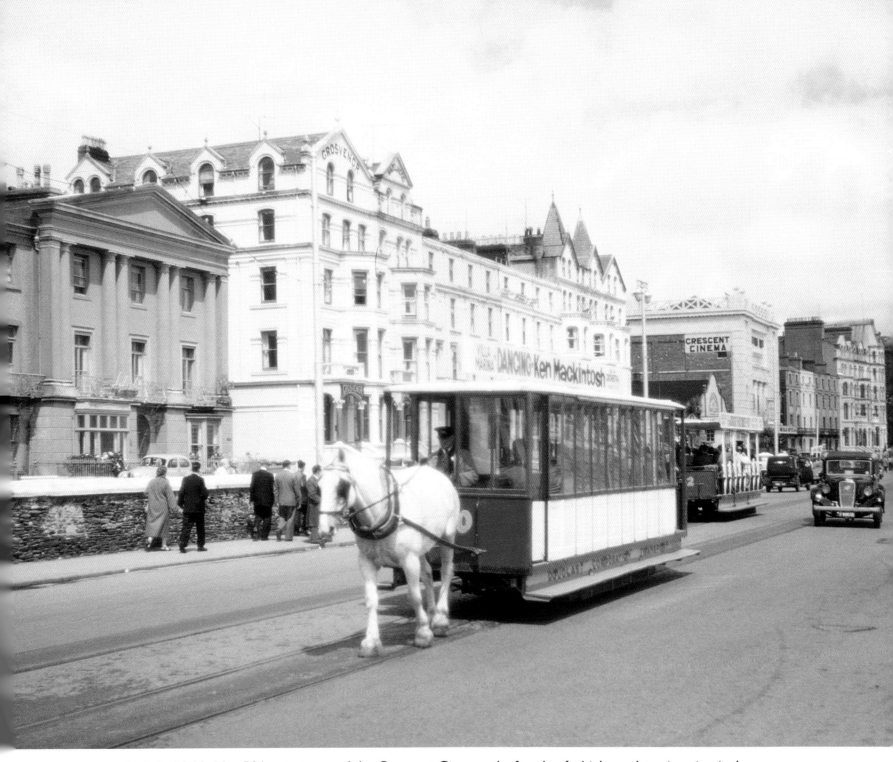

In July 1956, No. 50 has just passed the Crescent Cinema, the facade of which was later imaginatively incorporated into a new apartment complex. Despite having roller bearing axle boxes from new, the 'Tomato Boxes' were heavier for the horses than other cars. Unpopular with crews, no one really mourned their passing. (*Foster M. Palmer/Seashore Trolley Museum*)

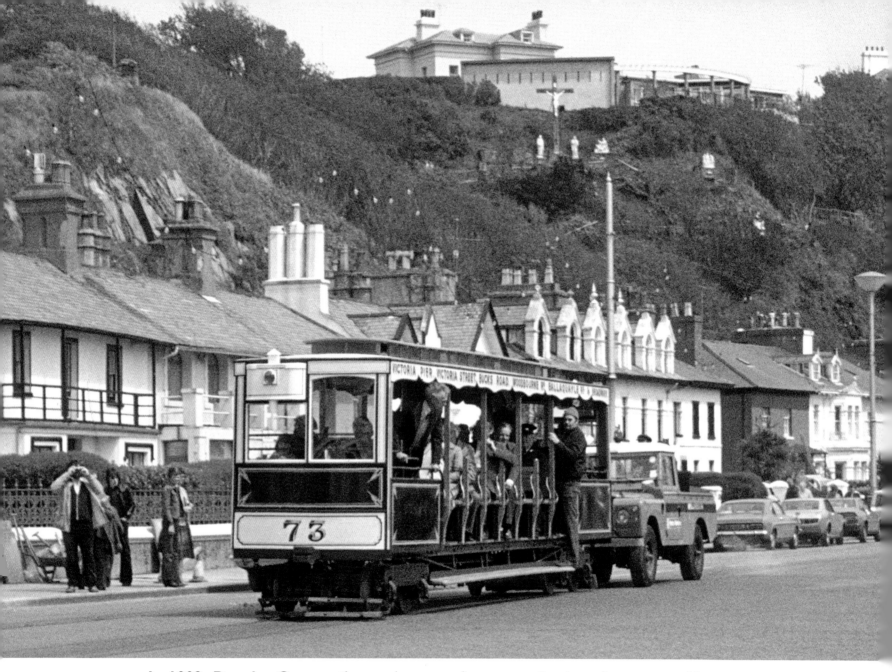

In 1902, Douglas Corporation took over a short two-mile, three-foot gauge cable tramway which had been built in 1896 to link the Promenade to Upper Douglas. During its final years, the steeply-graded line only ran during the height of the season. When it closed on 19 August 1929, the sixteen cars were sold, two of which – Milnes-built Nos. 72 and 73 of 1896 – survived as a holiday bungalow. Still on their original trucks, both were rescued for preservation in 1968. Using parts from each, a single vehicle was reconstructed which has 72 at one end and 73 at the other. It made its first outing in August 1976 when it was pushed by a Land Rover. Here it leaves Derby Castle in May 1979. Subsequently, it was fitted with batteries so it could run under its own power. It is now exhibited at the Jurby Transport Museum. (*Derek Bailey/Online Transport Archive*)

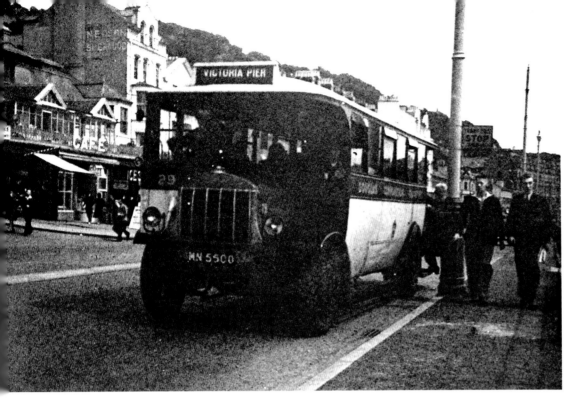

Douglas Corporation acquired its first buses in 1914. Most deliveries until 1930 were petrol-electric Tilling-Stevens, the last of which were withdrawn in 1949. Amazingly, one of these, No. 29 of 1928 was photographed during its final months on Queens Promenade. Its 34-seat rear-entrance body was supplied by Northern Counties. (*G. Lumb, courtesy Travel Lens Photographic*)

Delivered for lightly trafficked routes between 1936 and 1939, Leyland Cubs 8-12 and 14 had forward-entrance, 20-seat Park Royal bodies. A special union agreement allowed for one-man operation. Withdrawals took place between 1957 and 1959. This rare view shows No. 10 on the Promenade in July 1957. After being withdrawn between 1957 and 1959, the six Cubs were sold, with No. 10 being recorded as derelict in 1990. (*Bruce Jenkins*)

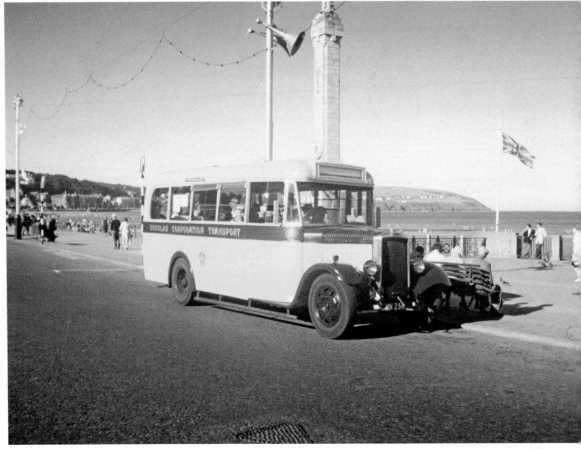

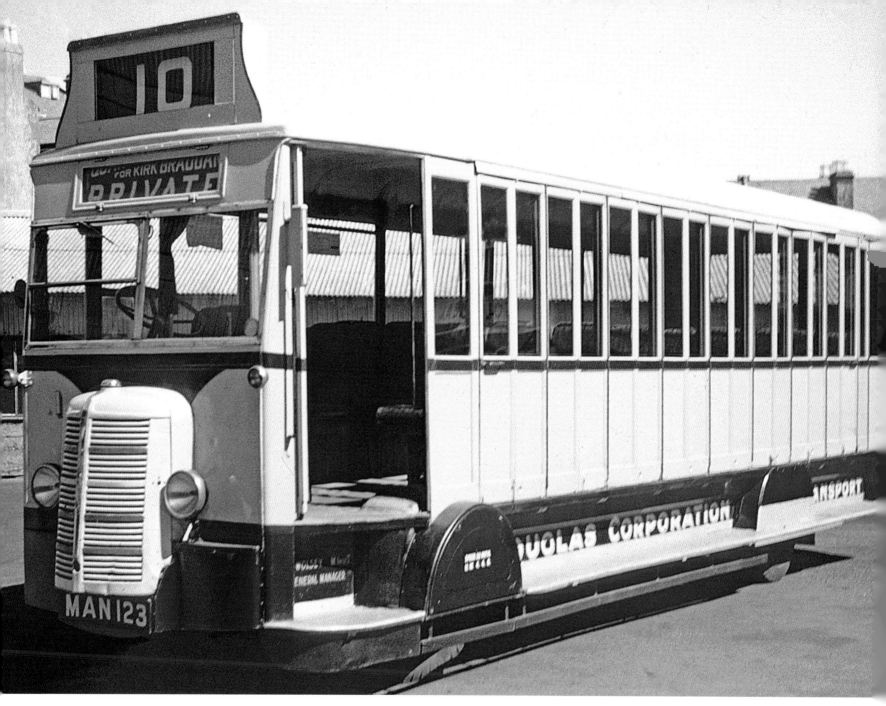

Among the Corporation's more unusual vehicles were three 'low loader toastracks' built by Vulcan of Southport. The first, No. 3 (later 17), was in the fleet from 1926 to 1948 and Nos. 1 and 2 from 1935 to 1957. Seen as a possible replacement for the horse trams, Wolsey also wanted an 'all weather' vehicle so the overall bus fleet could be reduced. Nos. 1 and 2 survived over twenty years after they were given new, more efficient 28hp Bedford petrol engines, radiators and gearboxes. By the time No. 2 was photographed in 1957, the troublesome folding screens on the nearside had been fixed in the closed position with a loss of eight seats. (*G.W. Morant*)

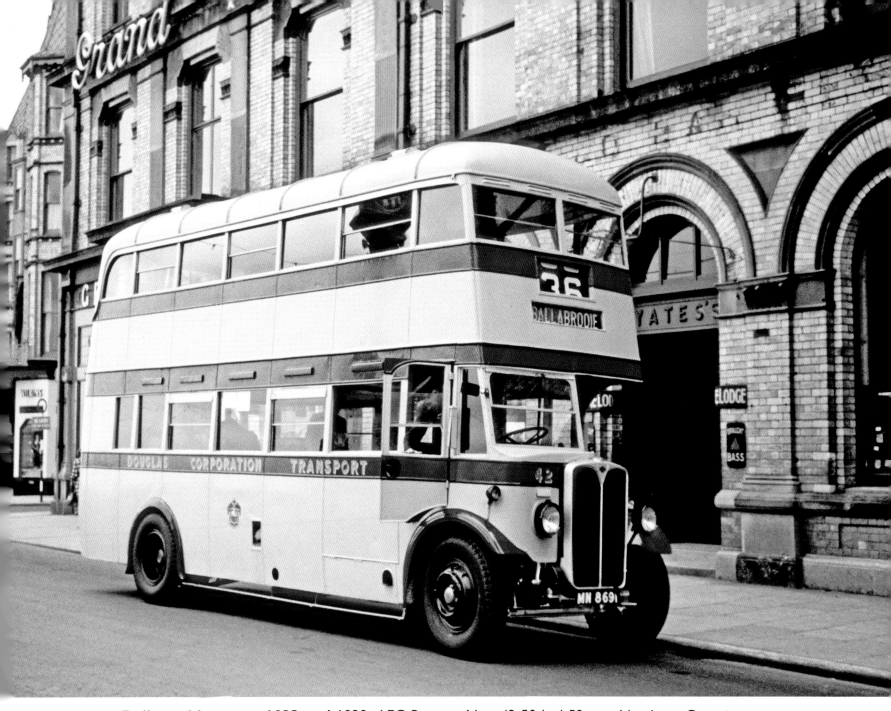

Delivered between 1933 and 1939, AEC Regents Nos. 42-50 had 52-seat Northern Counties bodies. Except for No. 50, all had petrol engines when new, although 45 and 47-49 were subsequently fitted with London Transport STL-type oil engines acquired from a scrap dealer in 1954, which effectively extended their lives by several years. One of the original petrol-engined pair of 1933, No. 42, is seen in June 1951 after front indicators had been added when route numbers were introduced in the late 1930s. Together with No. 43 it was withdrawn in 1957. *(W.J. Wyse/LRTA (London Area)/Online Transport Archive)*

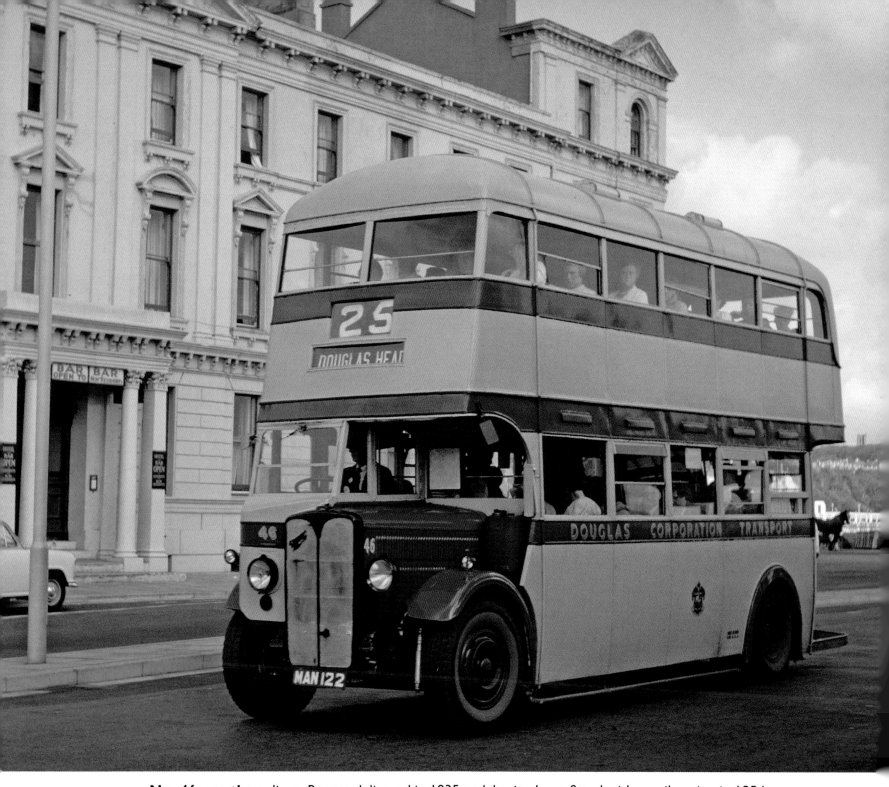

No. 46 was the solitary Regent delivered in 1935 and, having been fitted with an oil engine in 1954, survived in service until 1963. It is seen here in late June 1962 just a year before it was withdrawn. (*F.W. Ivey*)

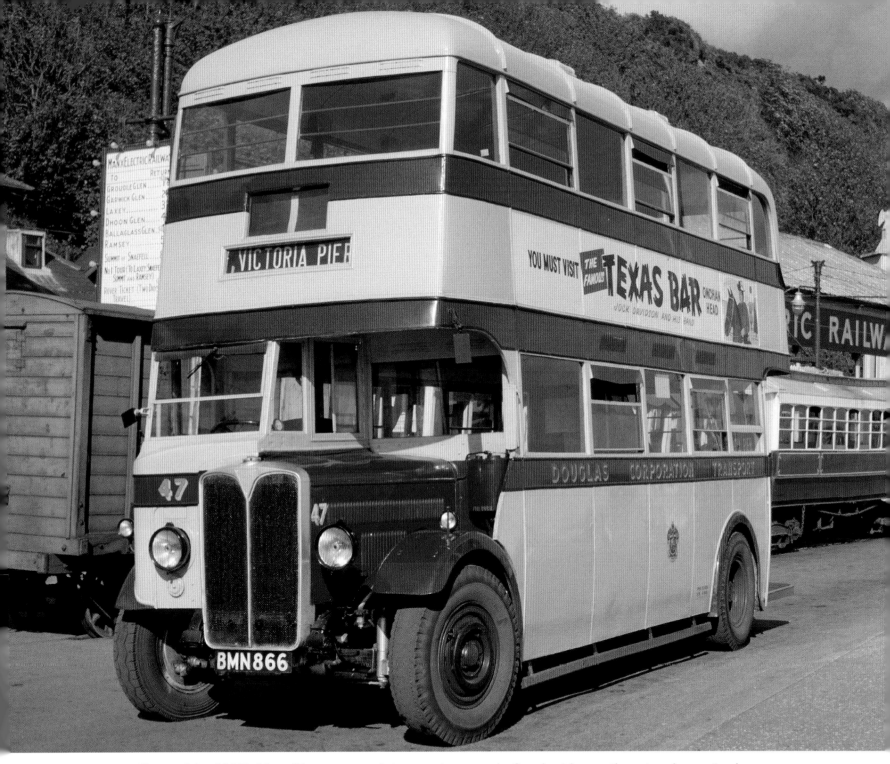

Delivered in 1937, No. 47 was one of those subsequently fitted with an oil engine. It survived until 1964. The livery was officially Primrose Yellow and Deep Mason's Red, so named after the paint supplier. Despite falling revenues, Douglas maintained its bus fleet in good order until nationalisation in 1976. (*F.W. Ivey*)

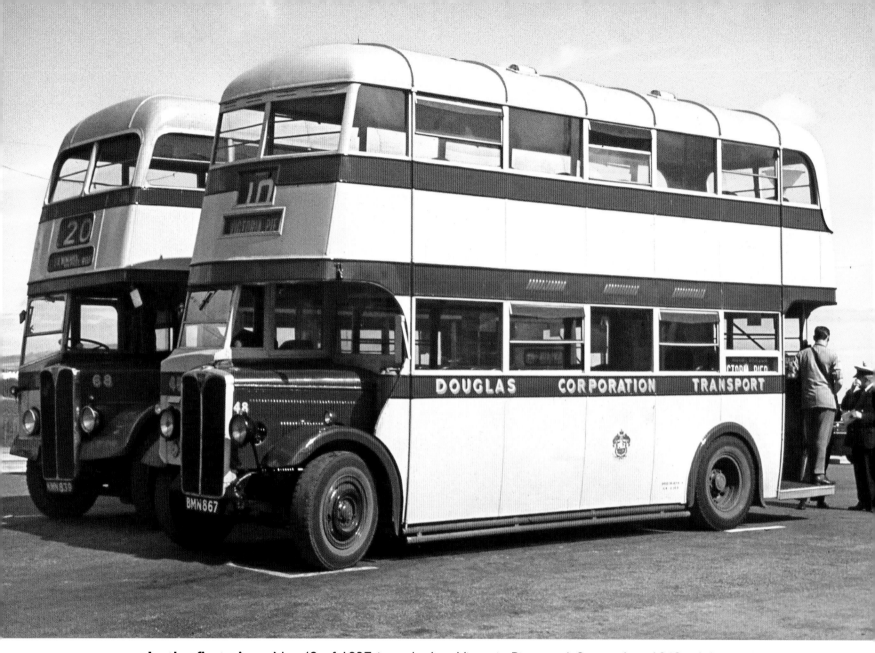

In the first view, No. 48 of 1937 is parked at Victoria Pier on 6 September 1963 whilst in the second (opposite), No. 50 of 1939 approaches the Pier in August 1964. These two buses were withdrawn in 1964 and 1967 respectively. Some Regents were scrapped, others became hen-houses but 46 and 50 were acquired for preservation. (*Brian Faragher/Online Transport Archive; F. W. Ivey*)

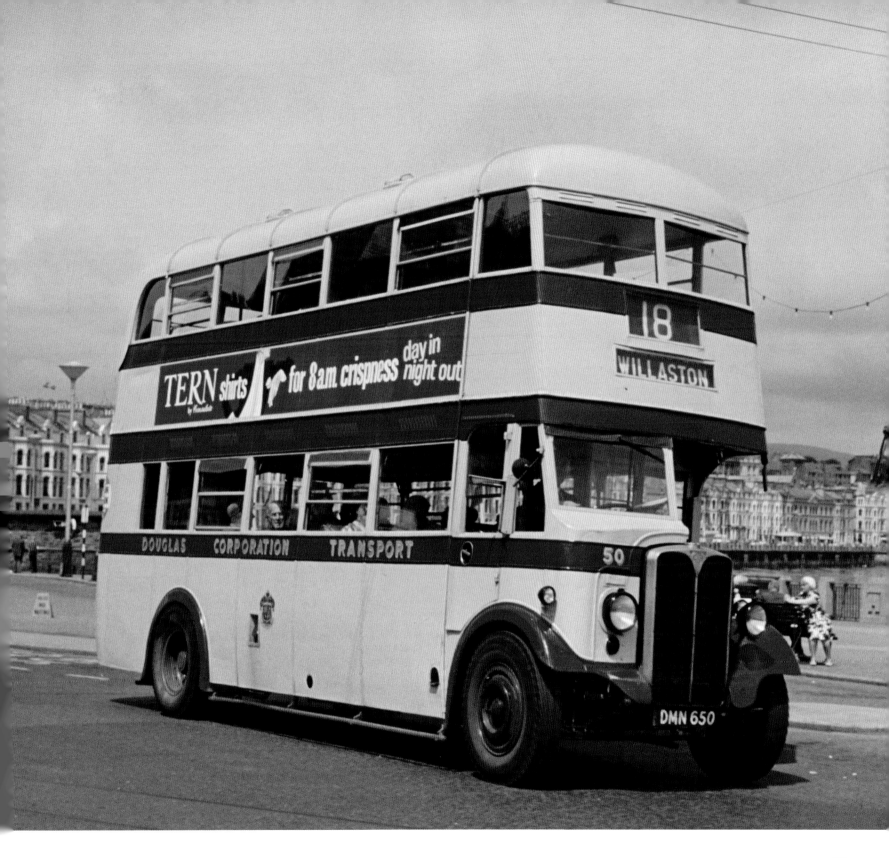

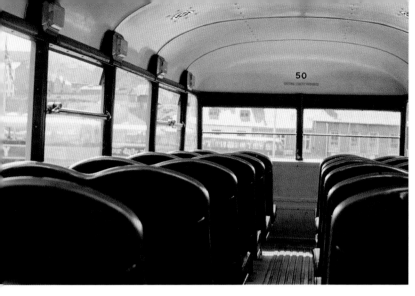

During his visit in June 1962, Fred Ivey recorded the interior of No. 50. The first image provides a perfect study of the upper deck whilst the second focuses on the eye-catching lower deck fitments which must have looked particularly impressive at night. Fortunately, the driver agreed to switch on the distinctive classical-style 'torch lights' to provide the photographer with some idea of the nocturnal impact. (*F.W. Ivey (both)*)

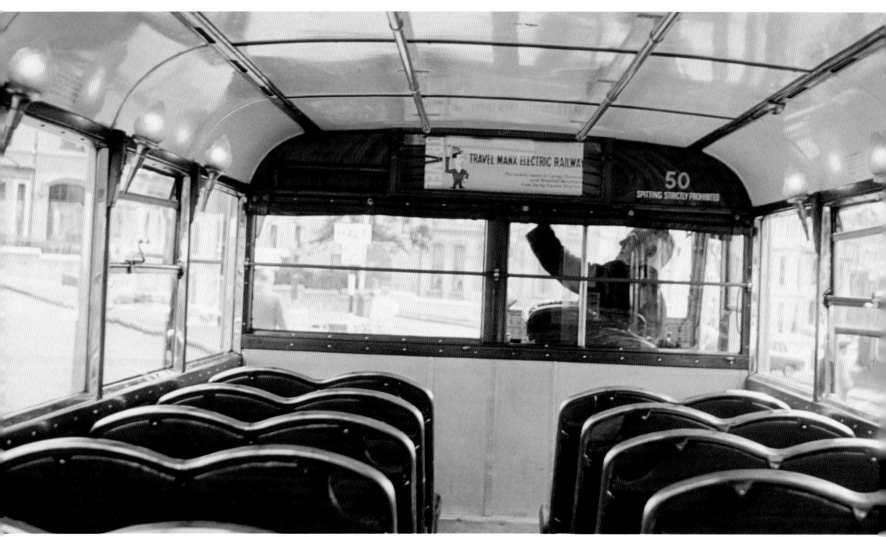

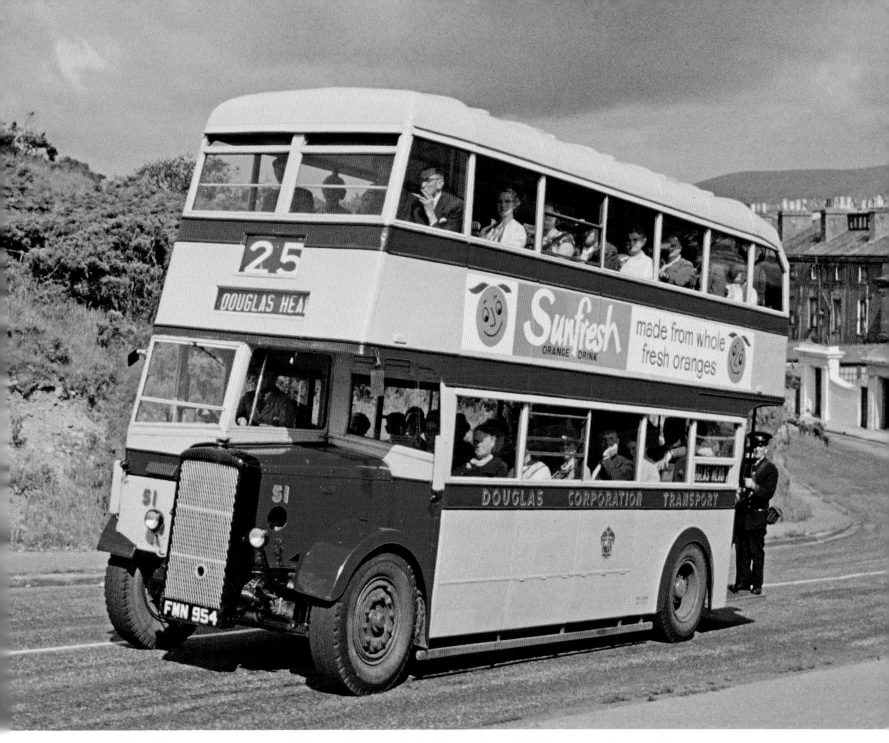

Despite evaporation of the holiday trade in September 1939, large numbers of buses were still needed for the movement of internees and military personnel. As a result, Nos. 51-53 were allocated by the Ministry of Supply in 1945. These Daimler CWA6s had AEC engines and 56-seat Duple bodies to Utility specification. On 18 August 1964, 51 tackles the demanding grade on the popular route 25 to Douglas Head. (*F.W. Ivey*)

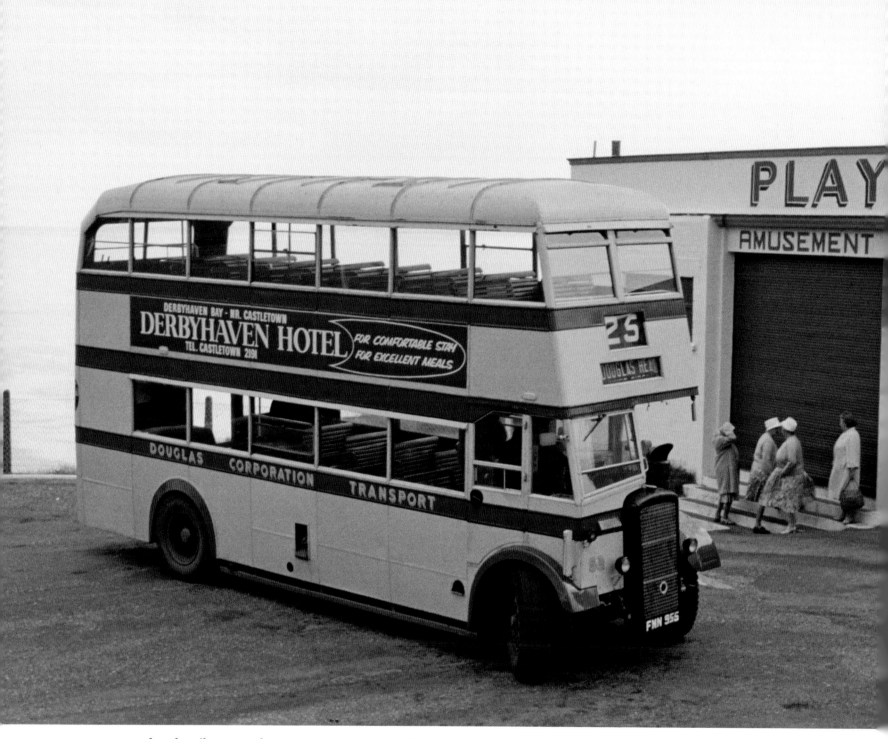

In the 'bumper' post-war years, the flood of summer visitors placed enormous demands on the fleet, although many buses saw little action during the rest of the year, clocking up low annual mileage which in effect extended their operating lives. On 18 August 1964, No. 52 waits at Douglas Head ready to make the short trip back into town. (*F.W. Ivey*)

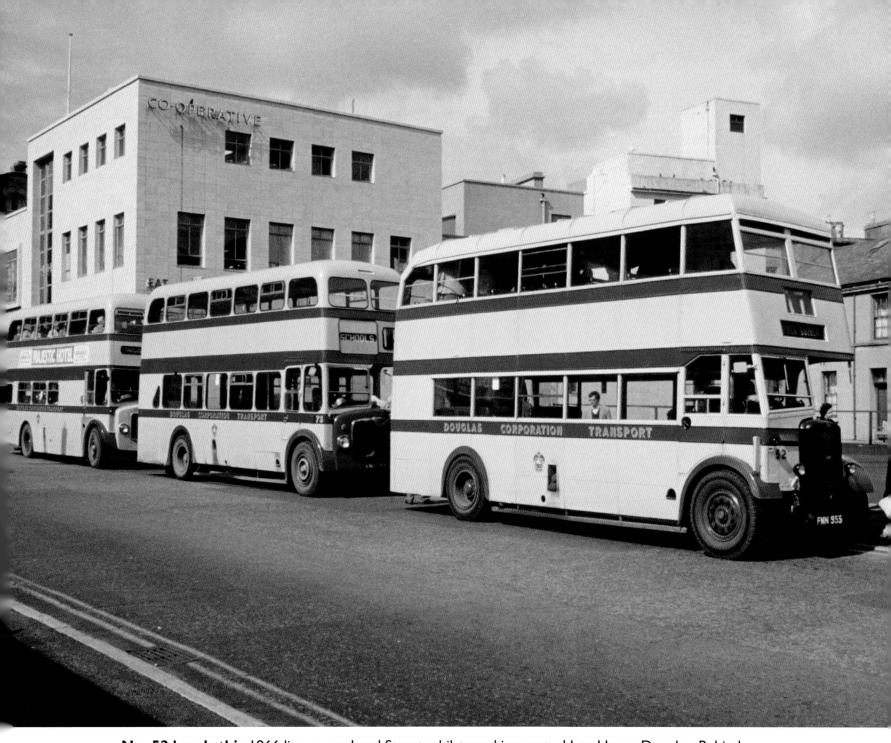

No. 52 heads this 1966 line-up on Lord Street whilst working route 11 to Upper Douglas. Behind are AEC Regent V No. 73 of 1957 on a schools duty and one of a pair of new front entrance Regent Vs delivered in 1965 with yellow bonnets. A closer look shows the fleet numbers and Corporation coat of arms are in different positions. (*J.M. Ryan*)

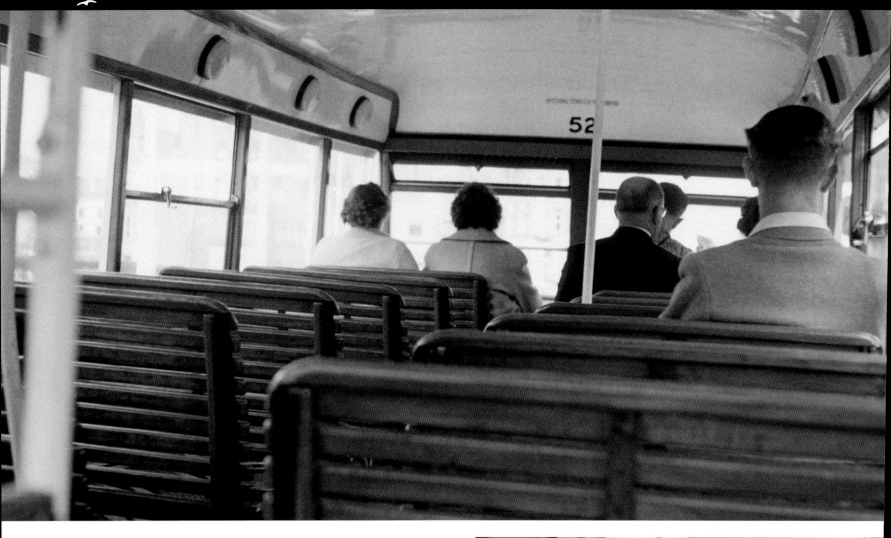

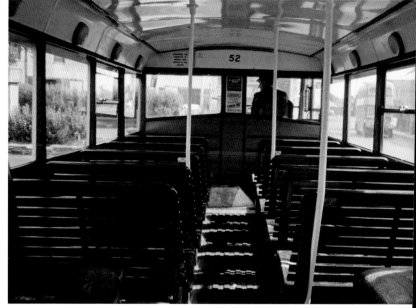

These interior views of No. 52 revive memories of Utility bodied buses with wooden seats on both decks. When these photographs were taken in the 1960s this type of austerity seating had all but disappeared elsewhere in the British Isles. No. 52 is preserved at the Sandtoft Trolleybus Museum. (*F.W. Ivey; J.M. Ryan*)

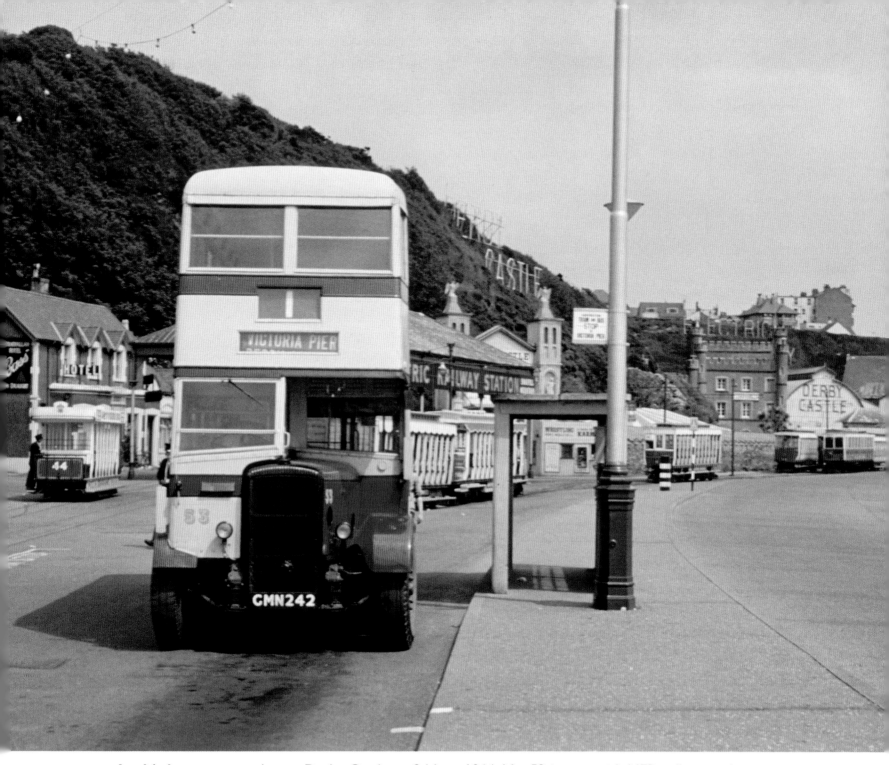

In this busy scene taken at Derby Castle on 24 June 1964, No. 53 is seen with MER rolling stock in the background together with Royal horse car 44. (*F.W. Ivey*)

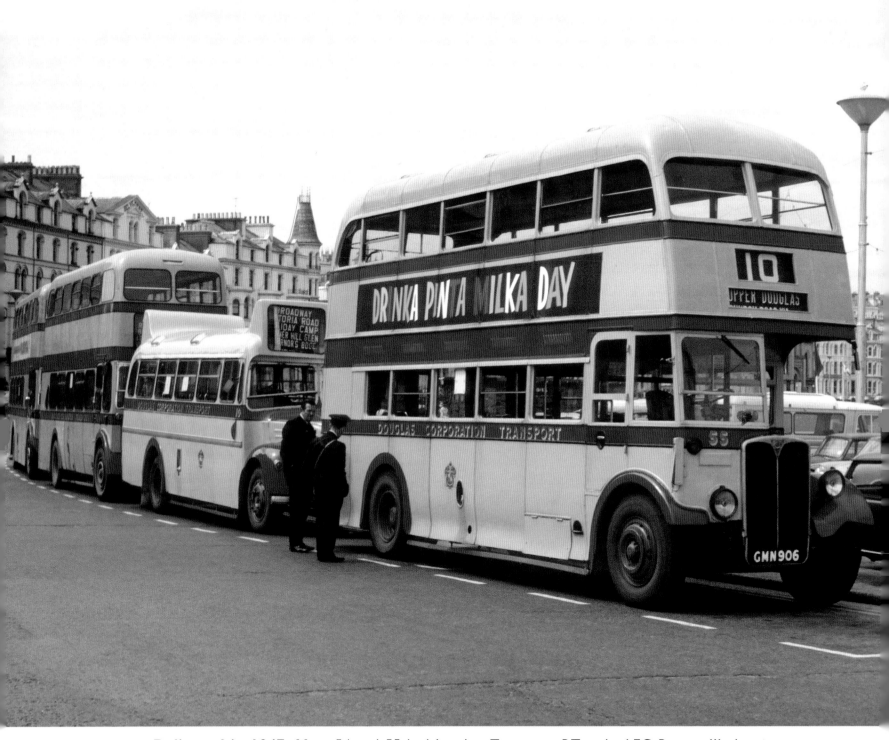

Delivered in 1947, Nos. 54 and 55 had London Transport RT-style AEC Regent III chassis with 55-seat Northern Counties bodies. In July 1969, 55 is seen on the Promenade with several other vehicles, including Guy Otter No. 10. Both Regents were withdrawn and scrapped in 1971. (*Bruce Jenkins*)

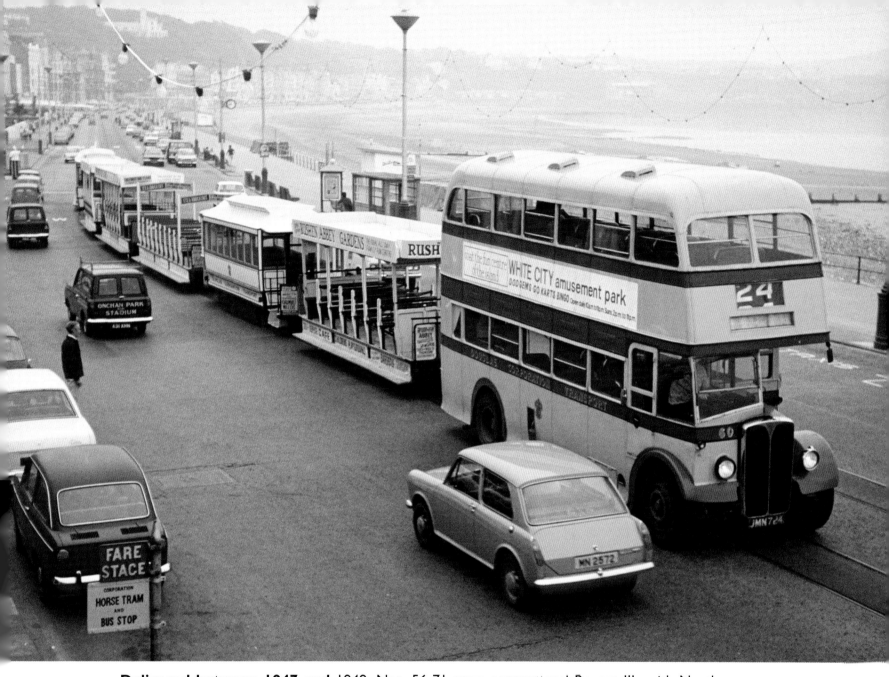

Delivered between 1947 and 1949, Nos. 56-71 were conventional Regent IIIs with Northern Counties bodies, some with 55 seats and some with 56, all but one of which had drop down as opposed to sliding windows. Fitted with air brakes and pre-selector gearboxes, they proved ideally suited for the town's hillier routes. It is early morning on 9 August 1976 and No. 60 is towing six horse cars wrong line running towards Victoria Pier so they will be on the right track for the big parade marking the 100th anniversary of the tramway. This would be the oldest Corporation bus to pass to Isle of Man National Transport (IOMNT) in October 1976. However, it was never operated and was subsequently acquired by a preservation group as a source of spare parts. The picture is taken from the Villa Marina terrace, illustrated earlier. (*Bruce Jenkins*)

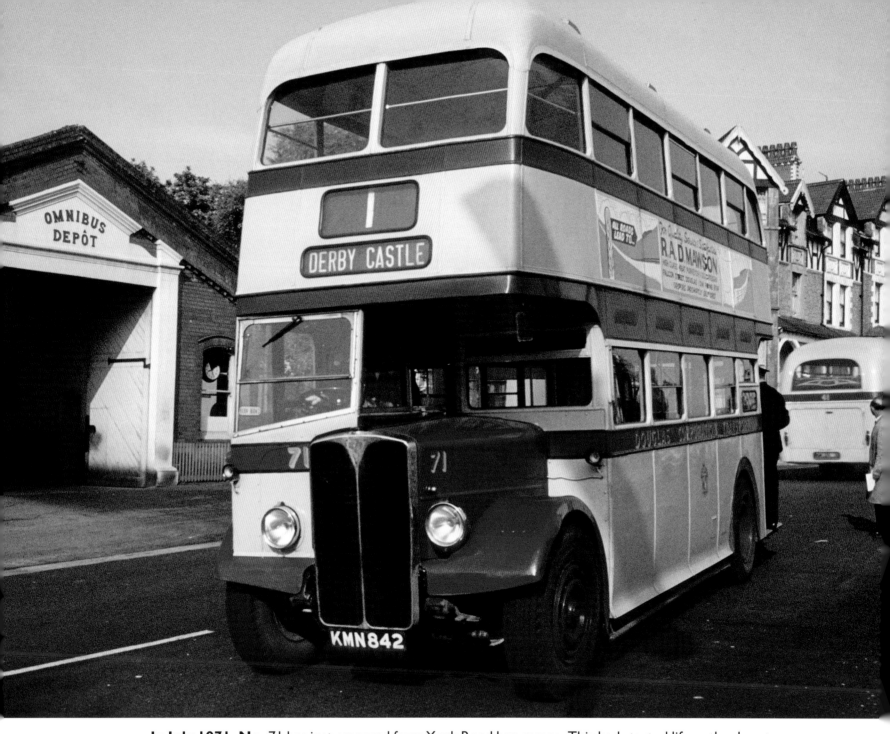

In July 1971, No. 71 has just emerged from York Road bus garage. This had started life as the depot and engine house for the Upper Douglas cable cars before being developed into the Corporation's bus garage and works. Following closure in the early 1980s, it was not demolished until 2009. The first of these Regent IIIs were withdrawn in 1974 with No. 71 lasting until the end of the 1976 season. (*Charles Firminger, courtesy Bob Bridger*)

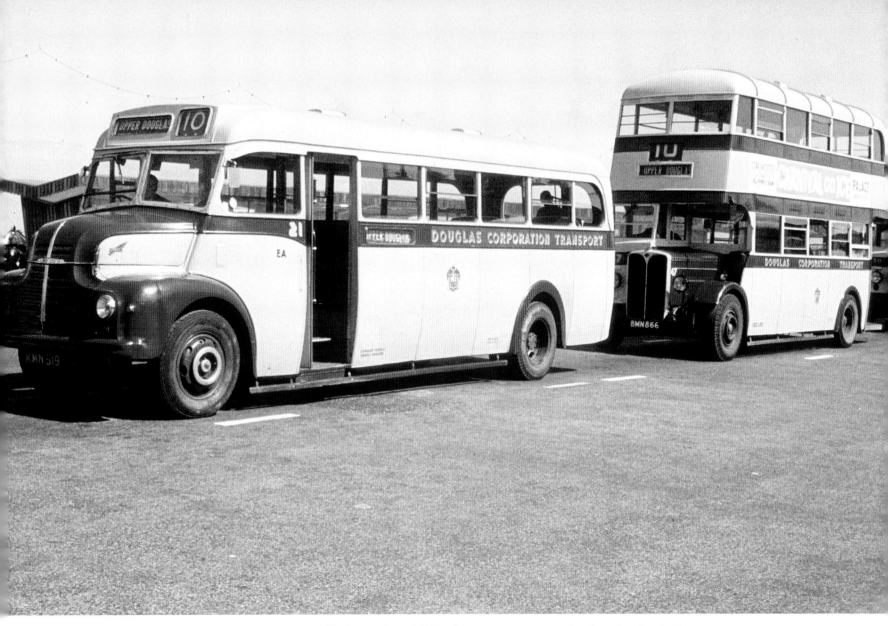

Nos. 20-22 were rare beasts. Delivered in 1950, they were among the few Leyland Comets to be built with passenger-carrying bodywork and the only ones to have Park Royal bodies for the domestic market. Furthermore, they were designed as 30-seaters but, owing to a union agreement which allowed only low capacity single-deckers to be operated by one man, they were licensed in Douglas for just 26 passengers for several years. In 1959, No. 21 waits at Victoria Pier with Regent 47 to transport holiday-makers arriving by steamer to their accommodation in Upper Douglas. The letters EA on the Comet stood for 'Extended Area' indicating the bus was licensed to operate some two miles beyond the borough boundary. After withdrawal in 1968, Nos. 21 and 22 became staff transport vehicles for a local contractor. No. 22 was scrapped in 1983 but 21 is now preserved. (*Harry Luff/Online Transport Archive*)

Nos. 30 and 31 were ex-demonstrators purchased from AEC in June 1951. Both were Regal IVs with underfloor engines with 30 having a 42-seat body by Willowbrook and 31 a 38-seat body by Park Royal. This view shows No. 30 shortly after delivery in June 1951, the year after it appeared at the Commercial Motor Show in the colours of the City of Oxford Motor Services. Note the unusual Vulcan van about to overtake cyclist and bus. *(W.J. Wyse/LRTA (London Area)/Online Transport Archive)*

It is understood both Regals inaugurated the Port Soderick route which passed under a low railway bridge. For a period, neither saw much use owing to the one-man agreement. However, when larger single-deckers were cleared for OMO in 1970, both saw more regular use especially on routes 32 and 36. Here, No. 31 leaves Lord Street bus station on 6 September 1963. Although 31 was scrapped in 1974, 30 passed to the nationalised company in October 1976 but almost immediately went for scrap. (*Brian Faragher/Online Transport Archive*)

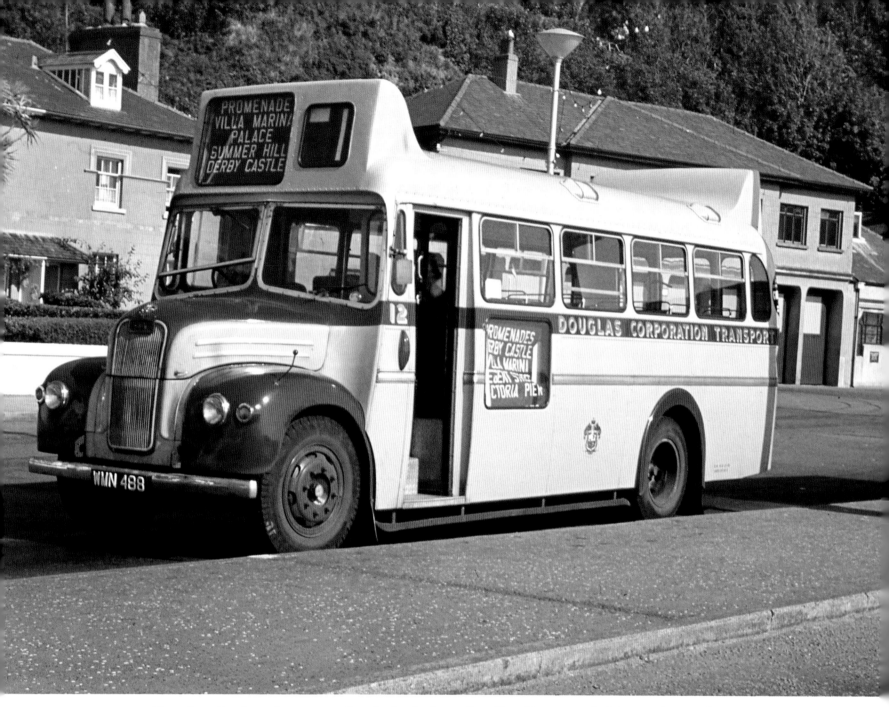

Needing further low capacity single deckers, five Guy Otters with 26-seat, forward entrance Mulliner bodies were acquired in 1957. Broadly similar to the London Transport GS class, 8-12 had Perkins P6 diesel engines and an unusual gate to the gear selector with first and second on the right-hand side. Usually operated as one-man, they were nicknamed 'Wolsey's Camels' owing to the large front and rear indicator boxes, these 'humps' providing space for much-enlarged destination displays. Unfortunately, the blinds rapidly distorted as illustrated in this view of No. 12 at Derby Castle on 17 September 1963. (*Brian Faragher/Online Transport Archive*)

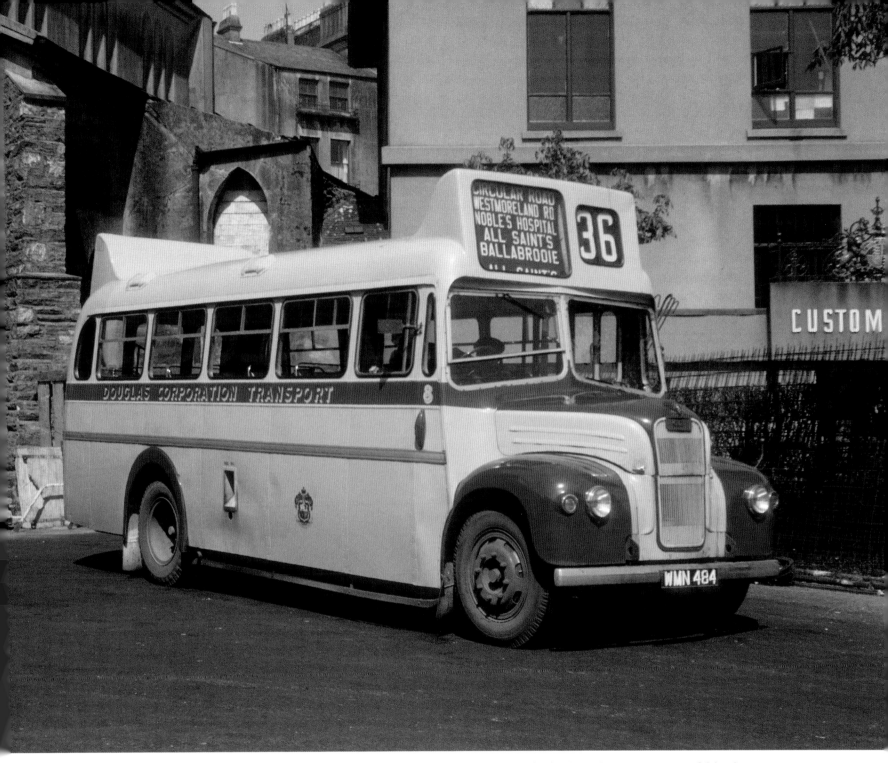

CIRCULAR ROAD
WESTMORELAND RD
NOBLE'S HOSPITAL
ALL SAINT'S
BALLABROOIE

36

DOUGLAS CORPORATION TRANSPORT

WMN 484

CUSTOM

No. 8 is seen here outside the Customs House on 15 May 1964, also showing signs of blind distortion. Following withdrawal of these vehicles en bloc in 1970, they saw further use with school and hospital boards, with some eventually passing into preservation. (*R.L. Wilson/Online Transport Archive*)

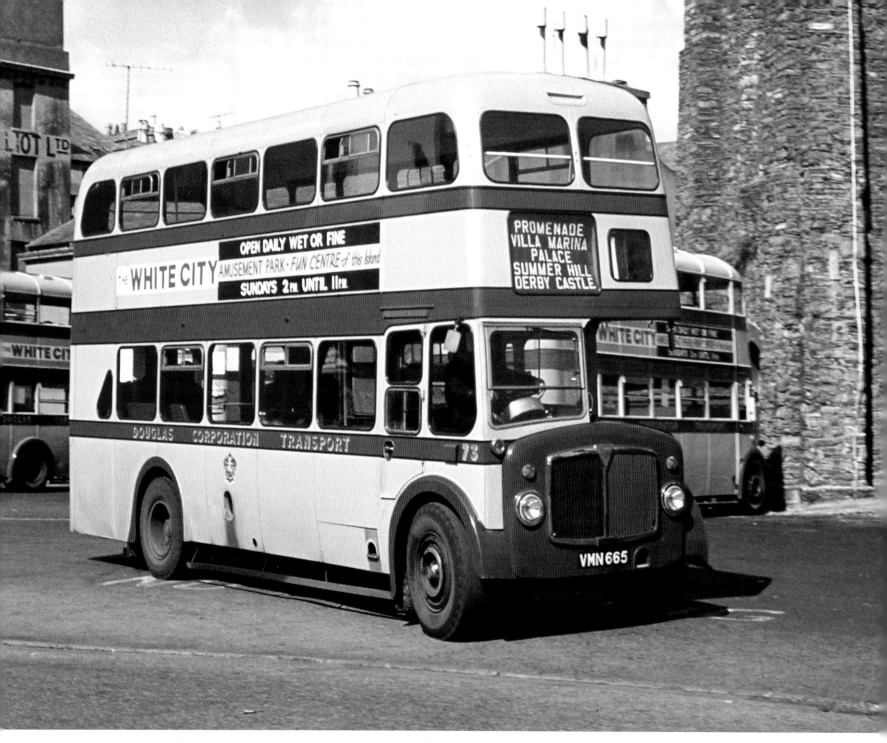

Dating from 1957, AEC Regent Vs Nos. 72-75 had 8ft-wide, 56-seat Metro-Cammell Orion style bodies and mono-control transmission which proved useful on the town's steep hills. They also followed the trend for large destination displays as seen on No. 73, although by 6 September 1963 the blinds were somewhat crumpled. All passed to IOMNT in 1976 but were sold for scrap when withdrawn the following year. (*Brian Faragher/Online Transport Archive*)

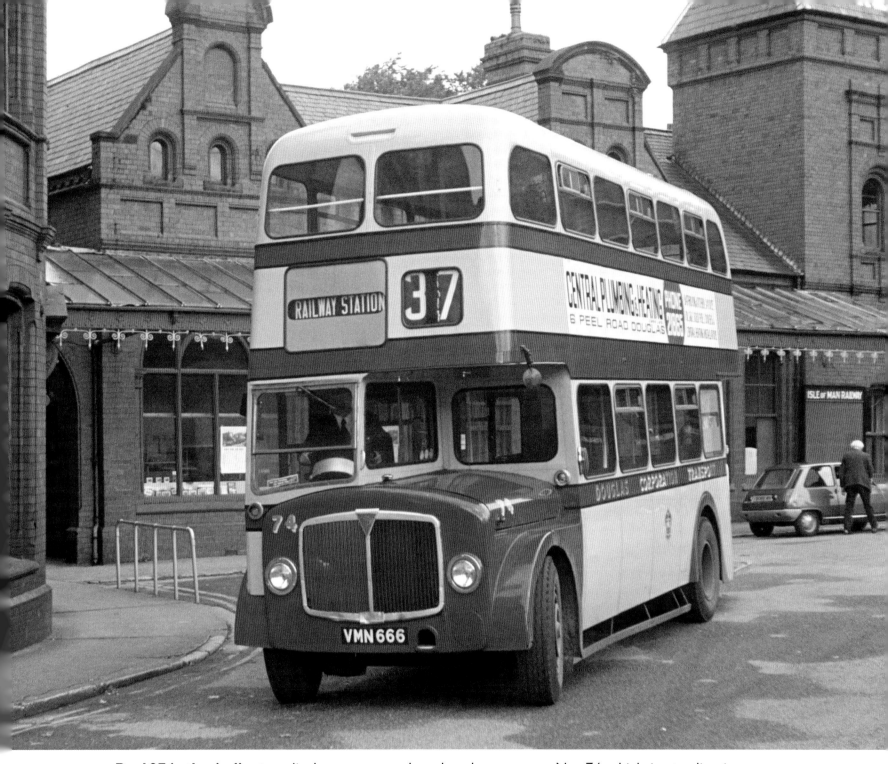

By 1974, the indicator displays were much reduced as seen on No. 74 which is standing in the forecourt of the imposing Douglas Railway Station. Route 37 was an occasional extension of route 1 linking the narrow gauge terminus to the Promenade and Derby Castle. (*Phil Tatt/Online Transport Archive*)

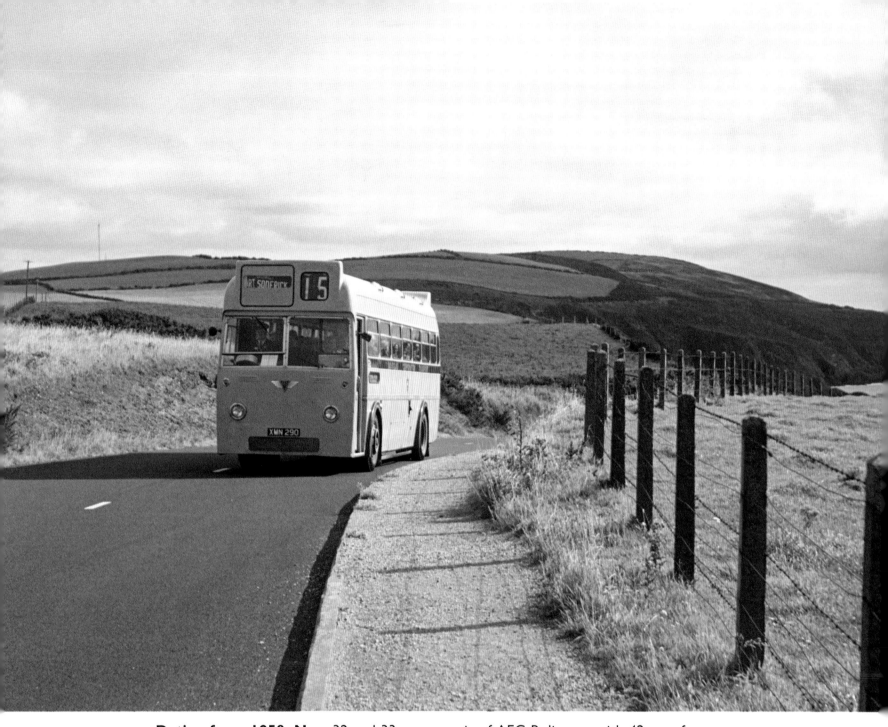

Dating from 1958, Nos. 32 and 33 were a pair of AEC Reliances with 42-seat front entrance Mulliner bodies. When this view was taken, the forward destination display on No. 32 was much reduced. The bus is en route to Port Soderick along a narrow section of road which once formed part of the Douglas Head Marine Drive Tramway (1896-1939). In bus days, this exposed stretch of road was used only by single-deckers and only in the Port Soderick direction. After transfer to IOMNT, the Reliances were scrapped shortly afterwards. (*Phil Tatt/Online Transport Archive*)

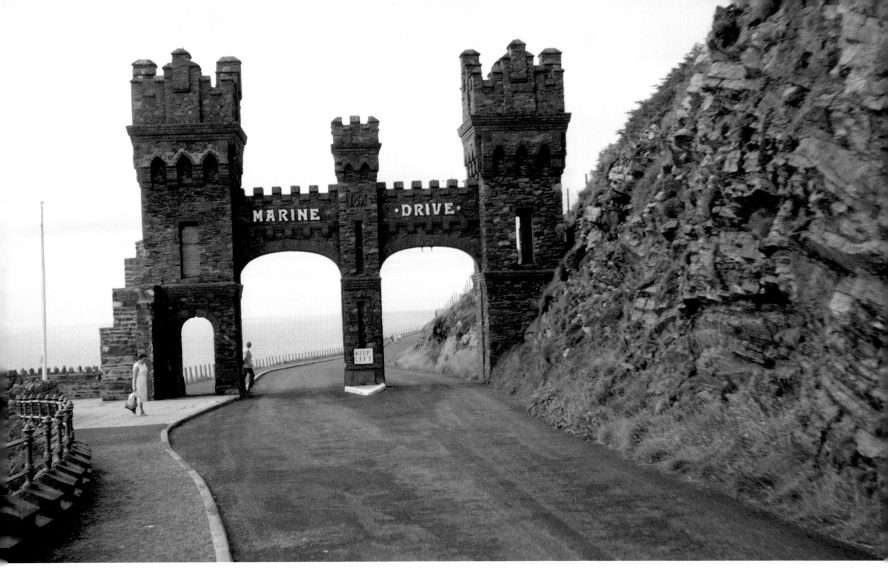

Although so much has survived, the former standard gauge tramway along Douglas Head Marine Drive represents a major loss. The line closed as usual at the end of the 1939 season but owing to the war was never reopened. The overhead was dismantled and the double-deck trams confined to their isolated depot. The four-mile cliff-edge tramway with its hairpin bends, viaducts and constantly changing vistas fulfilled the Victorian passion for 'bracing walks and rides'. Both termini also had funiculars providing links to the beaches. Virtually nothing now remains except for the castellated entrance to the Marine Drive through which the trams passed on the right side as well as one of the original cars. This was preserved after a group of enthusiasts visited the depot in June 1951 and found all the fleet slumbering inside. Doors were opened and trams pushed blinking into the sunlight. It has long been rumoured that a colour view was taken during this visit but, sadly, this has not come to light. However, No. 1 was rescued and resides at the National Tramway Museum at Crich in Derbyshire. At the time of this August 1963 view of the castellated entrance, the 'ears' from which the overhead wire was hung under the right-hand arch were still in situ, but had gone by the 1980s. (*Derek Norman/Online Transport Archive*)

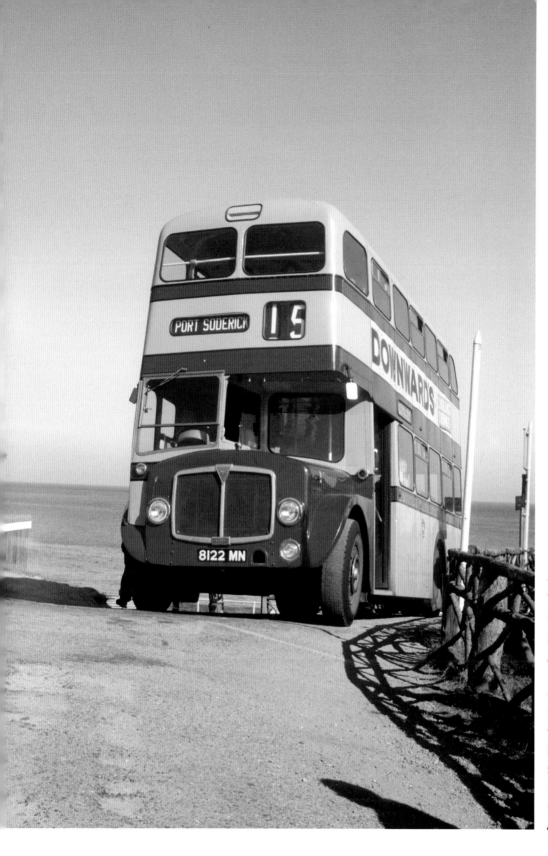

Delivered in 1964, Nos. 1-3 were forward-entrance Regent Vs with 64-seat Metro-Cammell Orion-style bodies and semi-automatic gearboxes. On 17 August 1965, No. 1 is seen at Port Soderick. By now its front destination had been reduced and it carried no route information at the rear. After passing to IOMNT in 1976, the trio remained in service until 1982. Today, only No. 3 survives in preservation. (*Brian Faragher/Online Transport Archive*)

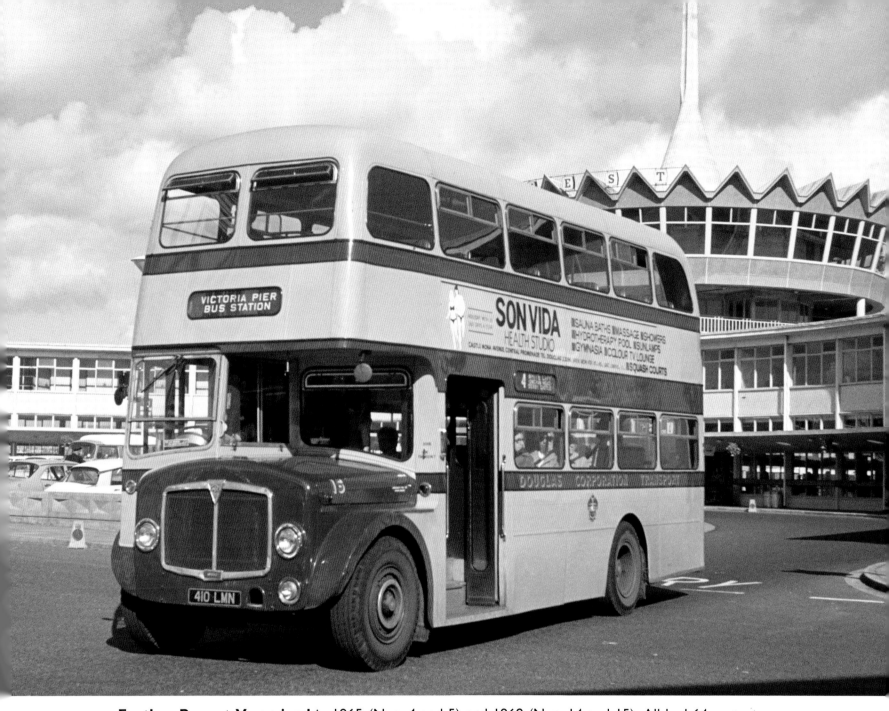

Further Regent Vs arrived in 1965 (Nos. 4 and 5) and 1968 (Nos. 14 and 15). All had 64-seat forward-entrance Willowbrook bodies. When delivered, the first pair had yellow bonnets and radiator panels whilst the others had yellow radiator surrounds and more powerful engines. No.15 was the last double-decker to be built by AEC and is seen in 1974 at the Sea Terminal, known colloquially as 'The Lemon Squeezer'. After passing to the nationalised company, all three survived in service until 1982. No. 15 is now one of the undertaking's heritage vehicles and can sometimes be seen at the Jurby Transport Museum. (*Phil Tatt/Online Transport Archive*)

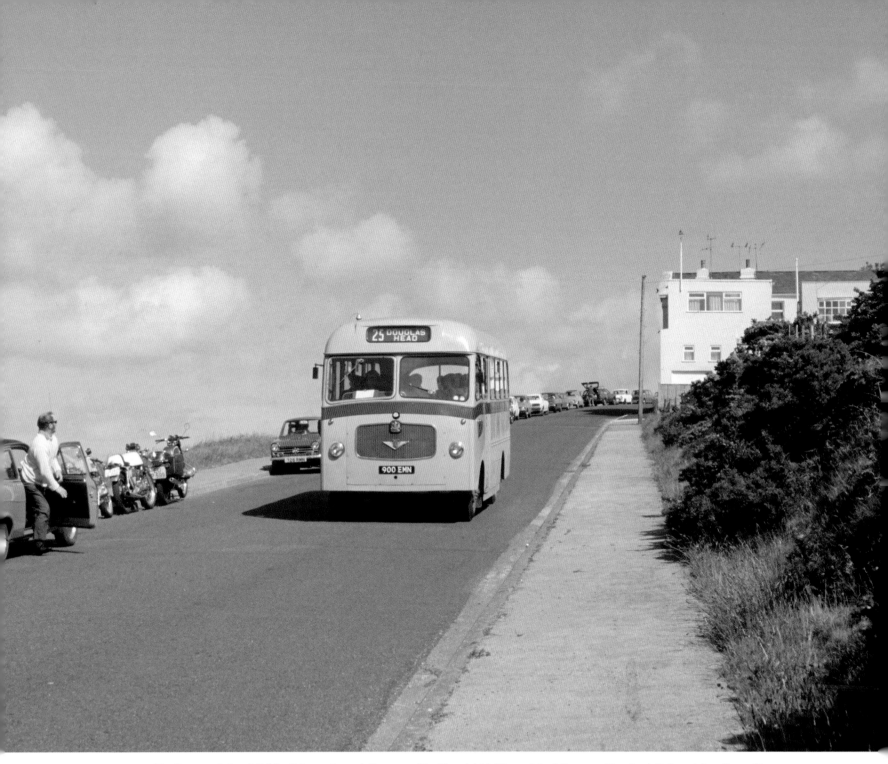

Delivered in 1966, Nos. 6 and 7 were Bedford VAS1s with 30-seat Duple Midland bodies. On 9 June 1974, No. 7 drops down from Douglas Head on route 25. On passing to IOMNT, they were renumbered twice before being sold in 1979. Former DCT No. 6 was scrapped in the mid-1980s but the former No. 7 is preserved. (*W. Ryan*)

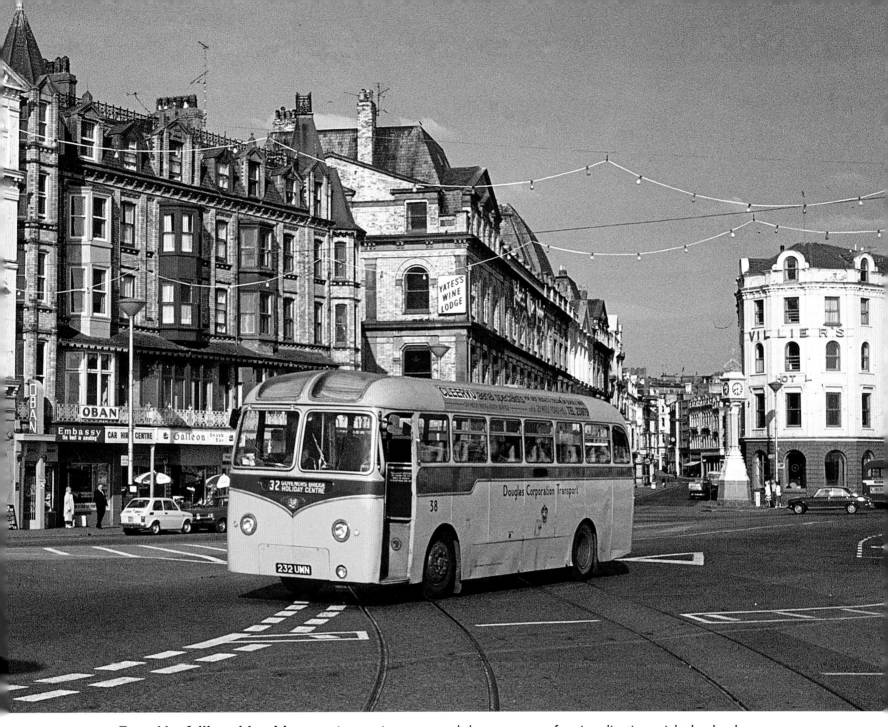

Faced by falling ridership, ever-increasing costs and the prospect of nationalisation, eight Leyland Tiger Cubs were purchased from Lancashire United Transport in 1970. These were from a batch built during 1957/8 with 41-seat dual purpose Duple Midland bodies. Given the fleet numbers 34-41, they were very much a 'stop-gap' measure. Three were withdrawn in 1974 with the remainder going for scrap soon after passing to IOMNT. No. 38 is seen at Victoria Pier on 28 June 1975. (*Michael J. Russell*)

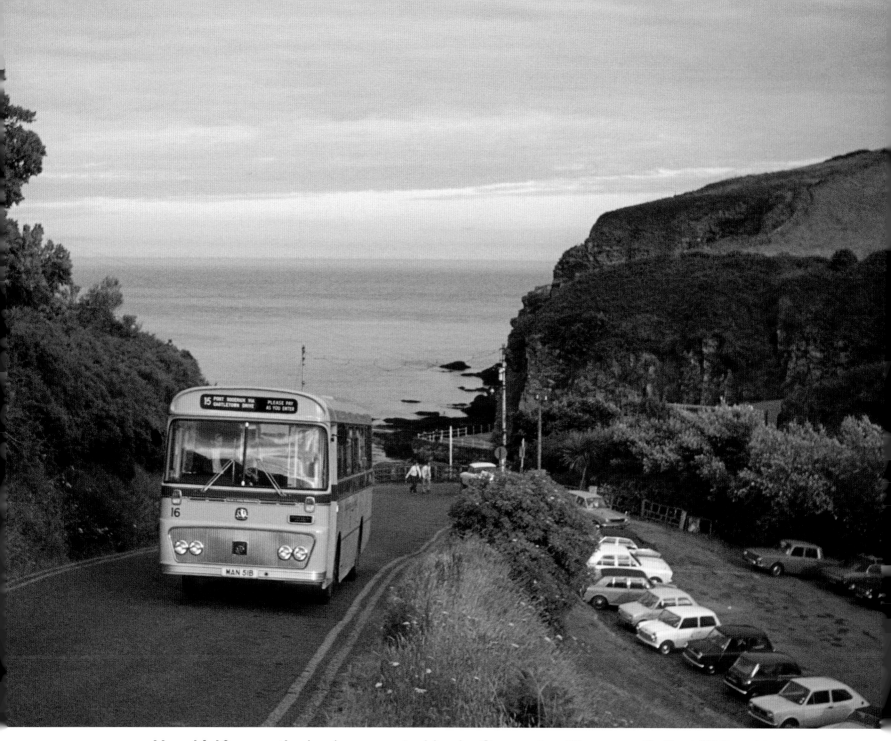

Nos. 16-19 were the last buses acquired by the Corporation. They were Bedford YRQs with 47-seat Willowbrook bodies. No. 16 arrived shortly after appearing at the 1974 Commercial Motor Show whilst the others followed in 1975. After passing to IOMNT they were renumbered and eventually sold for further service in England. In this view, No. 16 grinds up the hill from Port Soderick on 16 July 1975. (*A.F. Gahan/Online Transport Archive*)

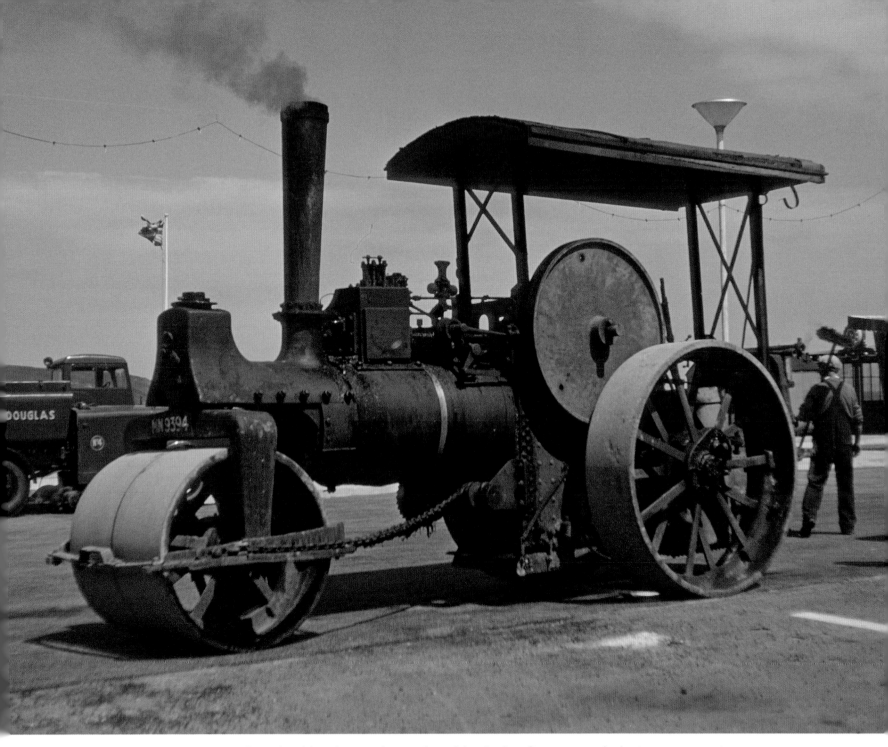

For many years, the island has been a haven for old vehicles. Seen at work during construction of the approaches to the new Sea Terminal in May 1961 is MN9394, an early Aveling and Porter Road Roller dating from 1893, which it is believed was scrapped at the roadside after breaking its axle at Union Mills. Also visible, picking up loose gravel, is Corporation Karrier road sweeper No. 4. *(A.S. Clayton/Online Transport Archive)*

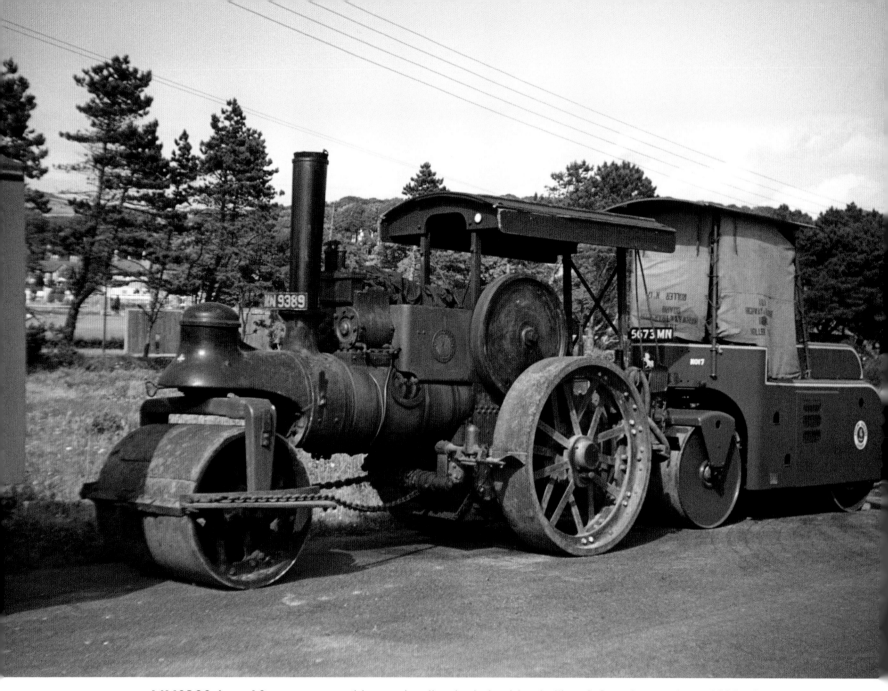

MN9389 is a 10-ton convertible road roller built by Marshall's of Gainsborough in 1922. On 3 August 1964 it was stored within the Isle of Man Highway's Board's Ellerslie depot near Crosby, although seemingly out of use by that time. This roller was sold for further use on the island and was still at work as late as 1970. It was subsequently preserved and for a time was on display at the Steamport museum in Southport before it moved back to the island with its then owner. It is now preserved in the UK and regularly attends vintage traction rallies. Behind it was its modern equivalent – 5673MN, an Aveling-Barford Tandem dating from about 1962. (*Charles Firminger, courtesy Bob Bridger*)

Among the island's many transport delights were various funiculars and cliff lifts, the last to survive being the one giving access to the Falcon Cliff Hotel, perched 250ft above the north part of the promenade. The first lift had opened in 1887 but nine years later it was dismantled and re-erected at Port Soderick. Then, in 1927 a second lift was built, this time to a five foot gauge on a grade of 1:1½. Located a short distance south of the original, it was electrically powered with a single cabin counterbalanced by a weight between the rails. When rebuilt in 1950, it was converted from DC to AC. On 7 June 1974, signs try to encourage people to ride the lift for the princely sum of 2p so they can visit the hotel and sample the delights of Okell's Ales (the local Douglas brewery). The former hotel (1836) now has Protected Building Status but the lift, which closed in 1990, is in a poor state of repair. (*W. Ryan*)

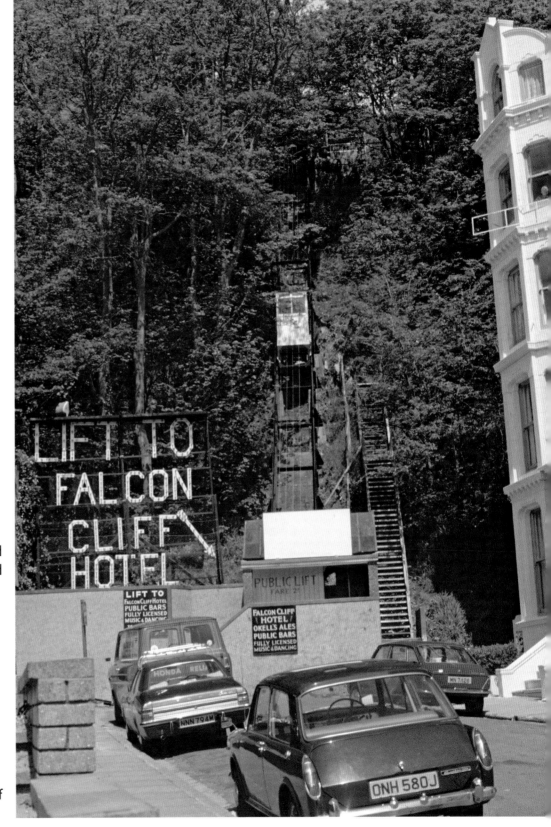

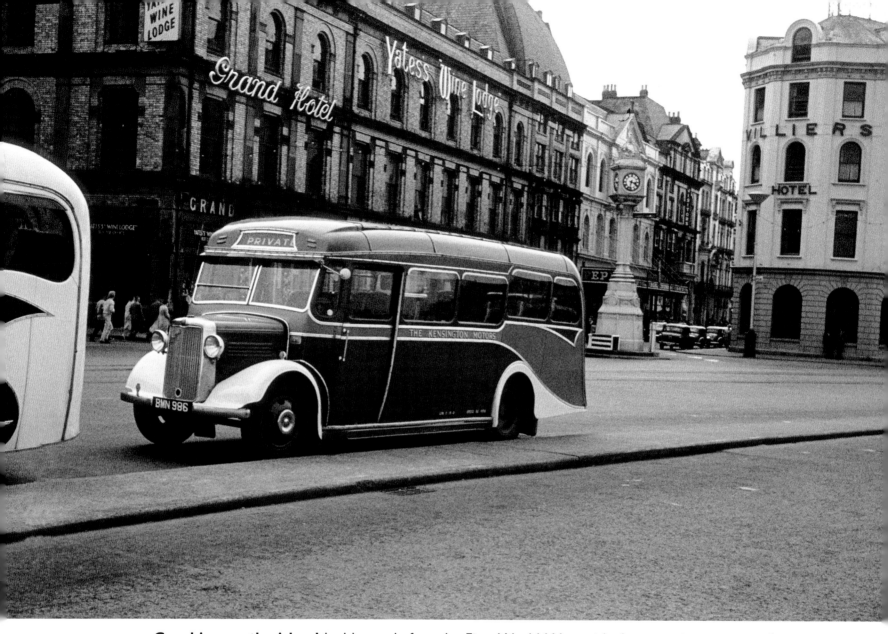

Coaching on the island had begun before the First World War, with the entry into service of a small number of charabancs – open saloon single deckers with cross-bench seating, and a canvas roof in case of inclement weather. By the late 1920s, there were over 200 in service, with over 40 different makes being recorded. When the last examples were withdrawn by the end of the 1930s, their place was taken by small, normal-control vehicles, i.e. with the driver seated behind the engine, which was enclosed in a protruding bonnet. Still giving yeoman service until the early 1960s was veteran pre-war Bedford WTB BMN986 with stylish Duple 25-seat bodywork. This vehicle was brand new when it came to the island and always ran for the same operator, Kensington Motors of Douglas. It had been delivered as a 20-seater but was upgraded when regulations changed in 1939. It is seen here between duties at the foot of Victoria Street, near the ferry terminal. (*Harry Luff/Online Transport Archive*)

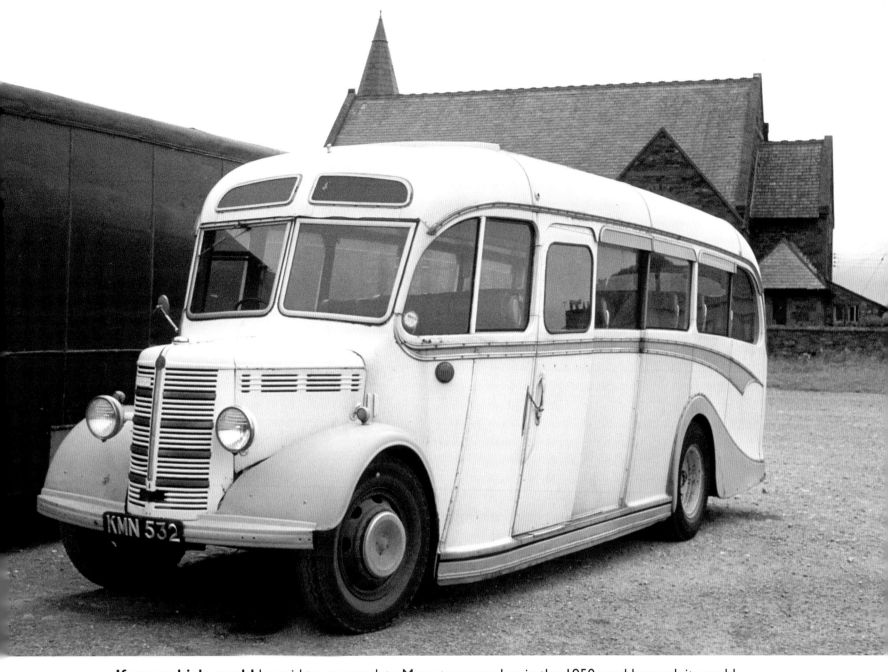

If one vehicle could be said to encapsulate Manx tour coaches in the 1950s and beyond, it would be the Bedford OB with Duple Vista 29-seat bodywork. Year after year, the distinctive sound of their petrol engines could be heard as they moved in procession from the Promenade to the various attractions around the island. KMN532 was new in 1949 to McMullin of Douglas, who traded as Mayflower Coaches. In 1962, it was sold to Hamill, another Douglas firm, where it remained for a further six years before serving as staff transport for the Ronaldsway Shoe Company. As operators took great pride in their vehicles, they were usually impeccably presented. The slightly down-at-heel look suggests the vehicle was photographed at Port Erin during its years as a staff bus. (*John Herting/ Online Transport Archive*)

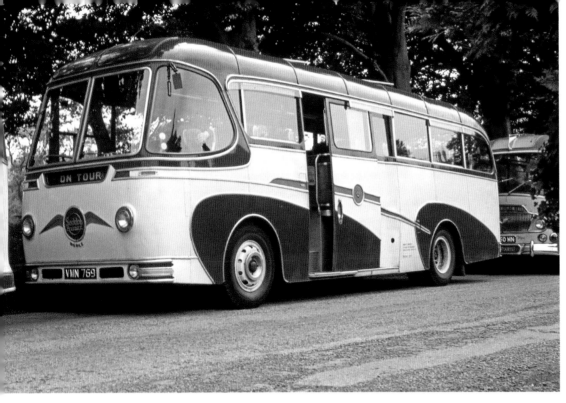

Some of the more unusual types of coach were photographed by Geoff Lumb in 1964. The first picture shows VMN769, a Seddon R6 with Duple 41-seat bodywork. Delivered to a Lancashire operator in 1954, it was transferred to the island in 1957, operating first for W.H. Shimmin of Douglas and then for Conister Motors also of Douglas, with whom it was serving when photographed. It remained with Conister until 1964 after which it returned to England for further service.

The second picture features another rarity – an Albion Victor with quirky 32-seat bodywork by Beccols of Westhoughton. During most of its time on the island, MMN85 belonged to the long-established operator Collister's Garage of Douglas. However, the decline in the coaching business during the 1960s led to a rapid fall-off in the number of operators and many – Collister's included – were taken over by Tours (IOM) Limited. Both views are taken in Saddle Road, Braddan, the coaches having brought worshippers to the special open-air Sunday morning service at Kirk Braddan Parish Church on 19 July 1964. (*G. Lumb, courtesy Travel Lens Photographic (both)*)

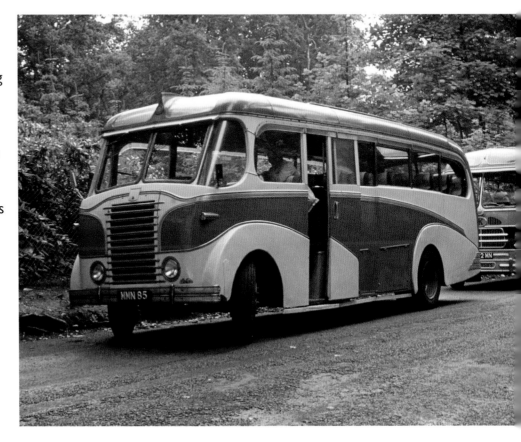

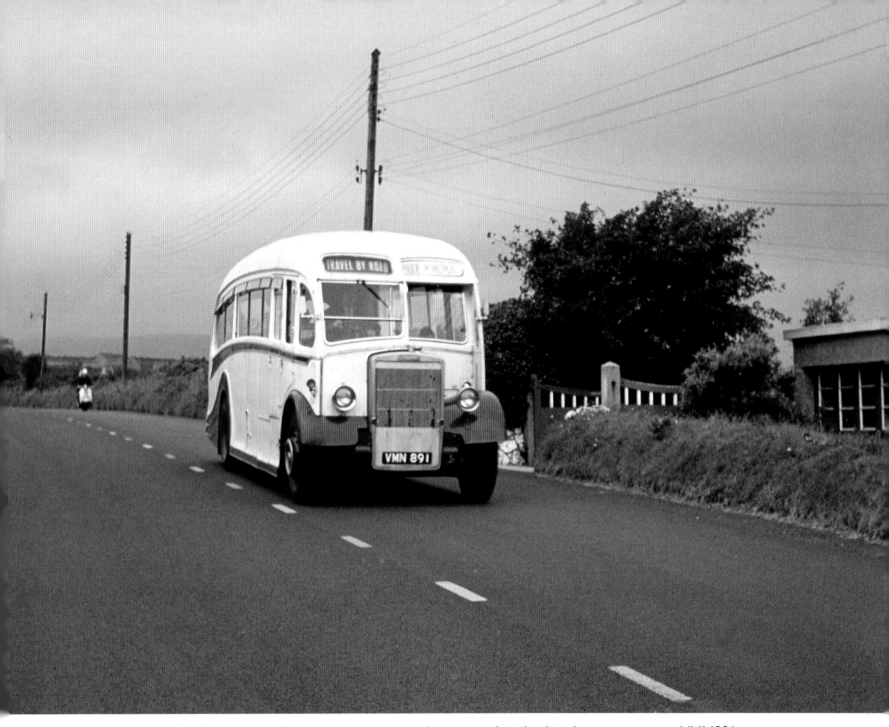

Exposed radiator coaches were comparatively rare on the island in the post-war era. VMN891 is a 1950 Leyland Tiger PS2/3 with Harrington 33-seat bodywork. New to an operator in Smethwick, it was imported to the island in 1957, its first operator being K's Motors of Douglas. Over the years, this company was run by several different permutations of the Kneen family but with a number of different trading names, making the job of tracing business and vehicle history extremely complicated. (*G. Lumb, courtesy Travel Lens Photographic*)

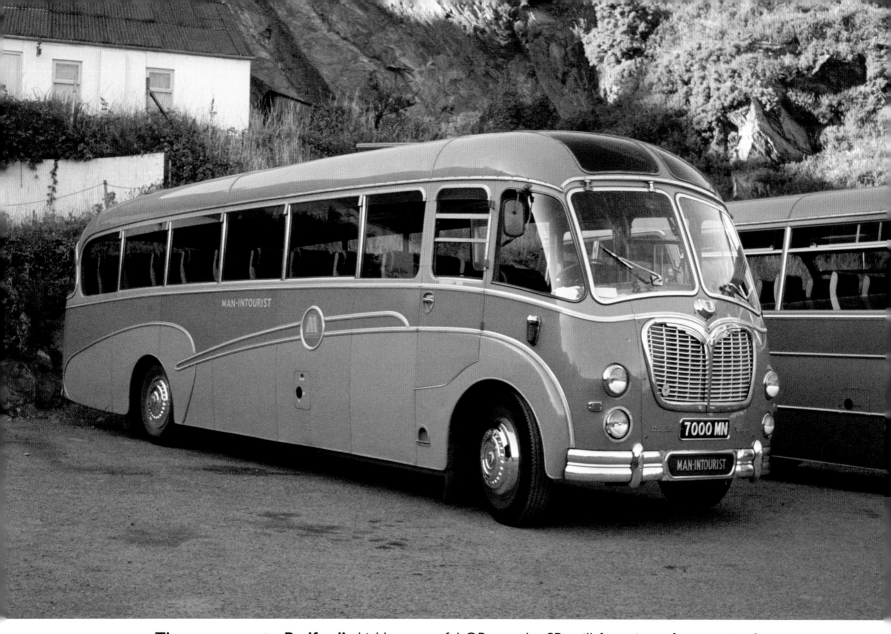

The successor to Bedford's highly successful OB was the SB, still featuring a front engine but this time in such a way that forward control (i.e. driver alongside the engine) was possible. It was a highly successful design, in production from 1950 until the demise of Bedford as manufacturer in 1987. Many coachbuilders produced designs to accommodate this chassis arrangement, all having the entrance door behind the front axle, with the engine being hidden – and to a certain extent its sound muffled – by a quilted cover which protruded into the saloon. 7000MN was a 1958 Bedford SB3 (this designation denoting a petrol engine) with Duple Vega 41-seat bodywork, which ran for two operators in the Potteries before being transferred to the island. By the time this view was taken, it was part of Tours (IOM) fleet, using the brand name ManIntourist, and is seen in their yard in Summer Hill, Douglas, near to the Horse Tram stables. Following withdrawal in 1971, the coach returned to the UK for a final period of service. (*John Herting/Online Transport Archive*)

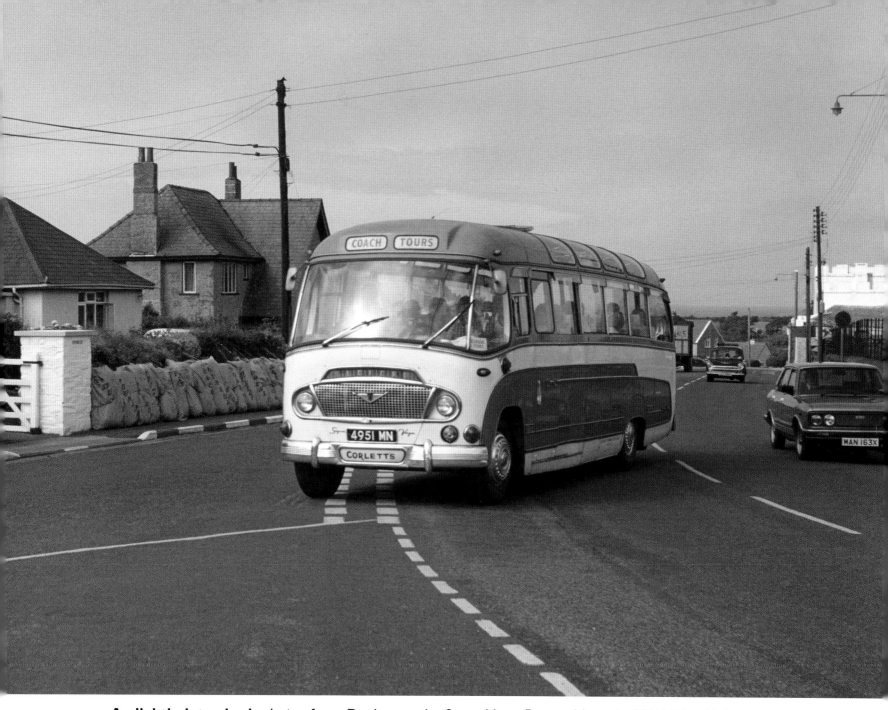

A slightly later body design from Duple was the Super Vega. Pictured here is 4951MN, which was new to Ashwell Coaches of Hertfordshire in 1961 but after just one season it was acquired by A.J. Turner of Douglas – trading as both Belmont Motors and The Huntsman. When it was photographed at Kirk Michael in the late 1970s, it had passed through several hands and was running for Corlett's Coach Tours of Port St Mary. Note the impact-absorbing material adjacent to the white gateposts. These bags provided some protection on this fast curve which is part of the annual Tourist Trophy (TT) motorcycle circuit. (*Peter Deegan*)

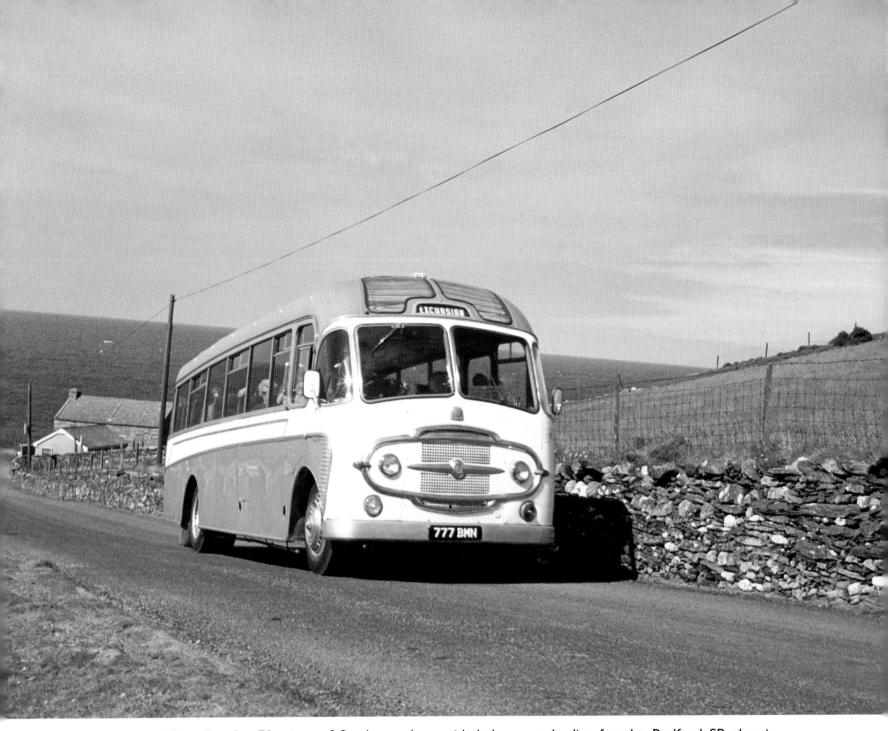

After Duple, Plaxton of Scarborough provided the most bodies for the Bedford SB chassis. 777BMN was a 1958 example with a 41-seat Embassy-style body. Originating with a coach company in the Manchester area, it was bought by Miller's Motors of Port St Mary in 1965. As with 4951MN, it passed to Corlett's and is seen pulling away from The Sound at the southern tip of the island. Subsequently, it served as a staff bus with the Ronaldsway Shoe Company until 1977. (*John Herting/ Online Transport Archive*)

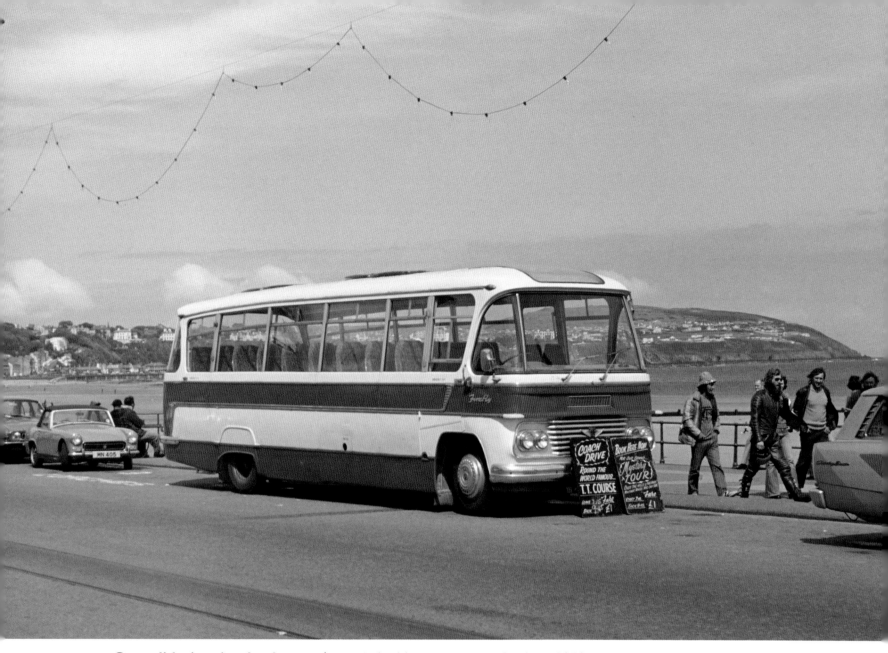

Consolidation in the bus and coach building sector in the late 1950s and early 1960s saw several businesses taken over by Duple. The former Burlingham factory in Blackpool became Duple (Northern) and produced the Firefly bodywork for chassis such as the Bedford SB. 224KMN touts for business on Victoria Promenade where competing operators had allotted stands. The most effective way of attracting business was the chalk board propped up against the coach. On this occasion, Victoria Coaches was advertising two evening tours for £1 each, punters choosing between a trip round the 'World Famous TT Course' or a 'Grand Mystery Tour'. Much of the guest house accommodation was run on very traditional lines, with fixed meals, normally at 5pm, creating a market for evening tours such as these, both departing at 7.15pm. The vehicle had been new to Fox of Hayes, Middlesex in 1964 and was sold to an Irish operator in 1979. (*Peter Deegan*)

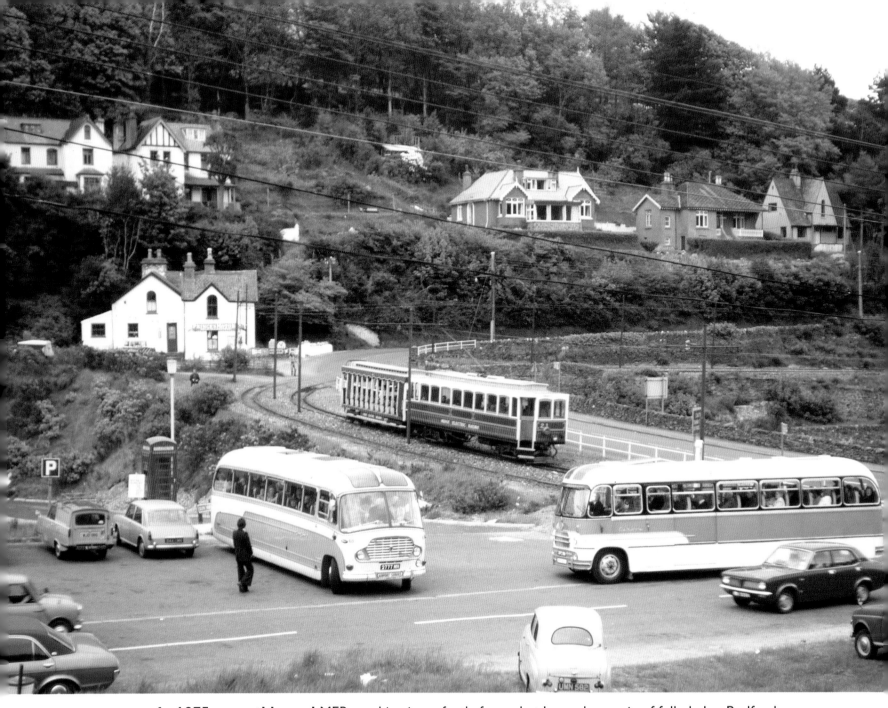

In 1975, a southbound MER working is perfectly framed at Laxey by a pair of fully-laden Bedford SBs. Those on board will be heading to the nearby 'Lady Isabella' wheel – another must-see destination – or possibly into the village for lunch. On the left is Duple Super Vega-bodied 2777MN. New to Happiways Tours of Manchester in 1960, it passed to Silver Star of Douglas when only nine months old. When this photograph was taken, it was No. 43 in the Tours (IOM) fleet and carries the fixed destination 'Airport Service' which was one of its regular duties. Just arriving is Yeates Europa-bodied 7092MN, operating for Amy Tours of Douglas. (*Nicholas Britton*)

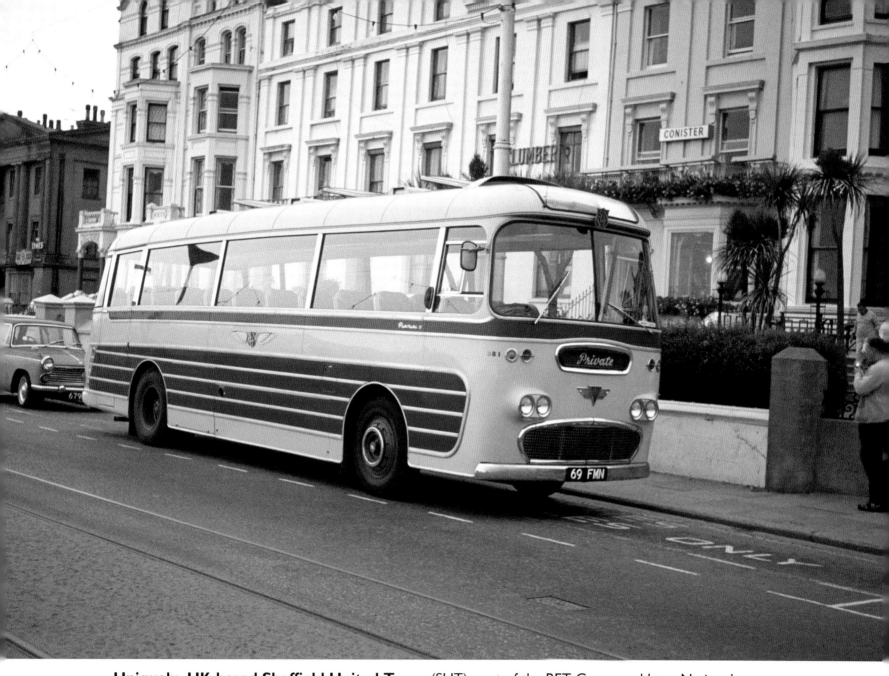

Uniquely, UK-based Sheffield United Tours (SUT), part of the BET Group and later National Bus Company, was granted dispensation to operate its own coaches on the island but only if carrying passengers booked on an SUT package holiday. The vehicles based on the island during the summer were given Manx registrations and garaged by Isle of Man Road Services, regaining their UK registrations when they returned to Sheffield for the winter. In this view, SUT No. 321 is waiting to pick up its package holidaymakers. It is a 1961 AEC Reliance with 41-seat Plaxton Panorama bodywork and was based on the island at various times during 1966-71. In its Manx guise it was 69FMN but back in the UK it was 1321WA. It was eventually scrapped in 1979. (*John Herting/Online Transport Archive*)

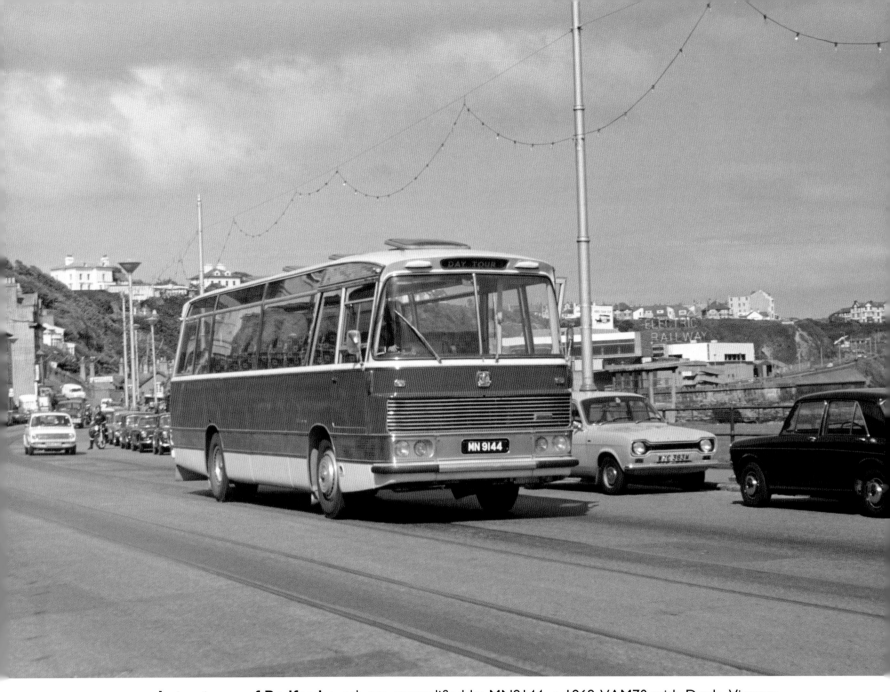

Later types of Bedford coach are exemplified by MN9144, a 1969 VAM70 with Duple Viceroy bodywork fitted out with 45 seats. Operating for Victoria Coaches, it is seen running light to central Douglas from the company's depot at Summer Hill. New to well-known Midlands independent Whittle's of Highley in 1969, it was transferred to the island in 1974. After serving with another Isle of Man operator from 1985, the vehicle was scrapped in 1989. Its registration is unusual, having been issued originally in the early 1930s but reissued in 1974 when the Department of Transport had exhausted all two and three letter combinations. An adaptation of the UK suffix-letter system was used from mid-1974 onwards. (*Peter Deegan*)

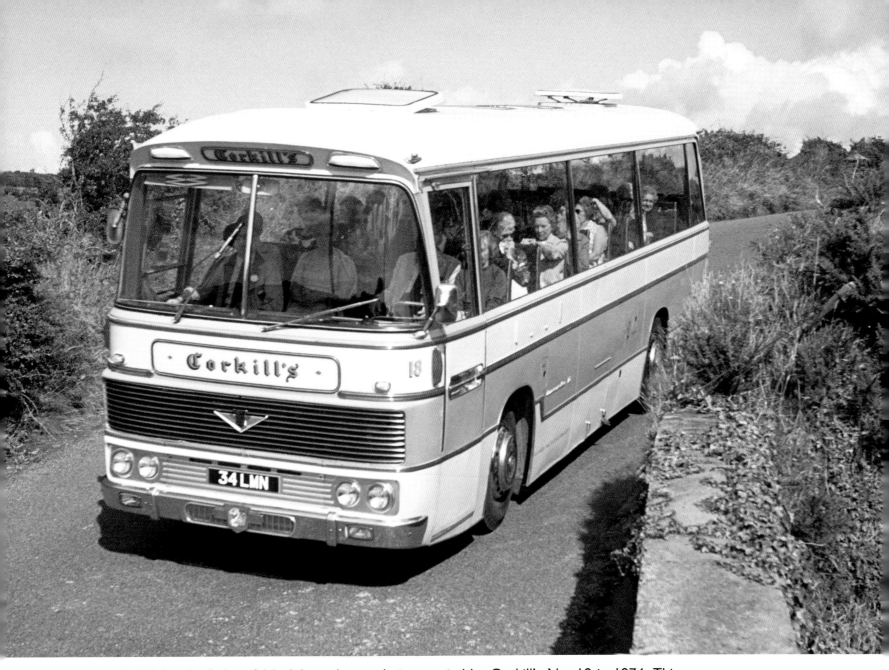

A full load of cheerful holidaymakers is being carried by Corkill's No. 18 in 1974. This was one of three Leyland Leopards with Duple (Northern) Commander bodywork which were new to Isle of Man Road Services in 1968 as its Nos. 34-36. When IOMRS pulled out of the coaching market in 1972, all three were sold to Tours (IOM) as it continued the process of absorbing virtually all of the remaining Manx coach operators. Corkill's Garage was a long-established operator, buying its first vehicle in 1926. A complex set of takeovers and buyouts in the early 1970 resulted in the name Corkill's being applied to many vehicles in the Tours (IOM) fleet. The company's fleet numbering was fluid to say the least, with 34LMN carrying the numbers 9, 18 and 34 at various times. All three Leopards were sold to a Dublin-based company in the early 1980s. (*Phil Tatt/Online Transport Archive*)

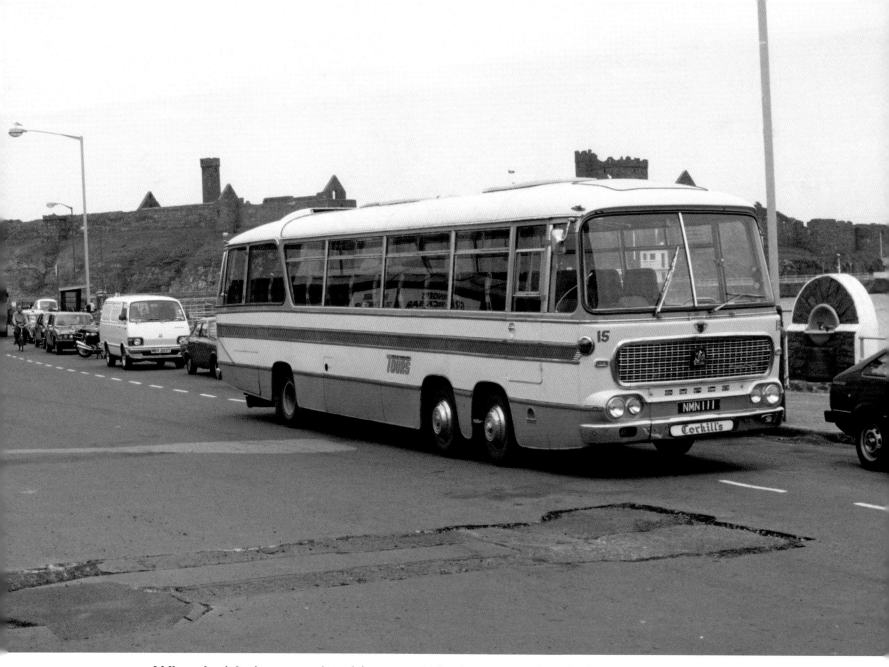

When legislation permitted it, several island operators bought 36ft-long, three axle Bedford VALs. Duple's bodywork on the Bedford VAL was given the name Vega Major and this combination is illustrated by NMN111. Owing to the overlap between fleet names, it carries both Corkill's and Tours (IOM) titles when parked on Peel Parade in 1974. Tours had a liking for registrations featuring the numbers 111. At times almost the entire fleet was so adorned and it was common for the same number to be transferred from one vehicle to another. In this incarnation, NMN111 was the former JAX898D, which ran for South Wales independent Jones of Aberbeeg from when it was new in 1966 before crossing over to the island in 1973. It was sold to an Irish operator in 1979, with the '111' plate being transferred to a replacement coach. (*Phil Tatt/Online Transport Archive*)

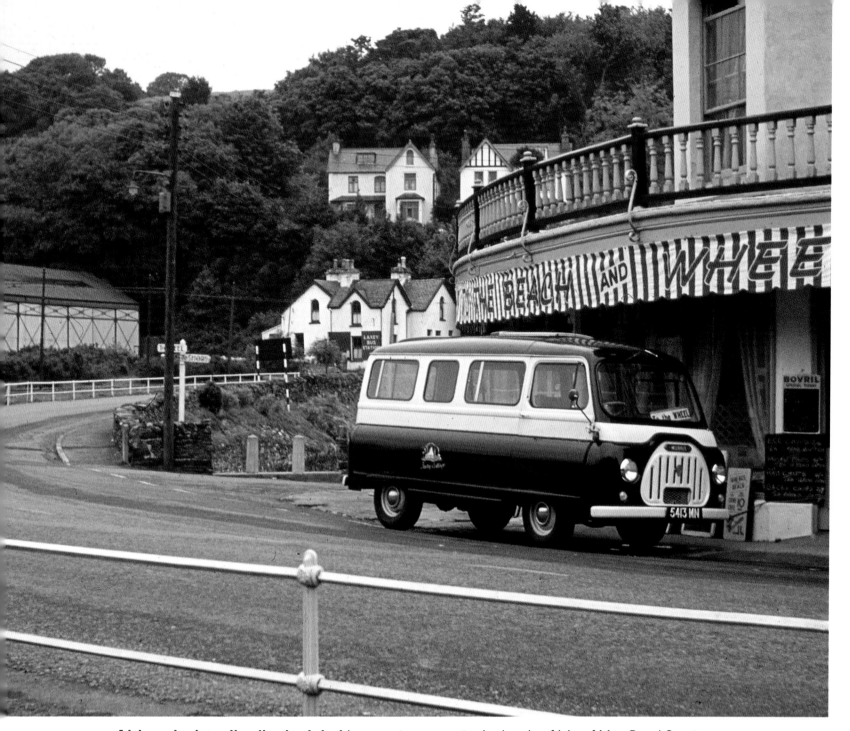

Although virtually all scheduled bus services were in the hands of Isle of Man Road Services or Douglas Corporation, a series of independent operators provided a local Laxey service between the beach and village and the famous 'Lady Isabella' wheel. R.W. Hardy (trading as Fairy Cottage) provided the service between 1962 and 1969 and illustrated here is 12-seat Morris J2 5413MN parked up outside a café in the centre of the town in July 1964. Perhaps the driver is availing himself of the egg and chips on offer for 8/6 (42½p). (*G. Lumb, courtesy Travel Lens Photographic*)

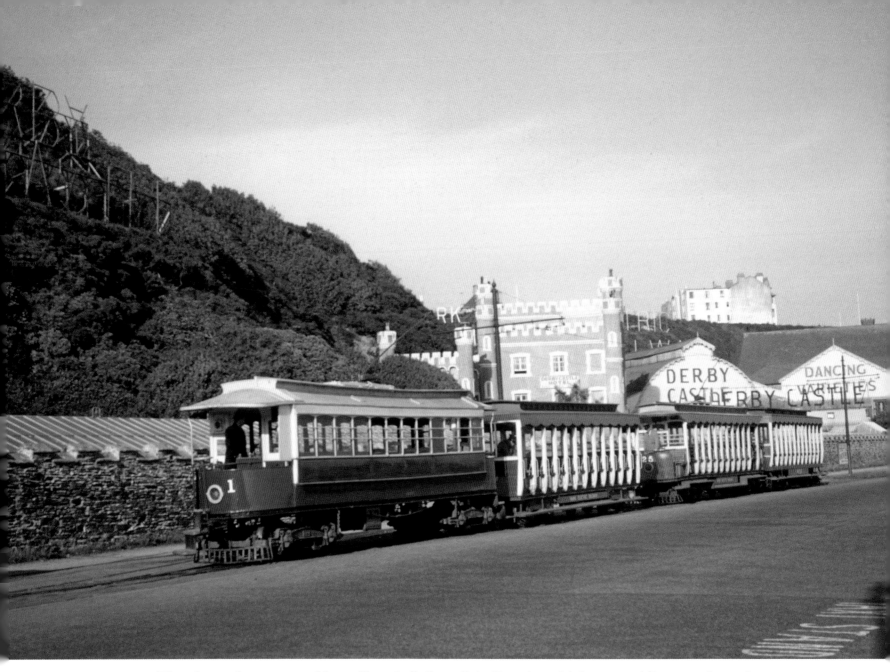

The three-foot gauge Manx Electric Railway links Douglas with Laxey and Ramsey. Apart from road crossings, the 18 mile interurban is entirely on private right of way, with long stretches of roadside running. More remote sections cut across country and there are dramatic coastal stretches. The line opened in stages between 1893 and 1899. During the years covered by this book, the fleet has been much reduced. The cars that remain date mostly from the late nineteenth century with the oldest being Nos. 1 and 2, survivors from a trio of unvestibuled cars with clerestory roofs built by G.F. Milnes in 1893. No. 1 is now the oldest electric tram in the world still operating on the line for which it was built and is seen at Derby Castle, Douglas, in July 1956. (*John McCann/Online Transport Archive*)

In 1903, the plate frame trucks and electrical equipment on Nos. 1-3 were replaced by Brush equal wheel bogies, four 25hp motors, air brakes and K11 controllers. Seating capacity was reduced quite early from 38 to 34. In July 1974, No. 1 has a home-made windscreen which provided some protection for the driver when 1 and 2 were employed as works cars during the winter. (*Martin Jenkins/Online Transport Archive*)

As part of the celebrations marking the 1000th anniversary of the Manx Parliament, No. 1 was restored to near original condition in 1979 and painted into a close approximation of its first livery. Only the 'Isle of Man Railways' looks somewhat out of place as it poses at Derby Castle. (*Derek Bailey/ Online Transport Archive*)

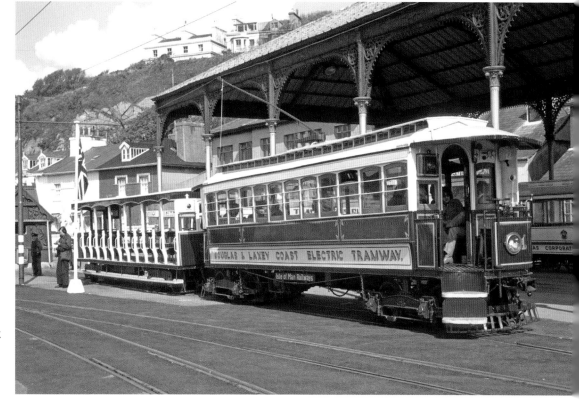

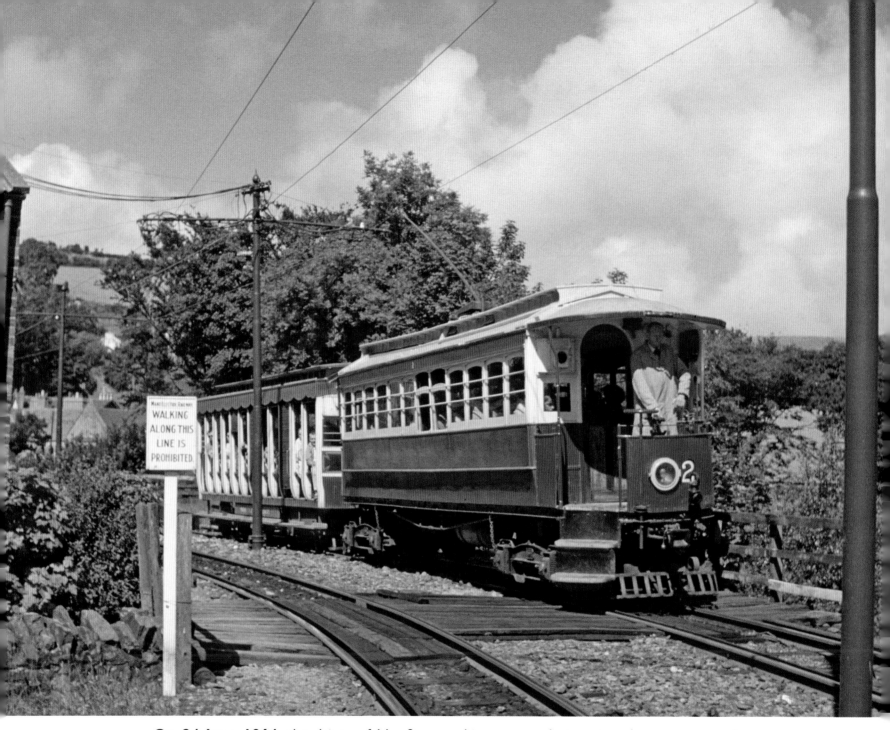

On 24 June 1964, the driver of No. 2 wears his summer dust coat as he powers south past Laxey substation, site of the original 1893 terminus. By this time, the controllers on 1 and 2 had been modified in 1947 and each had recently been fitted with Maley & Taunton (M&T) air brake equipment acquired from Sheffield Corporation. As with the 1956 view of No. 1 (page 104), the car carries no MER title. The final member of the trio, No. 3, was destroyed in a depot fire at Laxey in 1930. (*F.W. Ivey*)

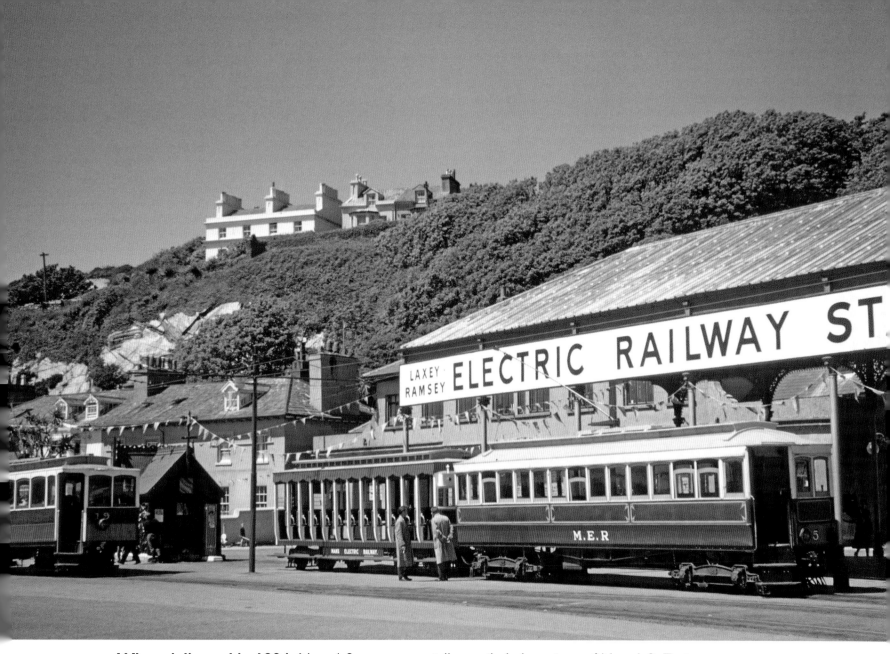

When delivered in 1894, Nos. 4-8 were essentially vestibuled versions of Nos. 1-3. To improve overall performance, 4 exchanged trucks and equipment with 16 in 1899 whilst four years later, 5-9 were given the same bogies and equipment as 1-3. Nos. 4 and 8 were destroyed in the Laxey fire. When No. 5 was rebuilt in 1932, a new internal partition created smoking and non-smoking compartments with two and one seating for thirty-two passengers. At the same time, the gates at the top of the platform steps were replaced by half glazed doors, a feature later fitted to Nos. 6, 7 and 9. In its new guise, 5 was christened 'The Cathedral' or 'The Shrine'. In this view, taken at Derby Castle on 10 June 1957, it has its original split windscreen and is in the simplified post-war livery with the abbreviated title, although the trailer has Manx Electric Railway in full. Like other members of the class, the controllers were modified post-war. *(John McCann/Online Transport Archive)*

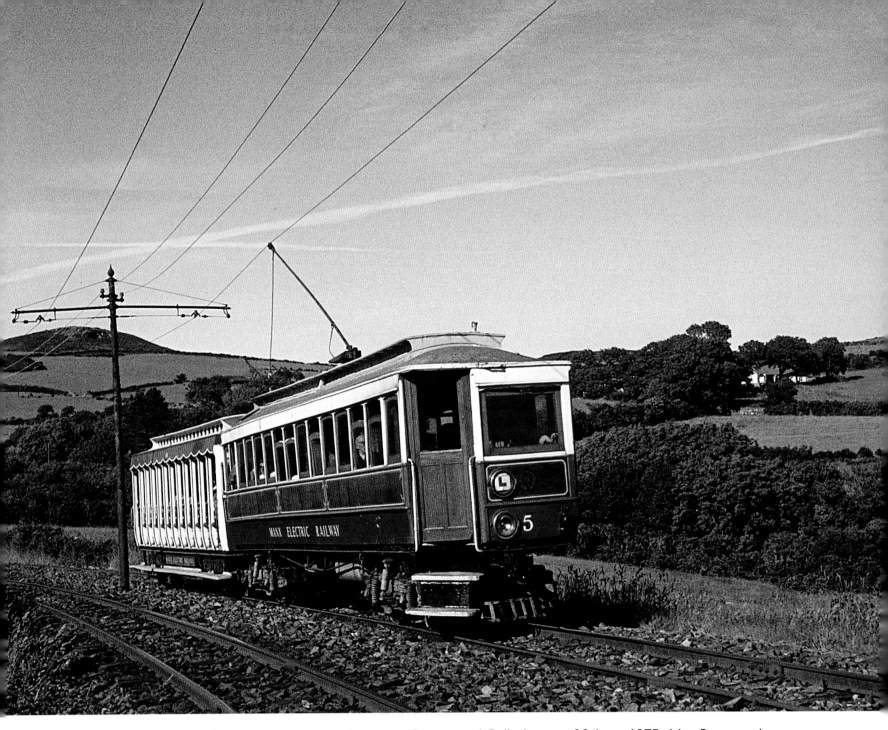

When this view was taken between Cornaa and Ballaglass on 28 June 1975, No. 5 sported a one-piece windscreen to improve driver visibility. Between 1972 and 1981, a second headlight was installed; in this instance, one has an 'L' plate to indicate driver training. To the right of the dash is the obligatory oil lamp. These were attached until the late 1980s along with a tail lamp on the trailer (or motor car if operating singly). Today, No. 5 is still regularly employed and is usually the first car to augment the 'Winter Saloons'. (*Michael J. Russell*)

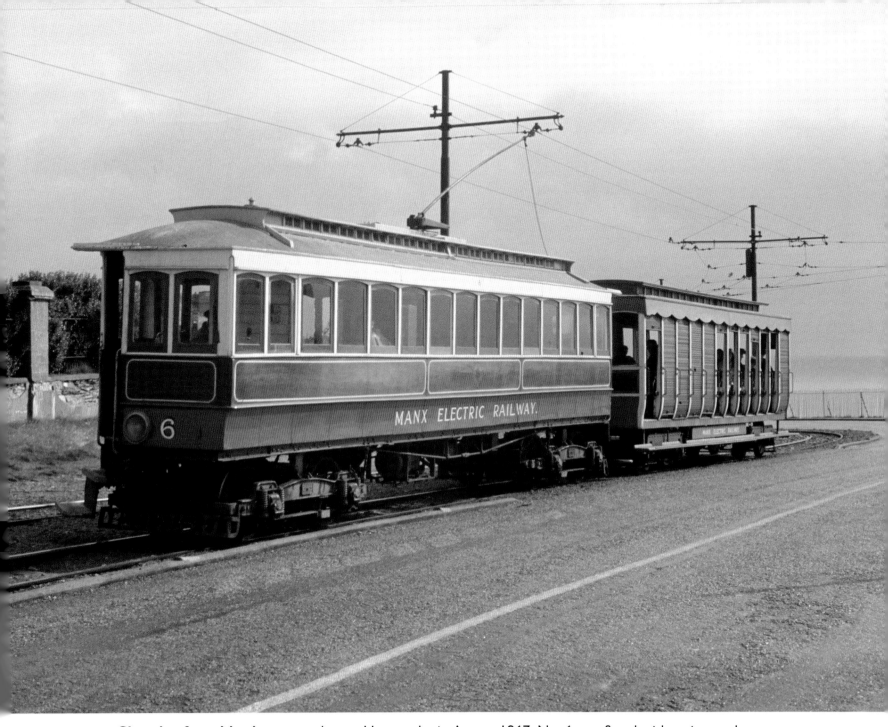

Shortly after this view was taken at Howstrake in August 1967, No. 6 was fitted with an internal partition, half-glazed platform doors and a single piece windscreen. By this time, only one vestibule window on these cars could be opened, whilst the saloon windows no longer dropped right down, so the protective window bars were removed. The car is active today, still with its original longitudinal seating. Owing to their narrow, arched interiors, this group are known as 'Tunnel Cars'. *(Brian Faragher/Online Transport Archive)*

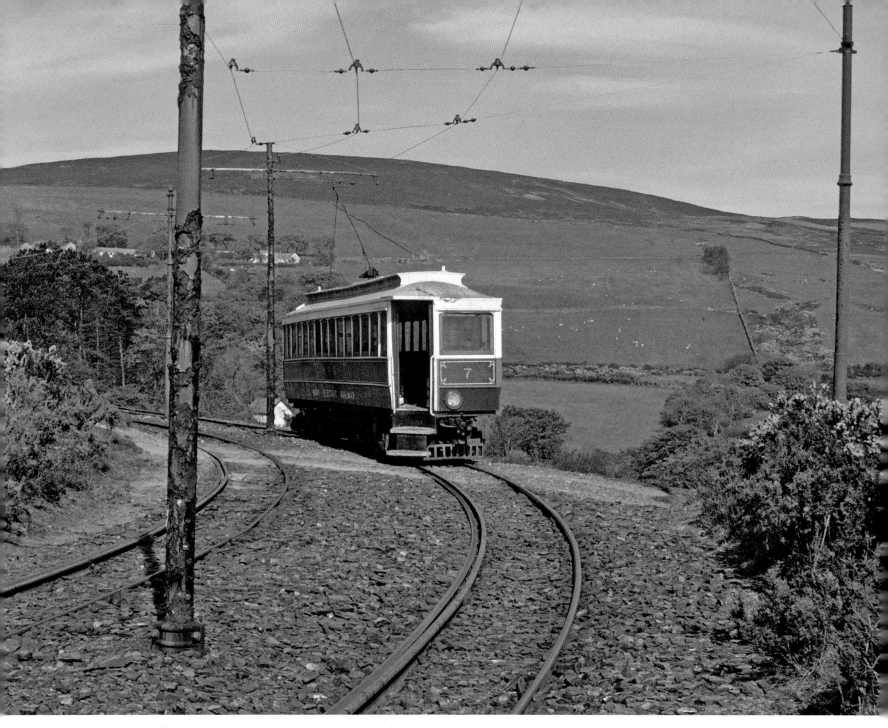

Visiting enthusiasts sometimes hire trams to have dozens of photo opportunities. A party of Americans toured the threatened Laxey-Ramsey section on 27 May 1975. Here, No. 7 poses on the tight curve on the ascent from Dhoon Glen, above Bulgham Bay which, at 558ft above sea level, is the highest point on the line. In 1970, No. 7 had received a single piece windscreen and half-glazed platform doors. Today it is part of the present fleet often providing backup for the 'Winter Saloons'. (*J. Canfield/Online Transport Archive*)

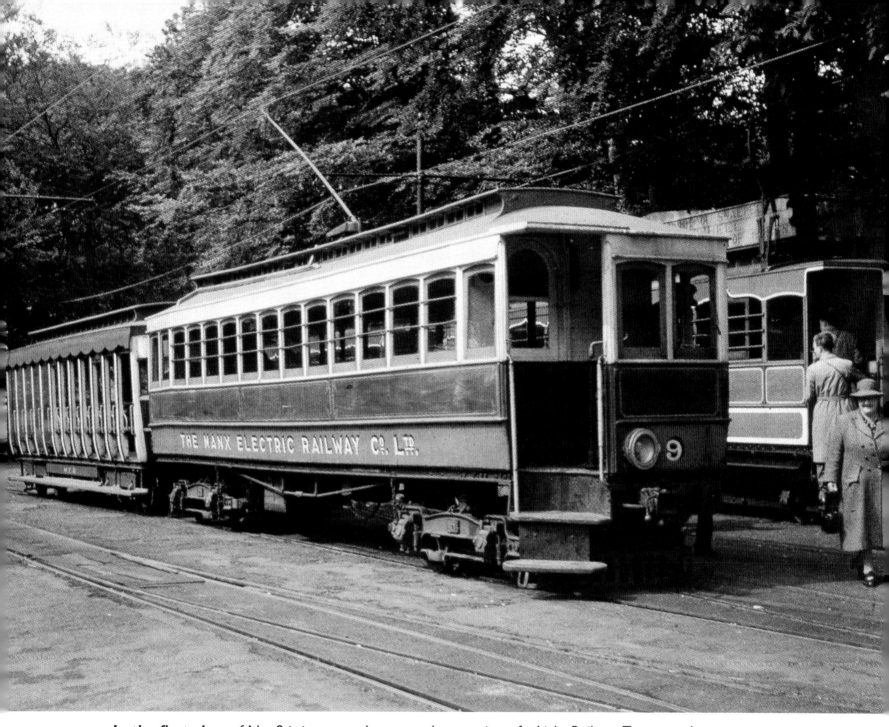

In the first view of No. 9 it is seen at Laxey on the occasion of a Light Railway Transport League (LRTL) visit in June 1951, when it still displayed the full company title and had protective bars along the windows. During the off-season, it was often employed as a works car or snowplough. The later involved removing the steps and fitting the plough to the underframe headstock at the north end. Single piece windscreens were fitted in 1977, together with half-glazed platform doors. (*W.J. Wyse/ LRTA (London Area)/Online Transport Archive*)

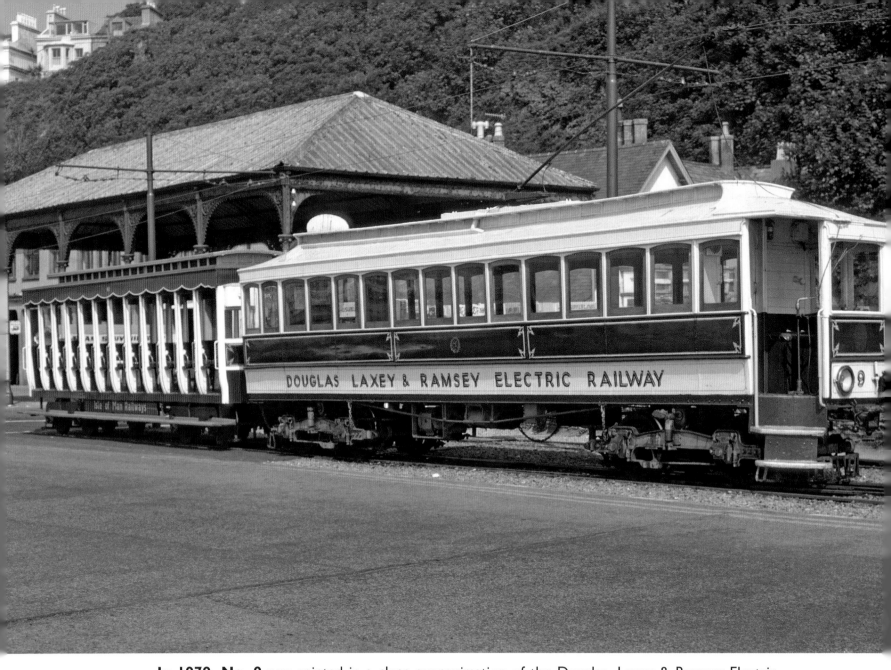

In 1979, No. 9 was painted in a close approximation of the Douglas, Laxey & Ramsey Electric Railway livery of the late 1890s and is seen in these colours at Derby Castle on 3 July that year. Later rebuilt with an internal partition it has, since the early 1990s, served as the island's first illuminated tram. (*G.W. Morant/Online Transport Archive*)

Resembling Snaefell trams, Nos. 10-13 were built on the cheap and only lasted for several seasons. Delivered from G.F. Milnes in 1895, they had plate frame trucks, transverse seats for 48, unglazed saloon windows and no clerestory roof. Two subsequently became powered freight cars whilst the others remained in store until modified as air-braked freight trailers in 1918. As the MER freight business declined, all were withdrawn. The sole survivor is former No. 10 which was put in store when withdrawn as freight trailer 26 in 1944. In the first view, it is semi-derelict in Ramsey depot in September 1975 whilst in the second it is restored and painted in freight grey, ready to participate in the parade marking the Tynwald millennium on 31 May 1979, when it was coupled to one of the 'Paddleboxes'. It is now stored at Laxey. (*Nicholas Britton; R.L. Wilson/Online Transport Archive*)

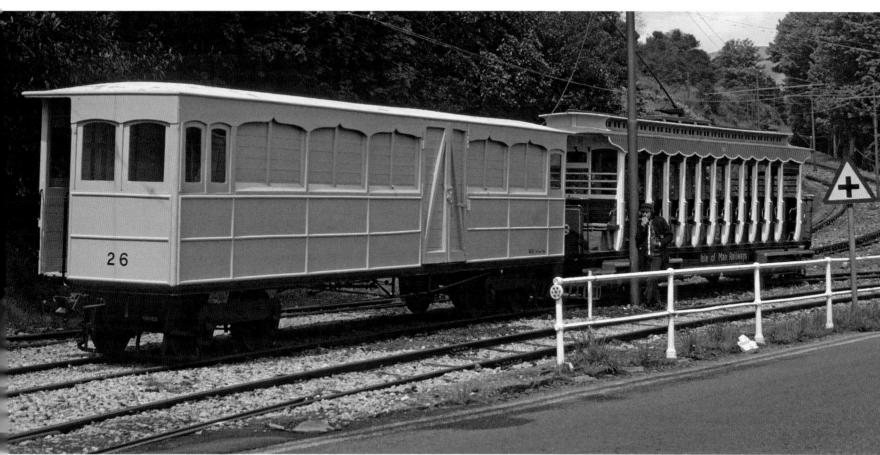

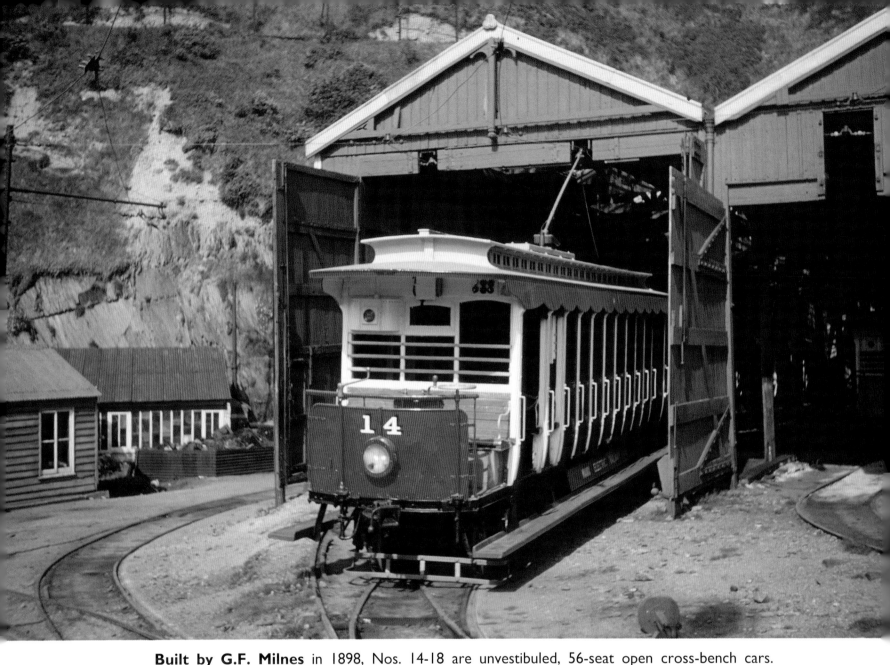

Built by G.F. Milnes in 1898, Nos. 14-18 are unvestibuled, 56-seat open cross-bench cars. Mounted on Milnes plate frame trucks, they have four 20hp motors and GE K11 controllers. Roller shutters were added by 1904 as well as extended footboards. Except for No. 16, these handbrake, or 'ratchet', cars remain almost as built, although 15 was given the K12 controllers off No. 25 in 1936 and Nos. 17 and 18 had their controllers modified to K12 immediately after the Second World War. Normally assigned to seasonal 'special' duties, all but 16 gradually became surplus to requirements as traffic levels declined. In this view, 14 stands outside No. 2 Car Shed (1894/5) on 20 May 1956. The car is in the unlined livery adopted by the cash-strapped Company prior to nationalisation. Withdrawn in 1982, it is now hoped that No. 14 will return to service as the only handbrake car in the operational fleet. (*John McCann/Online Transport Archive*)

No. 15 carries only the initials MER as it waits to leave Laxey in June 1964. The motorman has discarded his regulation headgear in favour of a flat cap which was more likely to stay in situ during strong wind. No. 15 was withdrawn in 1973 and is now semi-derelict. (*F.W. Ivey*)

In 1899, No. 16 exchanged trucks with No. 4. Then, as part of the 1903 re-equipment programme, it received roller shutters, air brakes, four 25hp motors and Brush Type D trucks. In order to accommodate the latter, the footboards were redesigned after which 16 became known as a 'Paddlebox', a name subsequently applied to other cars treated in the same way. Further alterations included modification of the controllers in 1946 and the fitting of air brake equipment acquired from Sheffield in the 1960s. On 20 May 1956, No. 16 is seen entering the depot. To the left is the original 1893 car shed. Contrasting with others in this group, 16 had different lifeguards and its fleet numbers were located below instead of above the headlamps. (*M.J. Lea/LRTA (London Area)/Online Transport Archive*)

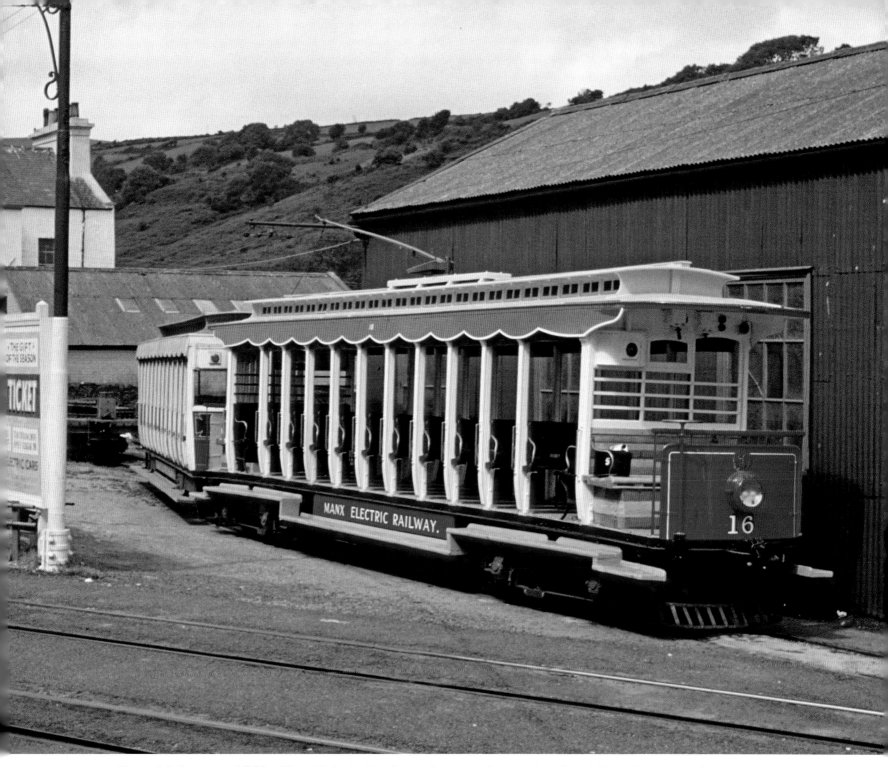

By mid-August 1962, No. 16 is in lined out livery and occupies the siding adjacent to Laxey Goods Shed. This is where 'specials' often lay over waiting for the Station Master to summon them for another trip south. When the terminal was redesigned during the winter of 2013/4 this siding was disconnected. (*F.W. Ivey*)

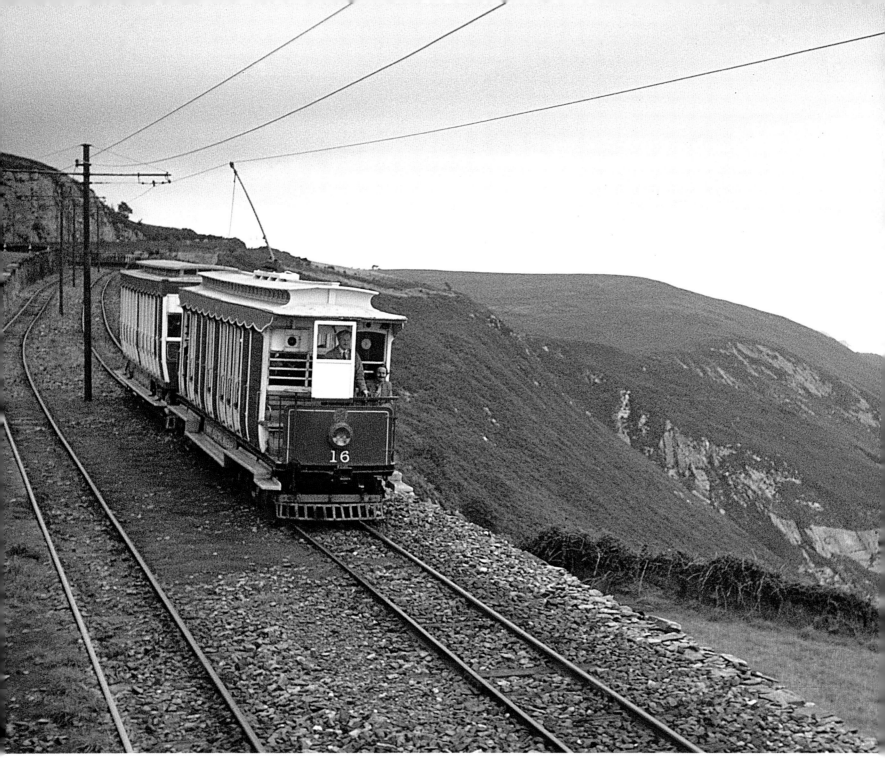

Occasionally, power cars were fitted with a variety of protective windscreens, including No. 16, which is seen coasting down from Bulgham towards Ballargh on 25 August 1975. On this long downhill section, motormen throw off the power and control the car on the brakes. (*Michael J. Russell*)

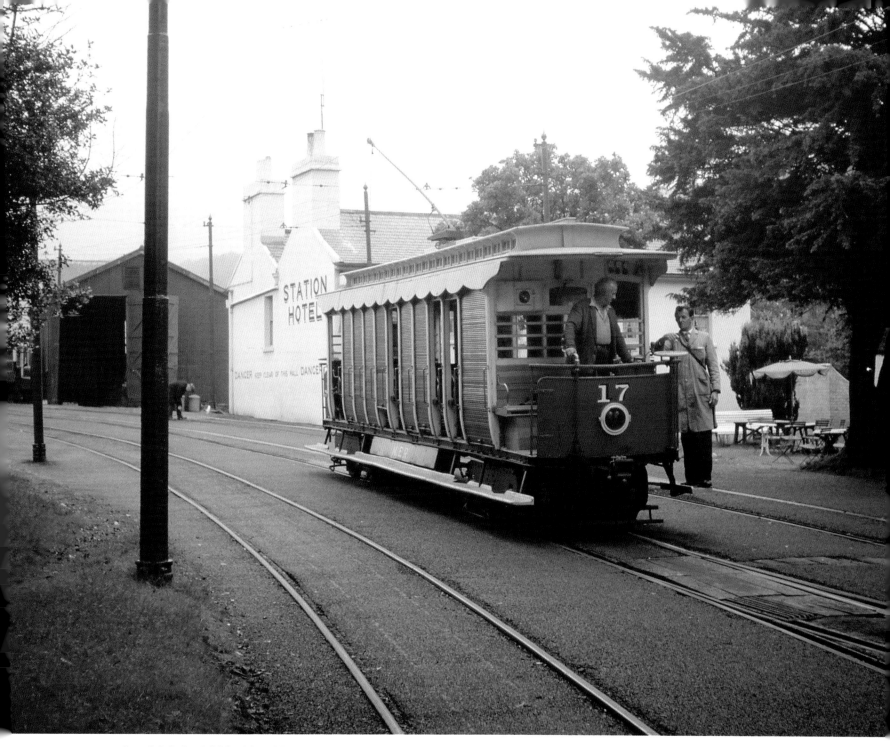

On 24 July 1963, No. 17 prepares to leave Laxey with an unscheduled 'special' for Douglas. The shutters are rolled down, the motorman is in 'civvies' and the conductor wears the regulation dustcoat. The door into the Goods Shed (1903) is open whilst No. 6 occupies the siding. Following its withdrawal in 1973, most of the electrical equipment on 17 was removed and it is now semi-derelict. *(Jim Copland, courtesy Malcolm King)*

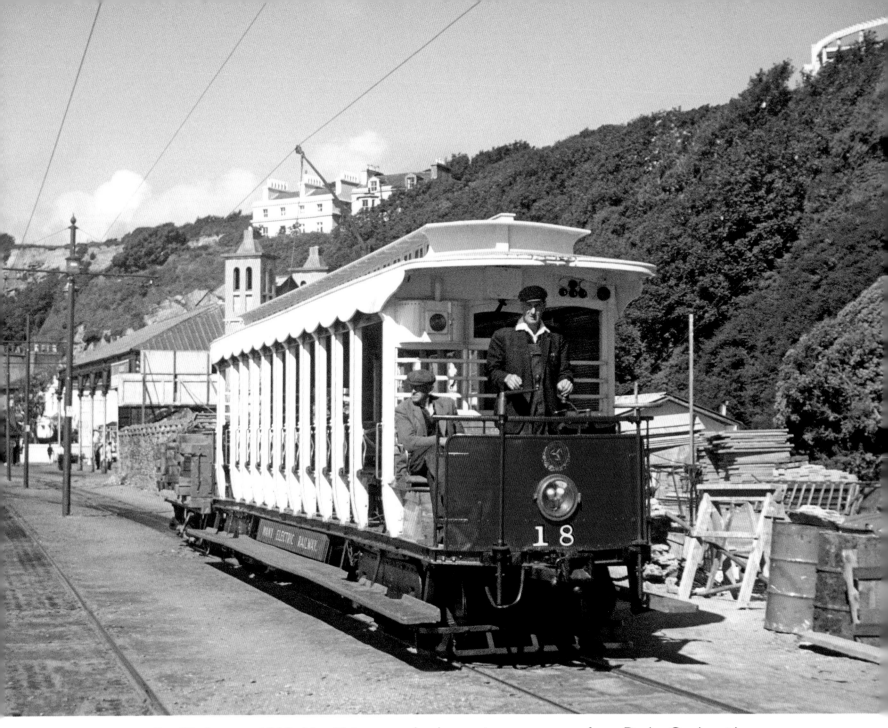

On 23 August 1969, No. 18 is on works duty as it powers away from Derby Castle with one of the small four-wheel wagons. Some of this group had white as opposed to red valances. After serving for a time as a works car, 18 returned to front-line service in 1977. Then, following a period in store, it saw limited use between 1993 and 2000. However, it was officially withdrawn in 2002 following a management decision to stop maintaining handbrake only cars on economic grounds. (*Richard Lomas/Online Transport Archive*)

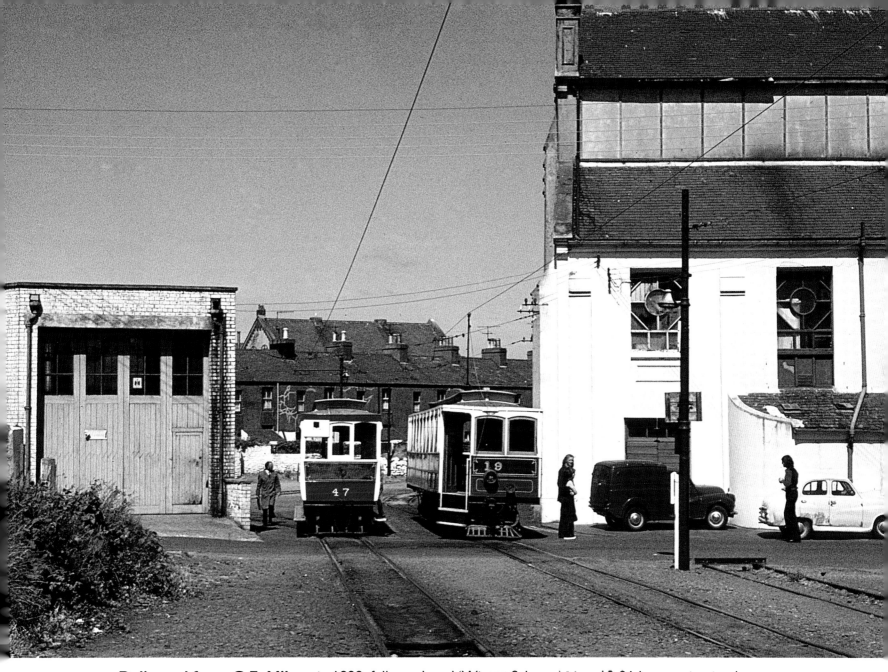

Delivered from G.F. Milnes in 1899, fully enclosed 'Winter Saloons' Nos. 19-21 have maintained the core service for nearly 120 years. To improve overall performance, their trucks and electrical equipment were exchanged in 1904 with those from newly delivered power cars which had Brill 27Cx trucks, four 25hp motors and air wheel brakes. At the same time, the 48-seat saloon was divided into smoking and non-smoking sections. Further improvements included the provision of seat cushions in 1932, upgraded controllers in 1936, M&T motor compressor sets from Glasgow and Sheffield in the early 1960s and upholstered seats in 1967/8. In this scene, 19 runs round its trailer at Ramsey on 28 June 1975. On the right is the Plaza cinema, since demolished, and the track which served as headshunt for the depot which closed in 2014. (*Michael J. Russell*)

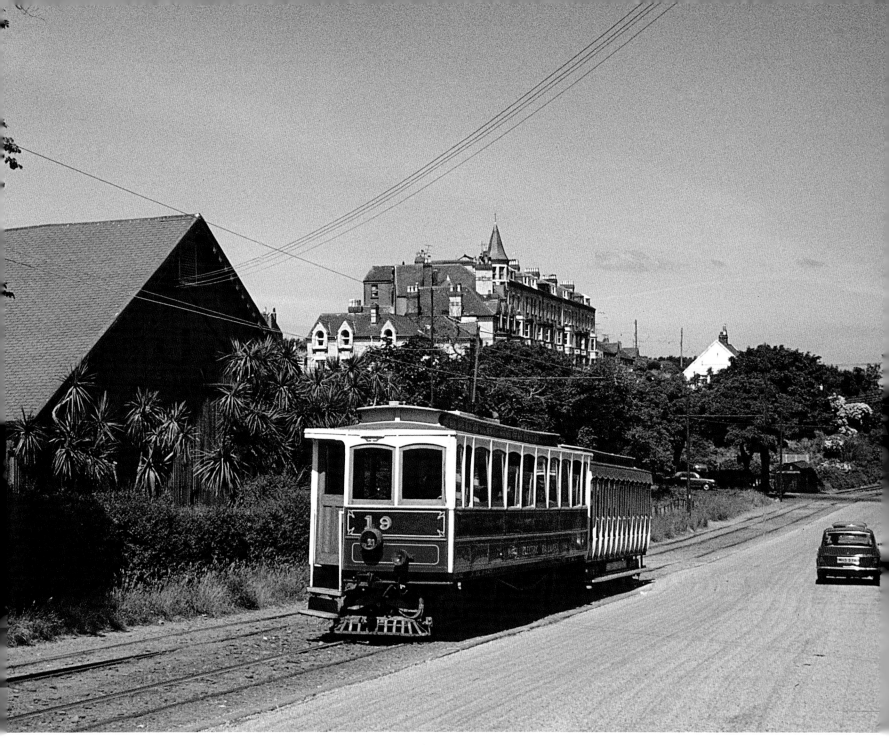

As the MER deficit increased during the 1960s and 1970s, some politicians demanded total closure whilst others called for closure of the northern section. When the latter was approved, enthusiasts flocked to the island. In this scene No. 19 heads south on Walpole Road. With its grooved rail and side bracket arms, this was the nearest the MER came to any type of street running. Now the tracks are within a clearly delineated reservation. (*Michael J. Russell*)

At the time it was believed this was the last ever passenger working on the northern section. Crewed by motorman Alan Radcliffe and conductor Dave Hodges, 19 and 58 pulled away from Ramsey at 4.25pm on 30 September 1975. A few minutes later a stop was made at Belle Vue where these schoolgirls alighted. Next day it would be school by bus. However, this was not the end. For a short time a morning and evening staff car was run and, after that was stopped, occasional non-passenger trips were made. Following sustained pressure, the section was reopened on 25 June 1977. (*G.W. Price/Online Transport Archive*)

On 28 June 1975, No. 20 heads a southbound train at Ballajora. Today, this stop still retains its passenger shelter as well as the last of the former lineside pillar boxes which once existed at various stops between Laxey and Ramsey. (*Michael J. Russell*)

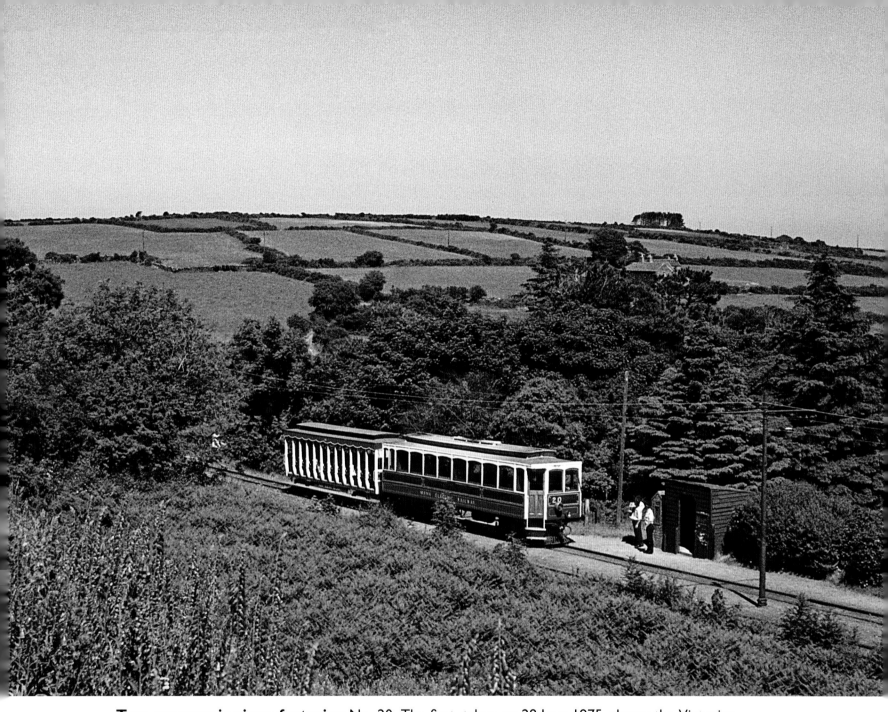

Two panoramic views featuring No. 20. The first, taken on 28 June 1975, shows the Victorian pillar box located on the north side of the rudimentary passenger shelter at Glen Mona. Almost from the beginning, the MER had derived income from carrying the mail with conductors being sworn in as auxiliary postmen. As a result, post boxes located along the line were emptied at specific times, the mail being forwarded to Derby Castle. However, by September 1975, only those at Belle Vue, Ballajora and Glen Mona were still being emptied by the conductor on the 11.50am departure from Ramsey. When the line reopened, this service was not resumed. (*Michael J. Russell*)

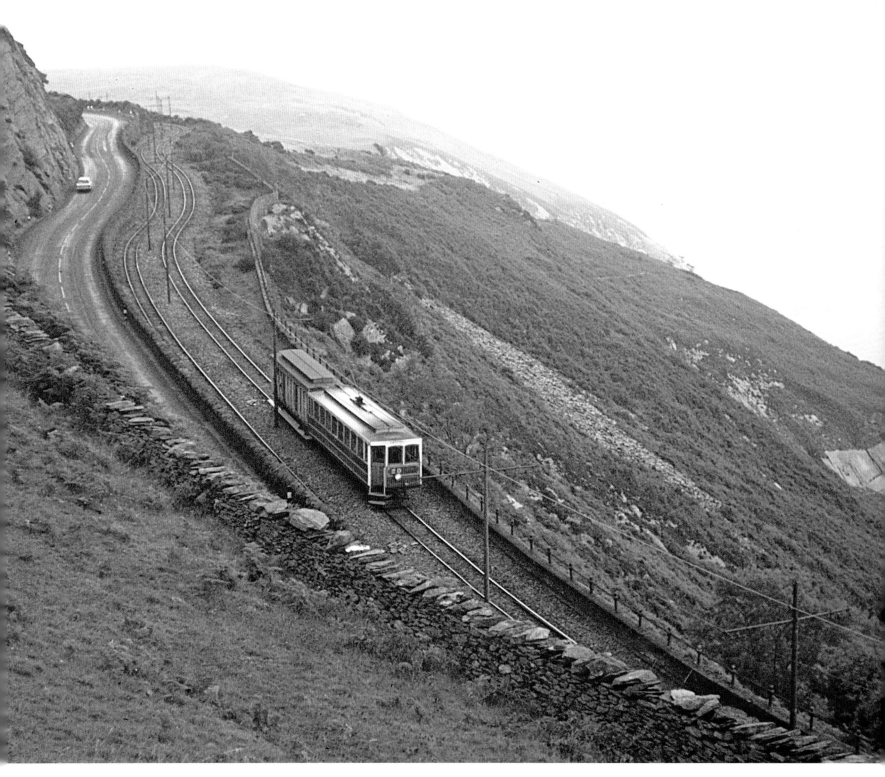

The second scene featuring No. 20, recorded on a misty 25 August 1975, shows the sinuous track formation stretching down from the summit at Ballaragh. (*Michael J. Russell*)

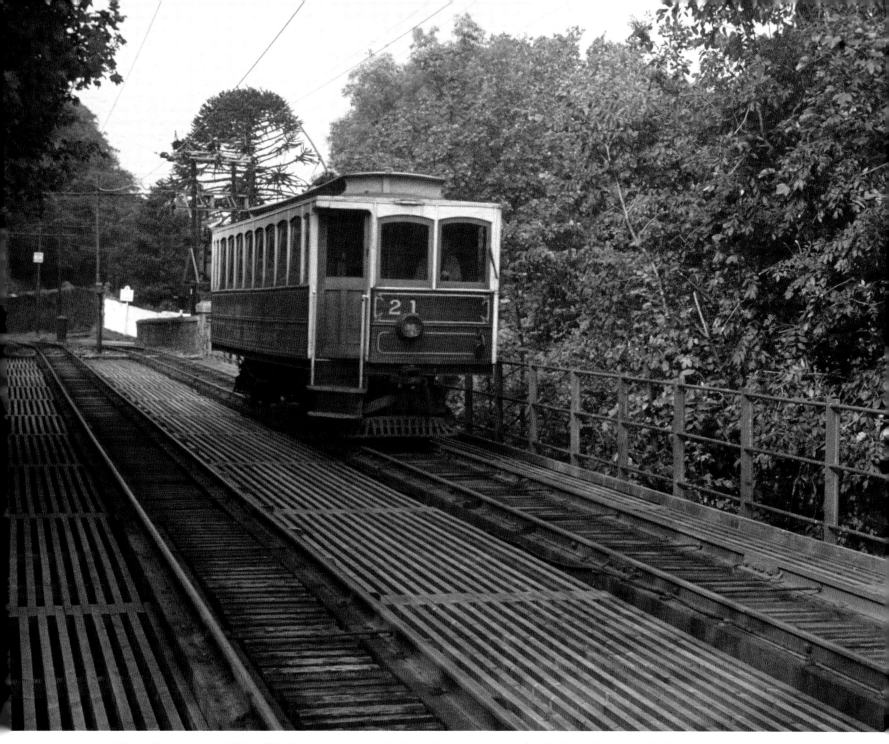

The first view of No. 21 shows it on the high viaduct spanning the Ballure River on 21 September 1963. Dating from 1899, this is one of the few engineering structures on the line and has recently been completely renovated. When the line first opened, the terminus was on the south side of the river where a temporary depot was opened. Later, this was relocated close to the new terminus after the line was extended over the glen. (*Brian Faragher/Online Transport Archive*)

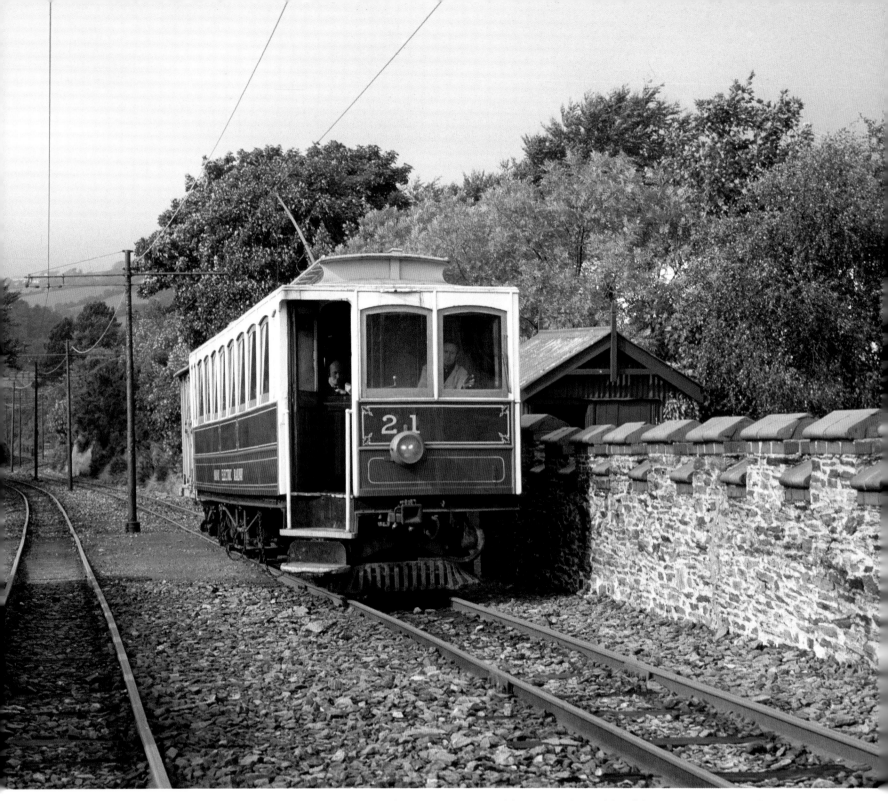

The only other viaduct on the northern section is at Minorca where No. 21 is seen crossing the impressive crenellated structure on 29 September 1975. (*G.W. Price/Online Transport Archive*)

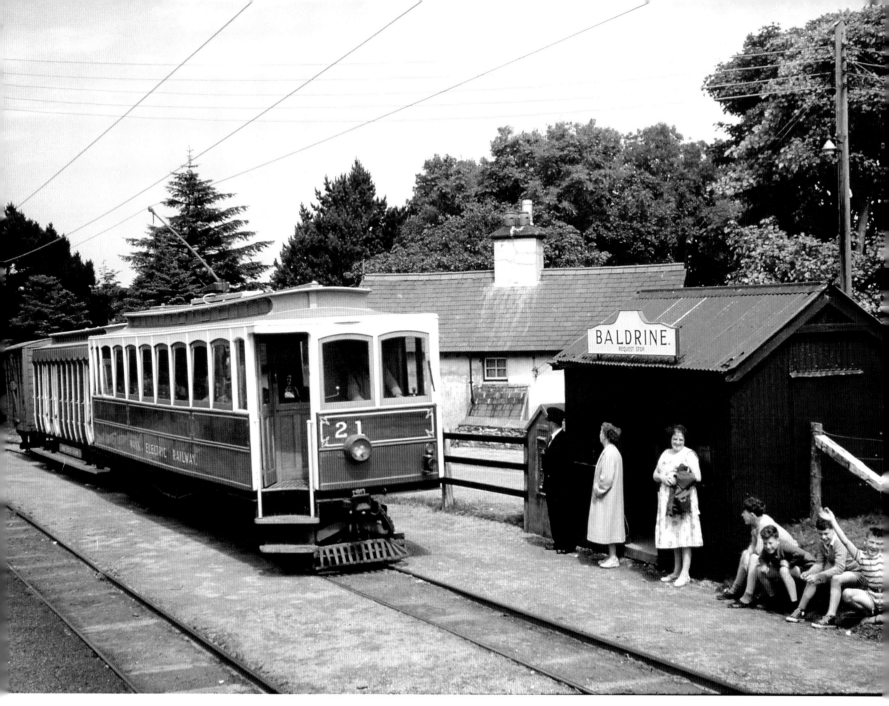

On 20 July 1960, 21 arrives at Baldrine, together with trailer No. 47. In this delightful scene, an inspector waits to board along with two lady passengers whilst a group of boys try to attract the attention of the photographer. One of the lineside pillar boxes can be seen on the north side of the dark green corrugated iron shelter which still survives today. (*Jim Copland, courtesy Malcolm King*)

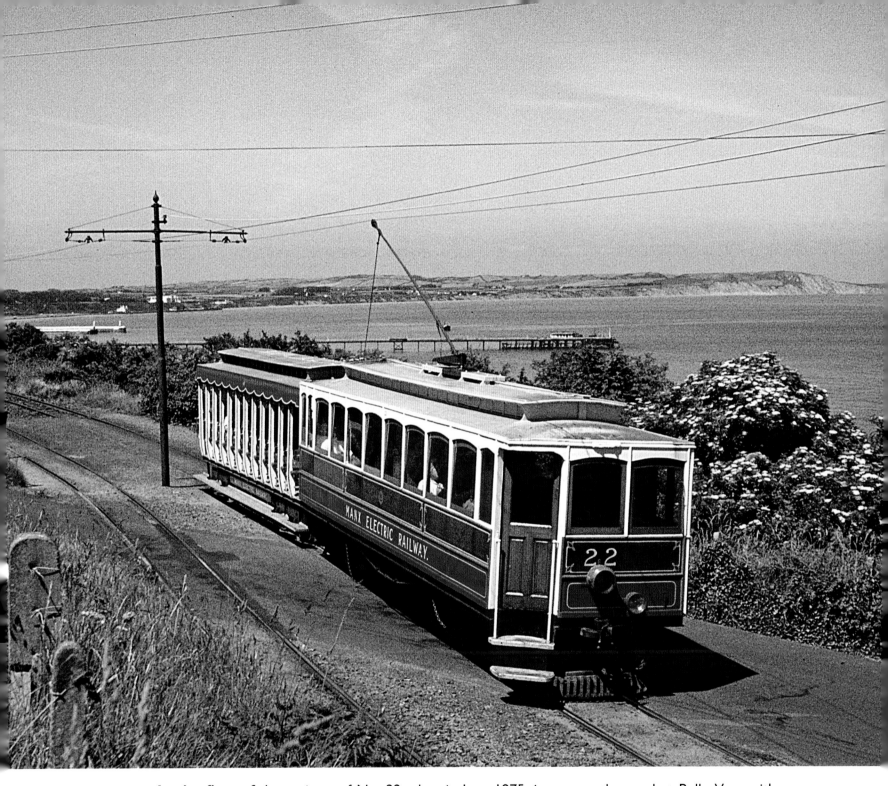

In the first of three views of No. 22 taken in June 1975, it crosses the road at Belle Vue, with Ramsey Bay and pier in the background. In September 1990, this car was gutted by fire but returned to service in May 1992 with a replica body. (*Michael J. Russell*)

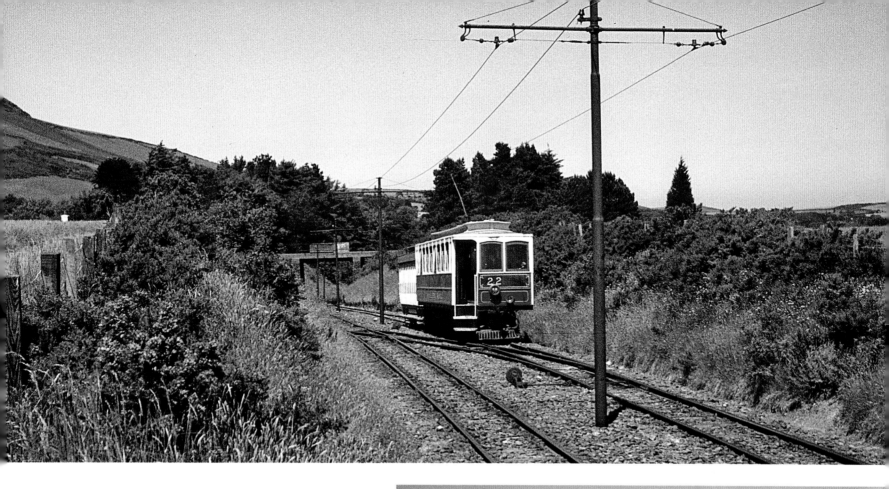

In the next scene, No. 22 ascends the 1:24 gradient through the steep-sided cutting at Ballagorry, just north of Glen Mona, with the only overbridge on the northern section forming the backdrop. The crossover has since been relocated a short distance to the south. In the final view, the car climbs away from Dhoon Quarry on the 1:29 gradient as it heads towards Dhoon Glen. (*Michael J. Russell (both)*)

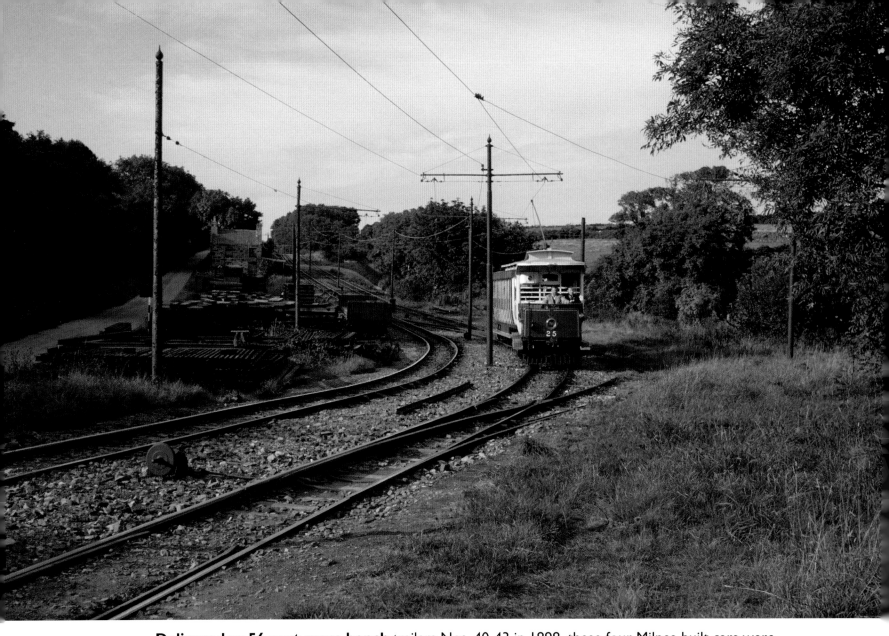

Delivered as 56-seat cross-bench trailers Nos. 40-43 in 1898, these four Milnes-built cars were renumbered 24-27 in 1903 when they were converted into power cars. They had new Brush Type D trucks, four 25hp motors, air-brakes, K11 controllers, later modified to K12, and roller shutters. Like No. 16 they were configured as 'Paddleboxes'. No. 24 was among the vehicles lost in the 1930 Laxey depot fire. Colour views of this class working the northern section are relatively rare. In August 1963, No. 25 heads south through Dhoon Quarry. For many years, the MER used the sidings on both sides of the mainline to store items such as rail and sleepers. Also visible are a couple of wagons and in the distance is Store Cottage (known as 'Creosote Cottage') which was demolished during 1979/80. Having clocked up a century of service, No. 25 was withdrawn in 1998, its trucks and motors subsequently being transferred to a new works vehicle in 2003. (*E.J. McWatt/Online Transport Archive*)

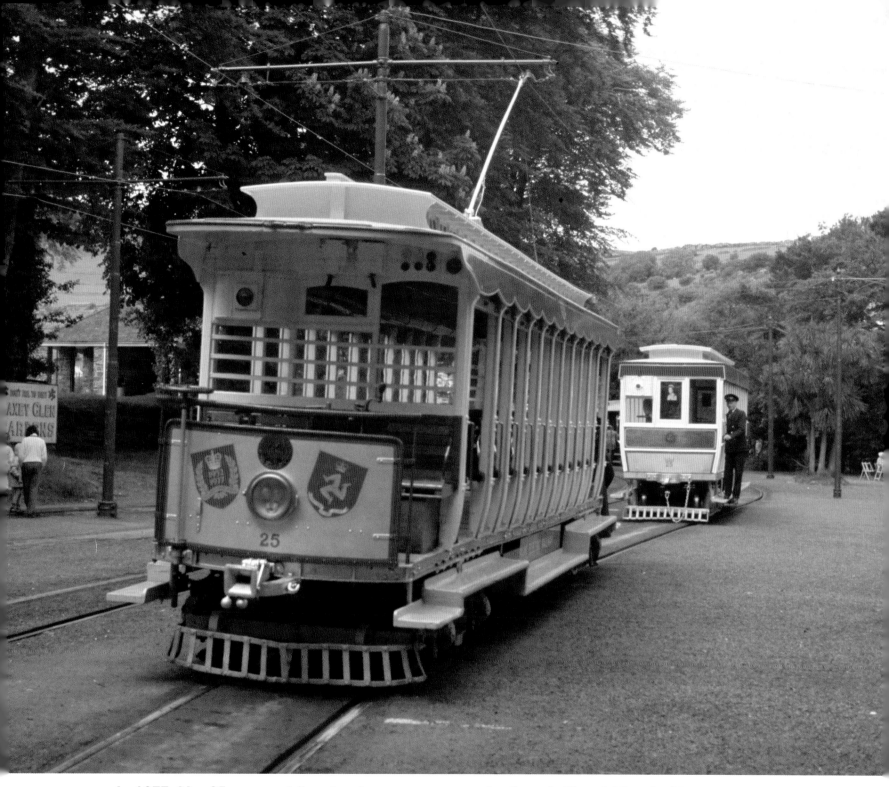

In 1977, No. 25 was specially painted to commemorate the Queen's Silver Jubilee. In this view it rests at Laxey together with trailer No. 55 which had been similarly repainted to create a matching set. (*Derek Bailey/Online Transport Archive*)

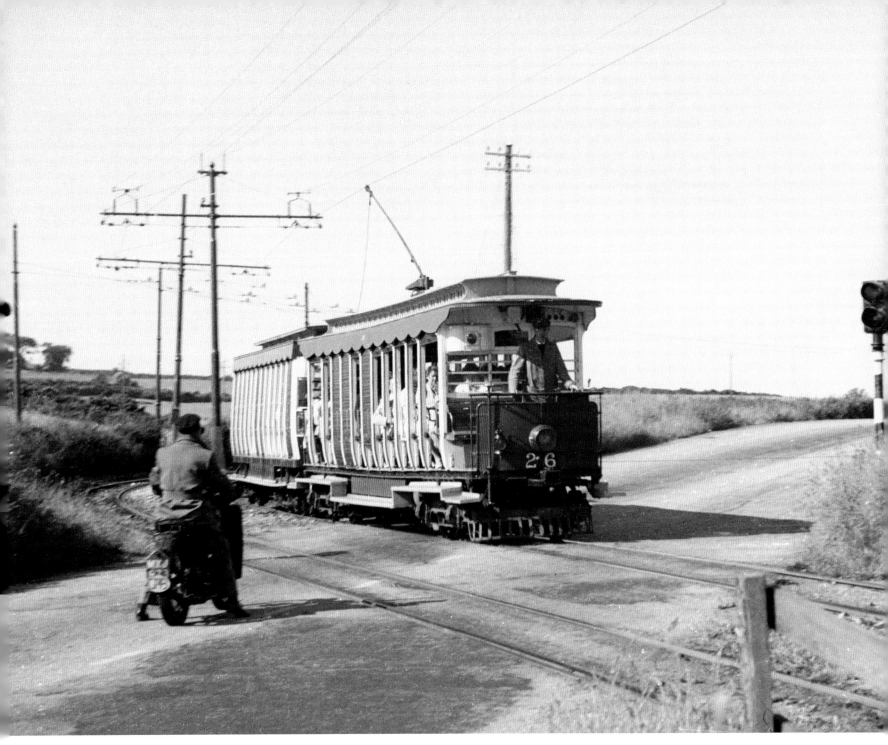

Here, No. 26 snakes over the road crossing at Baldromma in May 1955, a location also known as the Liverpool Arms (after a nearby hostelry) and Halfway (being the midway MER point between Douglas and Laxey). The unusual traffic lights later had yellow boards placed behind them to improve visibility. Today, this crossing is controlled by modern flashing signals. No. 26 has been in long term storage since 2009. (*W.G.S. Hyde/Online Transport Archive*)

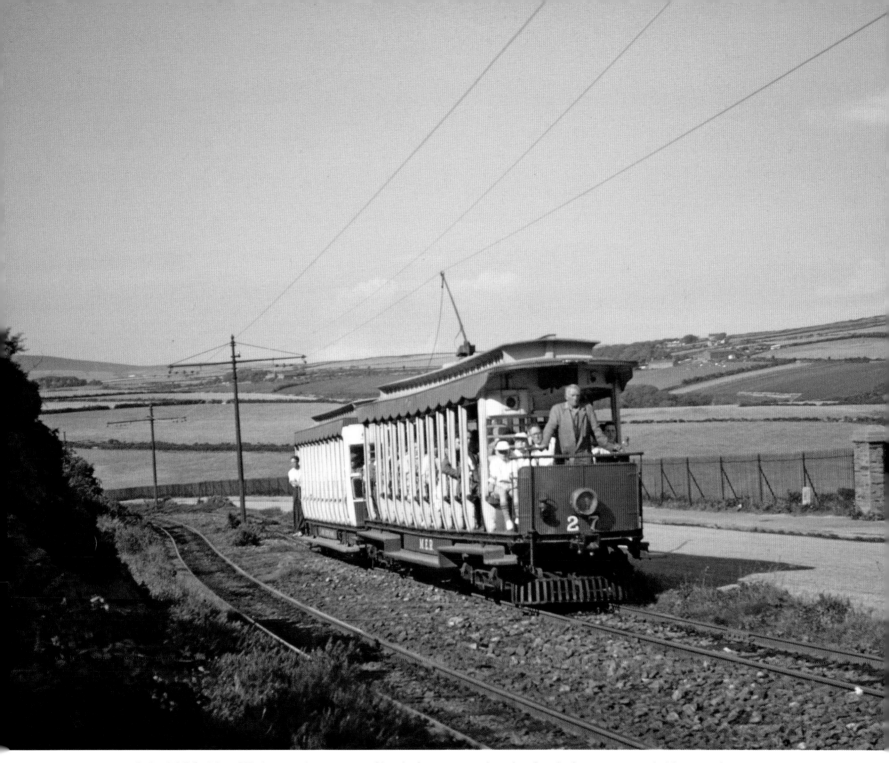

In July 1956, No. 27 shows clear signs of body fatigue as it heads a loaded train towards Howstrake. At this time, 27 had unlined dashes and still carried oil lamps. For a period, No. 27 also sported a white trolley pole and unlined white valances. Later the three cars were given M&T airbrake equipment acquired from Sheffield. (*John McCann/Online Transport Archive*)

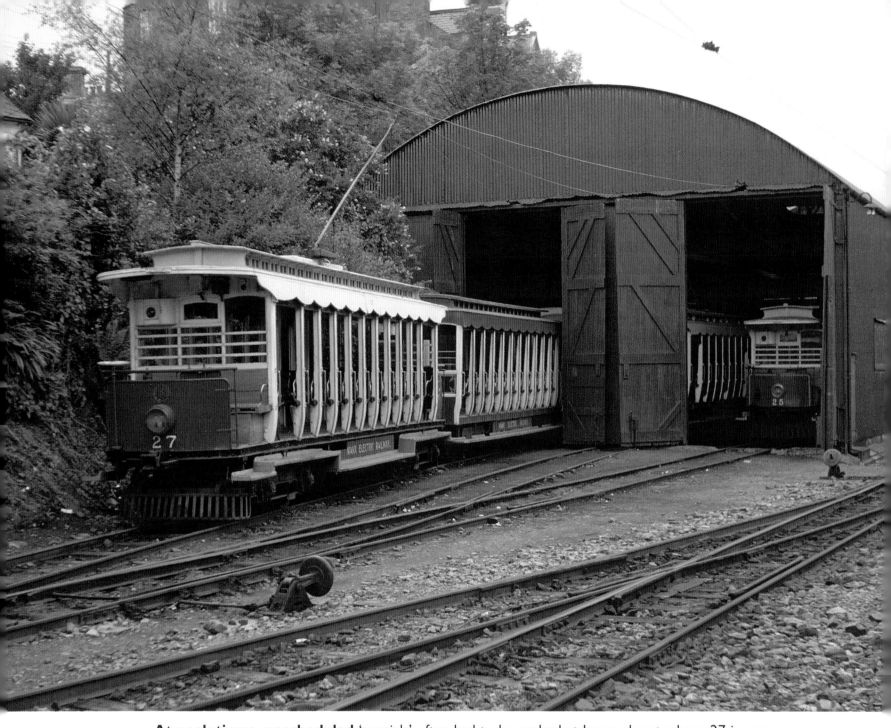

At peak times, unscheduled 'specials' often had to be parked at Laxey depot where 27 is seen in the this view which dates from August 1963. When the original depot was gutted by fire in April 1930, four power cars, seven trailers, three tower wagons and a mail van were destroyed. The replacement building served as a storage and running shed until it was replaced by a new facility in 2008. One of the present occupants is No. 27 which was withdrawn in 2003. (*E.J. McWatt/Online Transport Archive*)

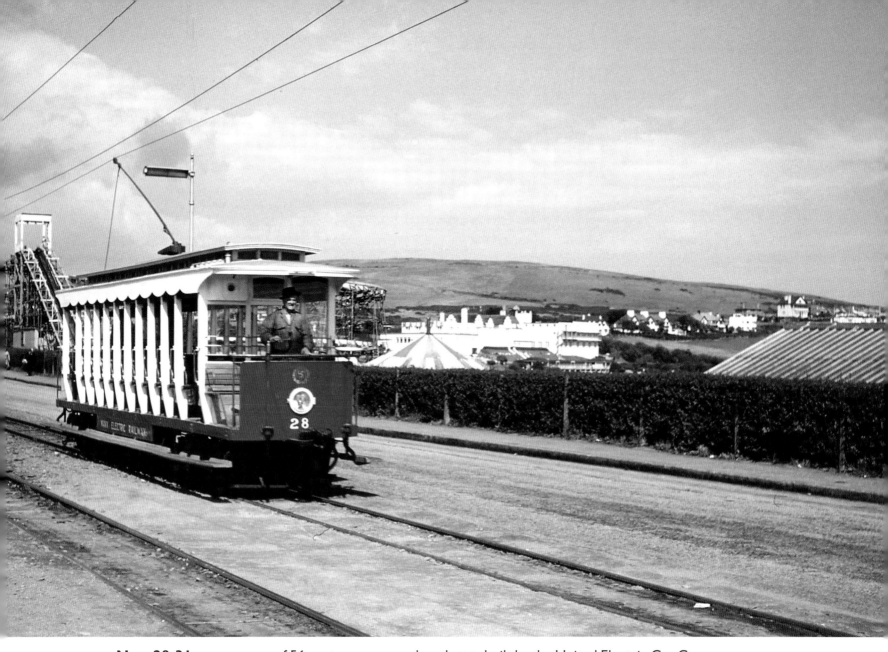

Nos. 28-31 are a group of 56-seat, open cross-bench cars built by the United Electric Car Company of Preston. Shortly after their delivery in 1904, their Brill 27Cx trucks, air brake equipment and more powerful four 25hp motors were exchanged with the plate frame trucks and 20hp motors then fitted to the 'Winter Saloons'. All four cars retained their original K11 controllers until 1954 when those on No. 28 were modified to K12. Owing to their slower motors and reliance on the handbrake, they were mainly employed as seasonal 'extras' mostly on the southern section. In this view taken on 20 July 1960, 28 coasts past the White City entertainment complex on its way back to Derby Castle from where it would work another 'special' to Onchan Head, Howstrake Holiday Camp or Groudle Glen. At the height of the season, the headway on this section was often down to every four minutes even into the 1970s. (*Jim Copland, courtesy Malcolm King*)

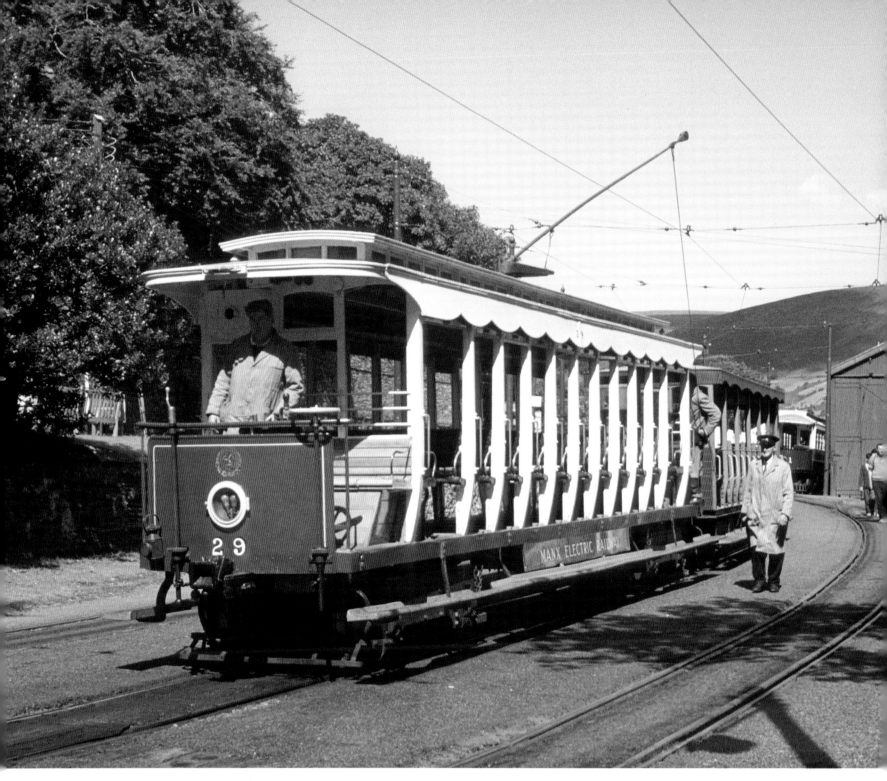

Some time after carrying the short-lived green and white livery, No. 29 was photographed at Laxey in the more aesthetically pleasing MER colours on 15 August 1966. No. 28 has been in store since 1967 and 29 since 1979. (*Brian Faragher/Online Transport Archive*)

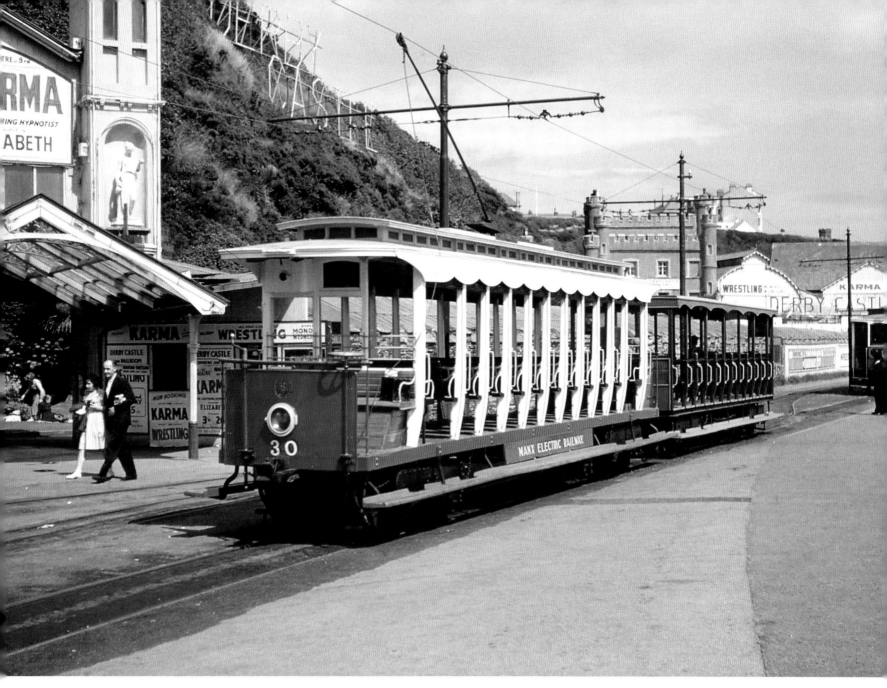

In this view, the motorman has turned the trolley on No. 30 so it can run up to the depot, possibly for a crew lunch break. Note the Isle of Man crest which, for a time, was carried above the headlight on this group of cars. The prime attractions at the Palace and Derby Castle entertainment complex on 20 July 1960 were wrestling and hypnotism. Opened in 1877, this complex featured a ballroom, theatre and gardens. After it was demolished in the mid-1960s, it was replaced by Summerland, a giant sports and entertainment centre which opened in phases between 1969 and 1971. Tragedy struck in August 1973 when many died as most of the complex was destroyed by fire. No. 30 has been in store since the end of the 1970 season. (*Jim Copland, courtesy Malcolm King*)

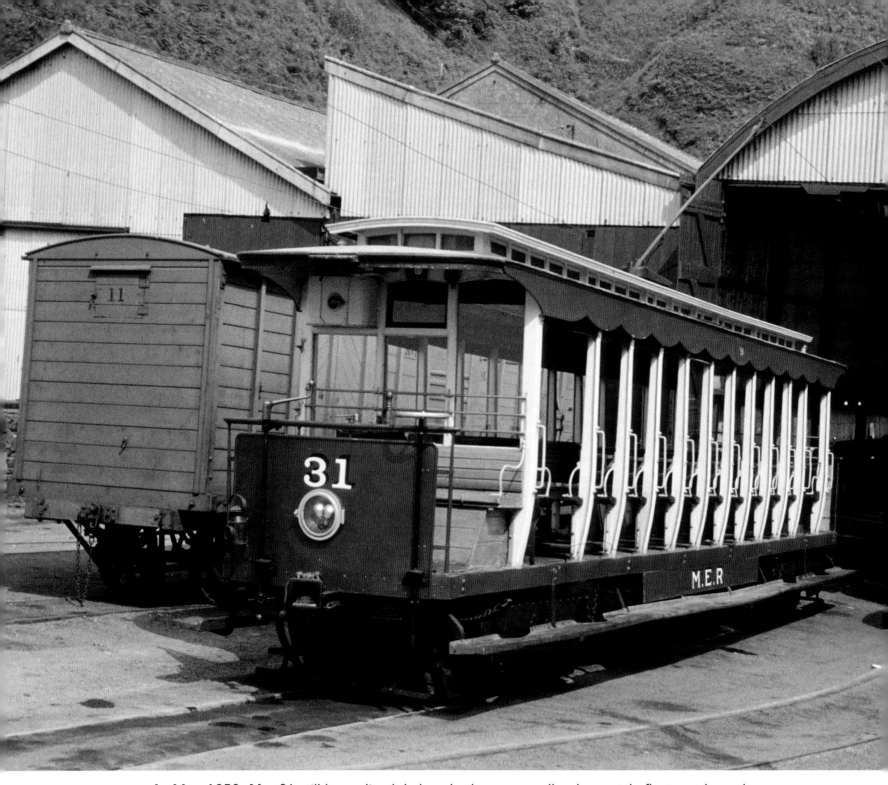

In May 1959, No. 31 still has unlined dash and valances as well as large style fleet numbers above the headlamp. It is outside the original 1893 No. 1 Car Shed at Derby Castle. Alongside is Van No. 11 of 1899. No. 31 last operated in 2002. (*Marcus Eavis/Online Transport Archive*)

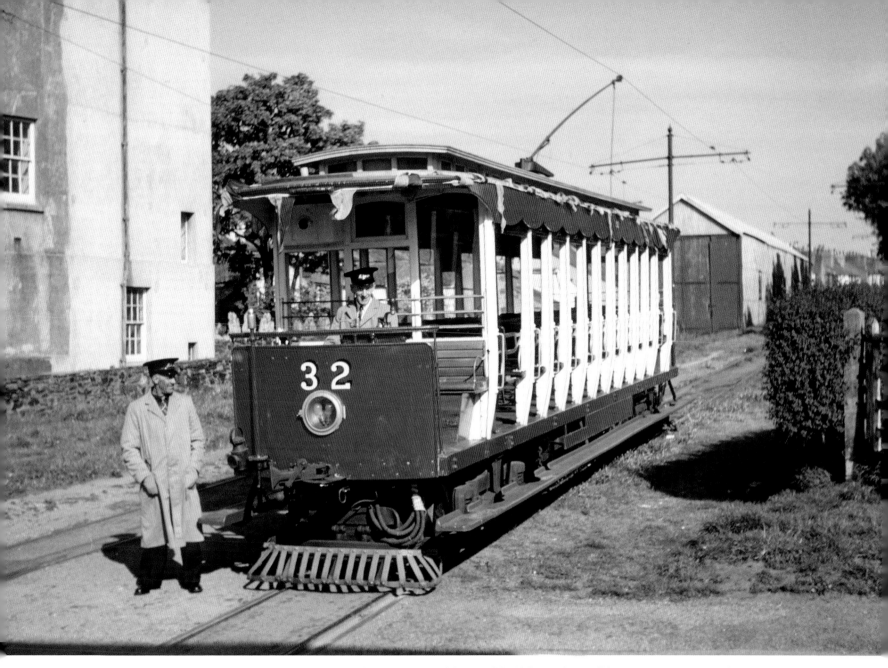

The last new trams to be purchased were Nos. 32 and 33. When these 56-seater cross-bench motor cars were delivered from the United Electric Car Co. of Preston in 1906 they had Brill 27Cx trucks, air brakes, K11 controllers and four 27hp motors, making them the most powerful trams in the fleet. Over the years, little has changed although their controllers have been upgraded and their air brake equipment was replaced in the early 1960s by M&T items acquired from Sheffield. During Whitsun 1955, No. 32 was hired by the LRTL, which was then campaigning against total closure of the MER. Bedecked with flags, it is seen at Ramsey, a town known to MER crews as 'Chip City' owing to the number of nearby fish and chip shops. In the background is Ramsey depot. (*M.J. Lea/LRTA (London Area)/Online Transport Archive*)

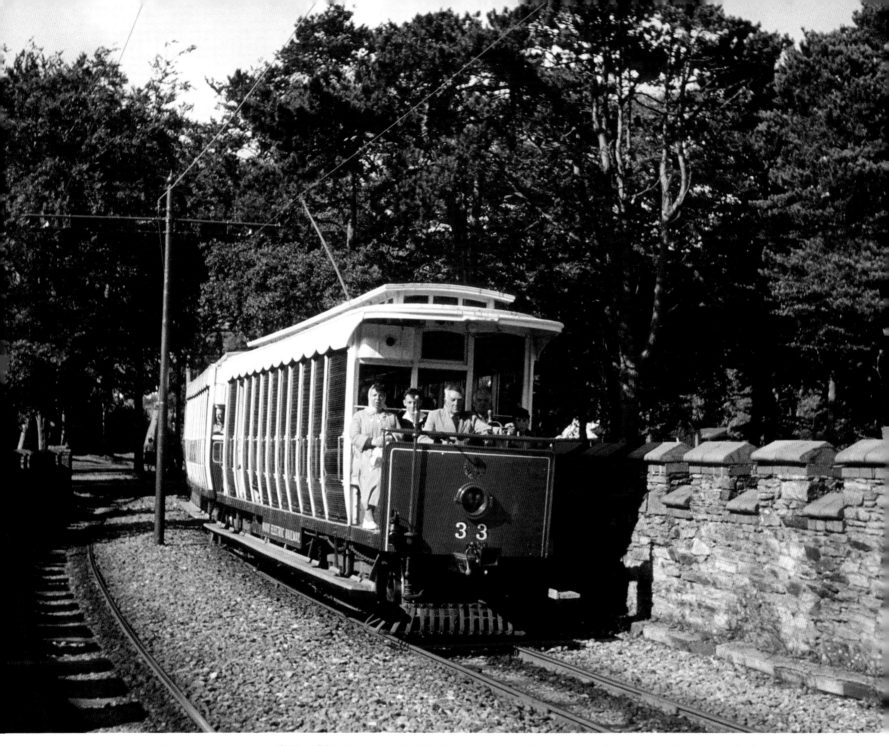

The motorman of No. 33 observes the 5mph speed restriction over the four-arch, stone viaduct spanning Glen Roy ravine at Laxey in May 1963. Note the livery variation with the car illustrated on the previous page. No. 33 has a lined dash, white valances, company crest and title and with its fleet number located below instead of above the headlamp. No. 32 is in the somewhat spartan post-war livery. (*Phil Tatt/Online Transport Archive*)

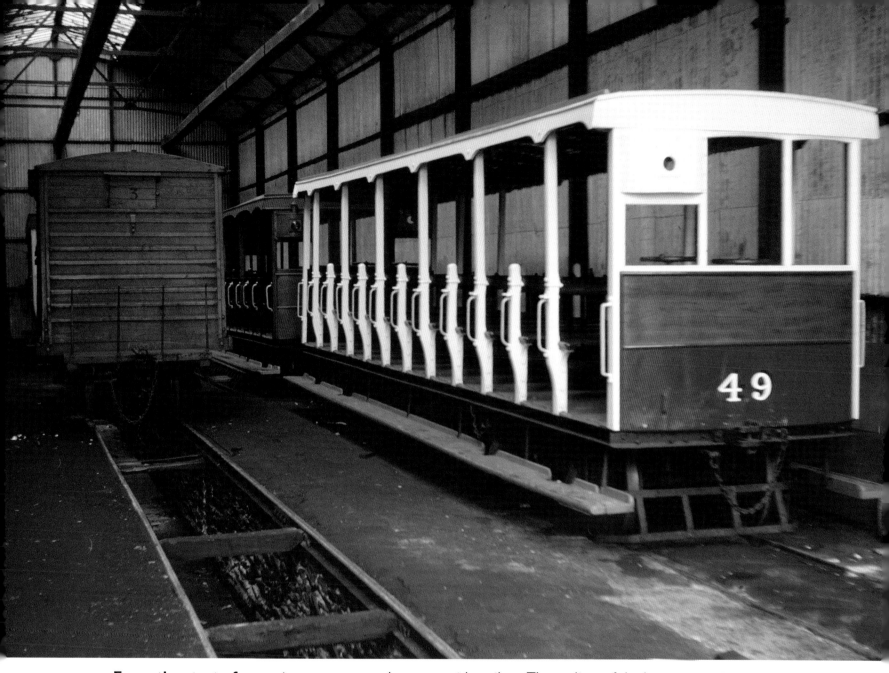

From the start of operations, motor cars have run with trailers. The earliest of the latter were six open cross-bench vehicles mounted on plate frame trucks delivered by G.F. Milnes in 1893. These and nearly all subsequent trailers have flip-over seats for 44 passengers. The flimsy canvas roofs fitted after the first season were replaced by more substantial wooden ones in 1903. Now known as 'umbrella' cars, these lightweight trailers were given glazed, slatted wood bulkheads. Eventually numbered 49-54 in 1904, they were only used during the season mostly behind the lower-powered handbrake cars. In this scene, recently painted No. 49 is at Derby Castle in August 1963. It has been stored since 2008. Also on view is wagon No. 3 and one of the super lightweight trailers of 1894. (*Derek Norman/Online Transport Archive*)

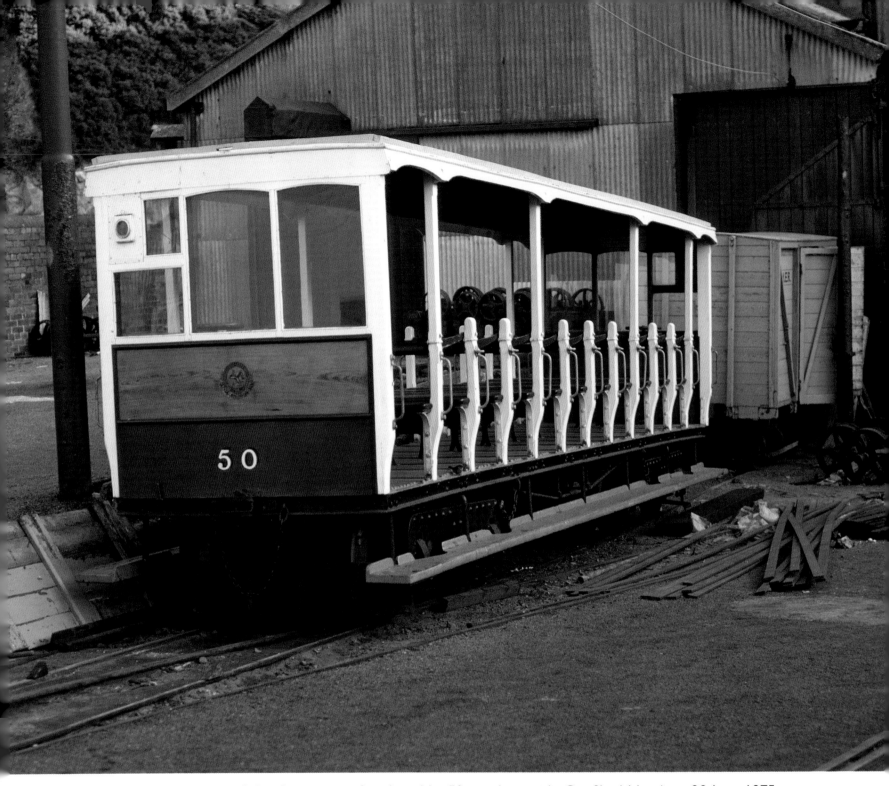

Also part of the first group of trailers, No. 50 stands outside Car Shed No. 6 on 28 June 1975. Unlike 49 on the previous page, it has just four roof support pillars. It has been in store since 1978. (*R.L. Wilson/Online Transport Archive*)

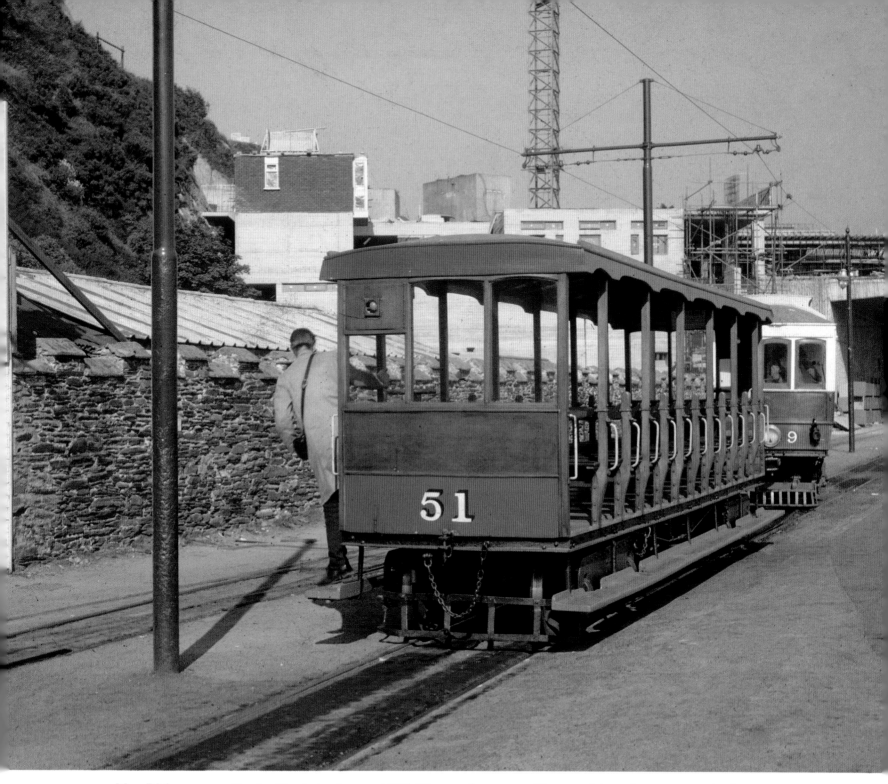

No. 51 is seen at Derby Castle in August 1970. The roof support pillars on this trailer are varnished brown unlike those on 49, which were white. When 51 was restored in 1987, it was given its original number 13. (*Courtesy Travel Lens Photographic*)

In these views, Nos. 53 and 54 are at Derby Castle. They last operated during the summers of 1978 and 1973 respectively. (*W. Ryan; G.W. Price/Online Transport Archive*)

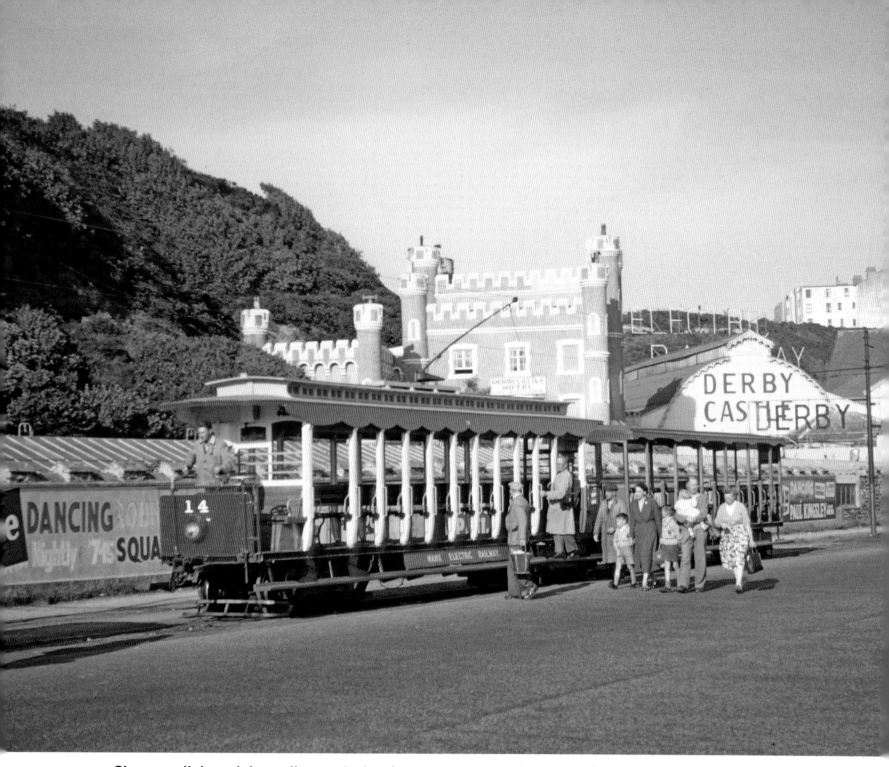

Six super lightweight trailers with plate frame trucks, six roof support pillars and end bulkheads arrived from G.F. Milnes in 1894. Originally numbered 17-22 they became 34-39 in 1898, with only 36 and 37 surviving the Laxey depot fire. In this July 1956 view, No. 36 has just arrived at Derby Castle. (*John McCann/Online Transport Archive*)

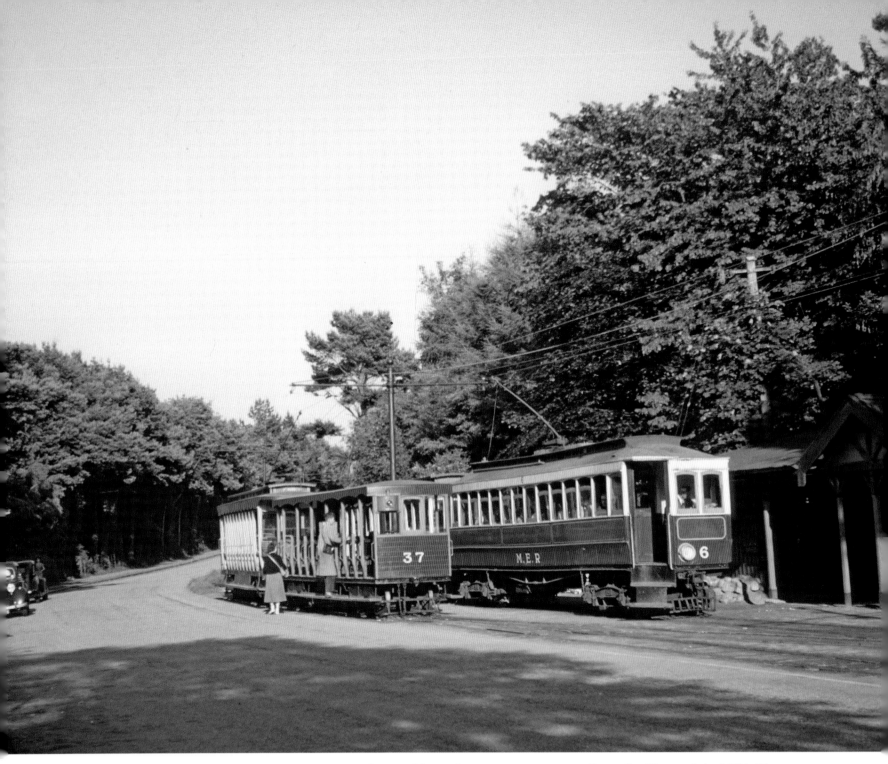

No. 37 is attached to the rear of a southbound train as it pauses at Groudle Glen in July 1956. To regulate the volume of traffic on this section, an inspector operated from a small office in the station building from where he was in phone contact with Douglas and Laxey. No. 36 was withdrawn in 1973 and No. 37 in 2009. (*John McCann/Online Transport Archive*)

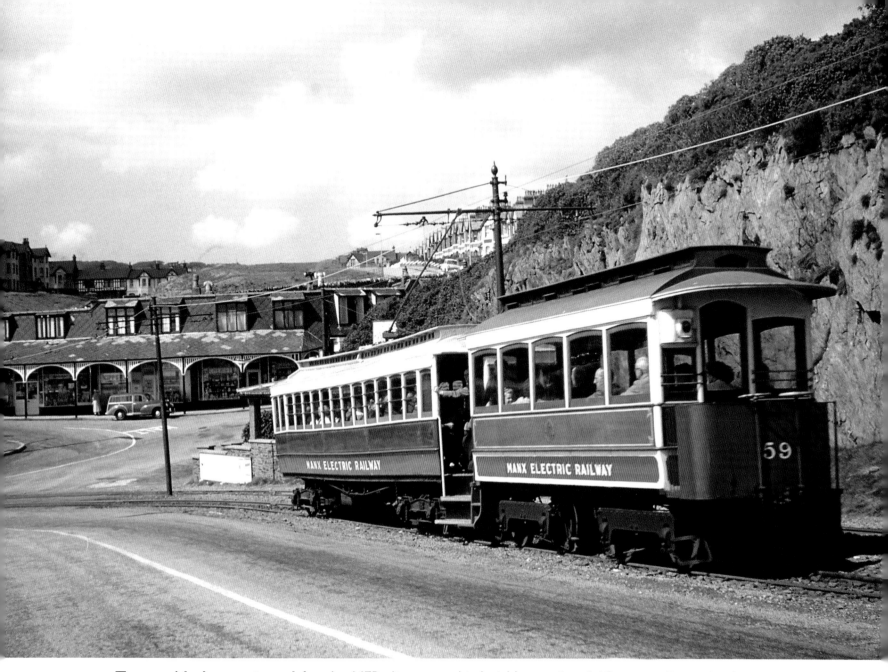

To provide luxury travel for the MER directors, this lavishly appointed 18-seat trailer arrived from Milnes in 1895. Riding quality was improved when the four-wheel trunnion gear was replaced by a pair of spare plate frame bogies in 1900. No.59 is variously known as the 'Doll's House', the 'Royal Saloon' or 'Royal' tram after transporting King Edward VII to the outskirts of Ramsey in 1902. Subsequently, it saw little use until modifications were made in 1945, after which it was available for private hires or special duties. Regular passengers must have revelled in its ornate fittings and red upholstery as the trailer descended the steep grade at Port Jack behind No. 9 on 20 July 1960. They may also have noticed it was in an early version of the MER livery with a white edge round the red rocker panel. It is part of today's fleet. (*Jim Copland, courtesy Malcolm King*)

Another one-off trailer arrived from Milnes in 1896. Delivered with glazed bulkheads and fixed roof, it did not become No. 60 until 1906. Although damaged in the Laxey depot fire, it was rebuilt at Derby Castle. On 29 May 1979, it is seen alongside one of the cars acquired from Aachen in 1976 to provide electrical equipment for the elderly Snaefell fleet in 1976. This was the only one to come to the island, the rest being stripped by London Transport who were undertaking the work. No. 60 is still active today, whilst 1010 survived as a store until 1985. (*Nicholas Britton*)

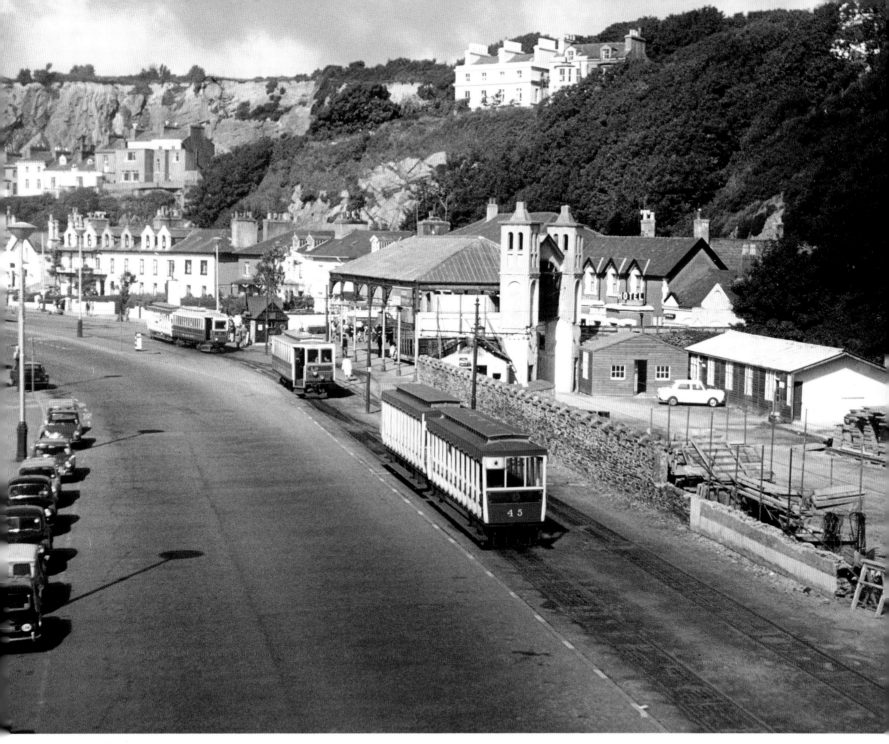

When delivered in 1899, Milnes trailers Nos. 44-48 were heavier than their predecessors. Overall weight was further increased when roller shutters were provided in 1903. No. 44 was another victim of the Laxey depot fire. On 23 August 1969, 45 was photographed from the pedestrian footbridge accessing the ill-fated Summerland. In 2004, this car was reduced to a flatbed for use by the permanent way department. (*Richard Lomas/Online Transport Archive*)

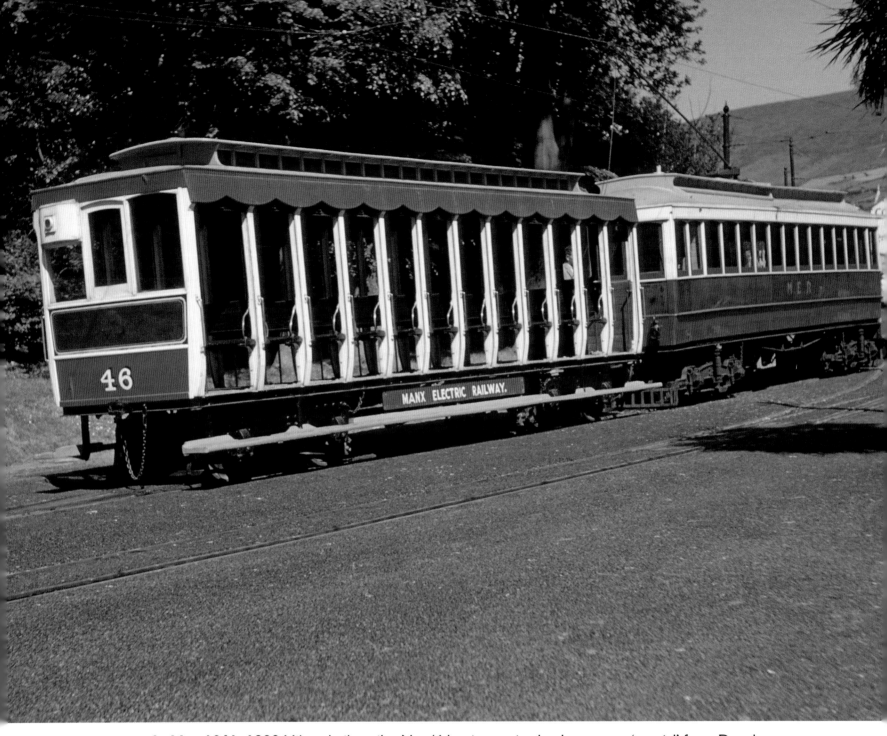

In May 1961, 1899 Milnes-built trailer No. 46 has just arrived at Laxey on a 'special' from Douglas.
(*W.J. Wyse/LRTA (London Area)/Online Transport Archive*)

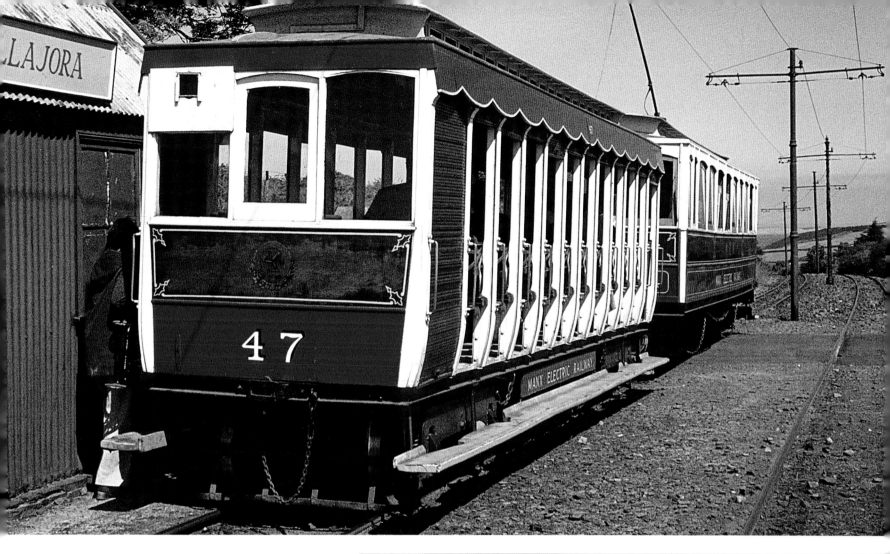

In the first scene, No. 47 prepares to leave Ballajora on 28 June 1975 whilst, in the second, 48 is at the rear of a southbound train as it coasts down the roadside reservation between Howstrake and Groudle. Both are still active. (*Michael J. Russell; Phil Tatt/Online Transport Archive*)

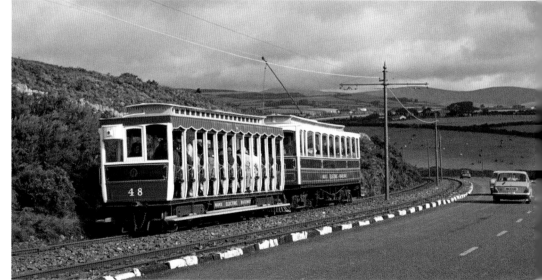

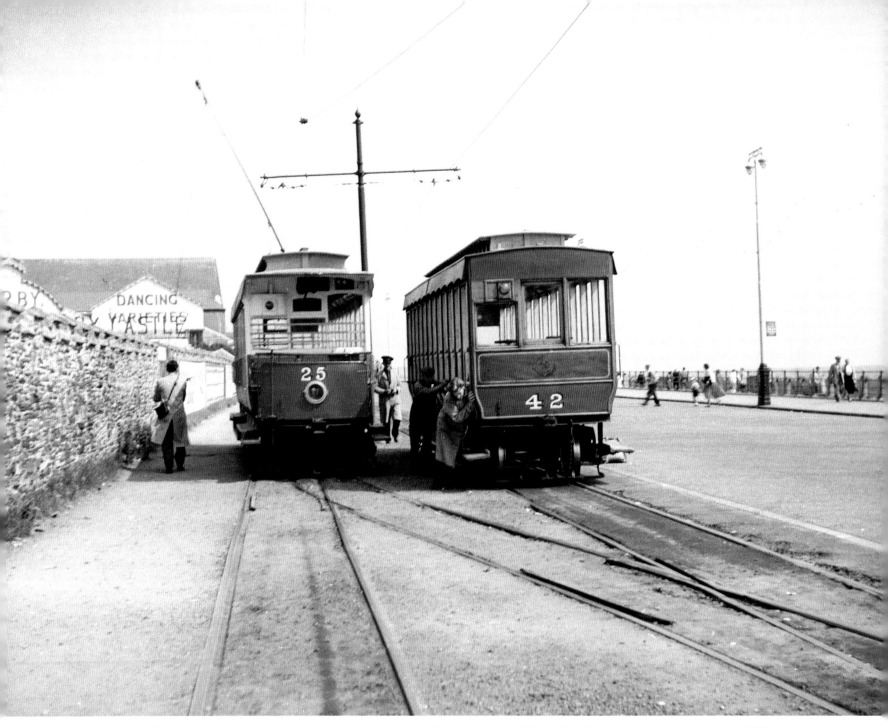

To cater for growing seasonal demand, Milnes trailers Nos. 40-43 entered in service in 1903. Although similar to 44-48, they ride on plate frame trucks formerly under power cars. Nos. 40 and 41 were lost in the Laxey depot fire and replaced by new trailers (see page 162). In this view taken in May 1955, No. 42, wearing the post-war 'varnished' livery, has been uncoupled from 'Paddlebox' No. 25 and is being manually shunted so the pair can be reassembled at Derby Castle. No. 42 has been in store 2007. (*W.G.S. Hyde/Online Transport Archive*)

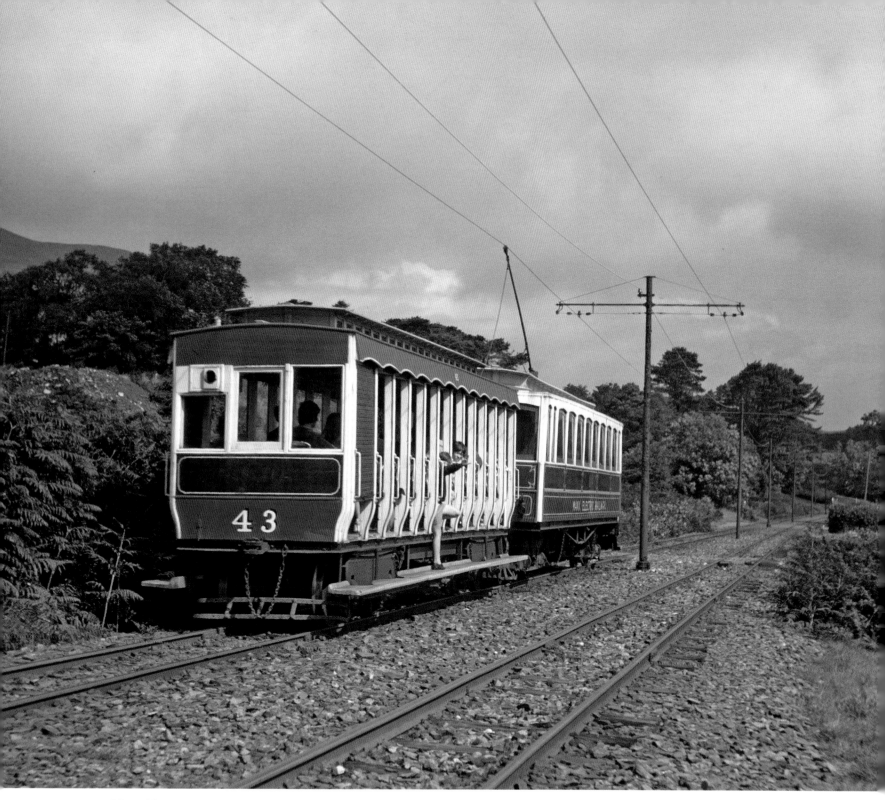

No. 43, seen here approaching Glen Mona on a northbound working in August 1974, remains in regular use today. (*Martin Jenkins/Online Transport Archive*)

Nos. 55 and 56 were built by the Electric Railway & Tramway Carriage Company (ER&TC) of Preston. Mounted on the trailer version of the successful Brill 27Cx bogie, they entered service in 1904. In the first of two Laxey views, No. 55 prepares to head south on a dull day in August 1963, whilst in the second, taken in May 1977, the same car has been beautifully painted and specially renumbered 25 to mark the Queen's Silver Jubilee. Throughout the season, the two '25s' were coupled as an attractive matching pair. In 1978, it was renumbered 55 and has been in store since 1997. (*E.J. McWatt/Online Transport Archive; Derek Bailey/Online Transport Archive*)

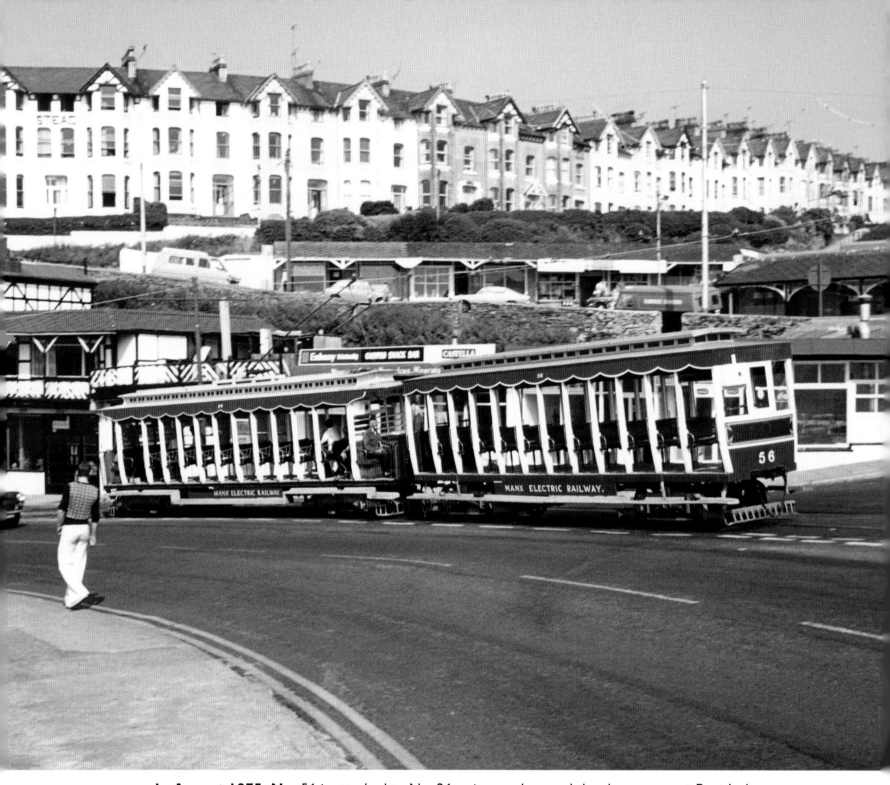

In August 1975, No. 56 is attached to No. 26 as it squeals round the sharp curve at Port Jack on the descent into Douglas. At this time, both vehicles have white-edged valances. In 1995, 56 was completely rebuilt in order to carry disabled passengers. (*Richard Lomas/Online Transport Archive*)

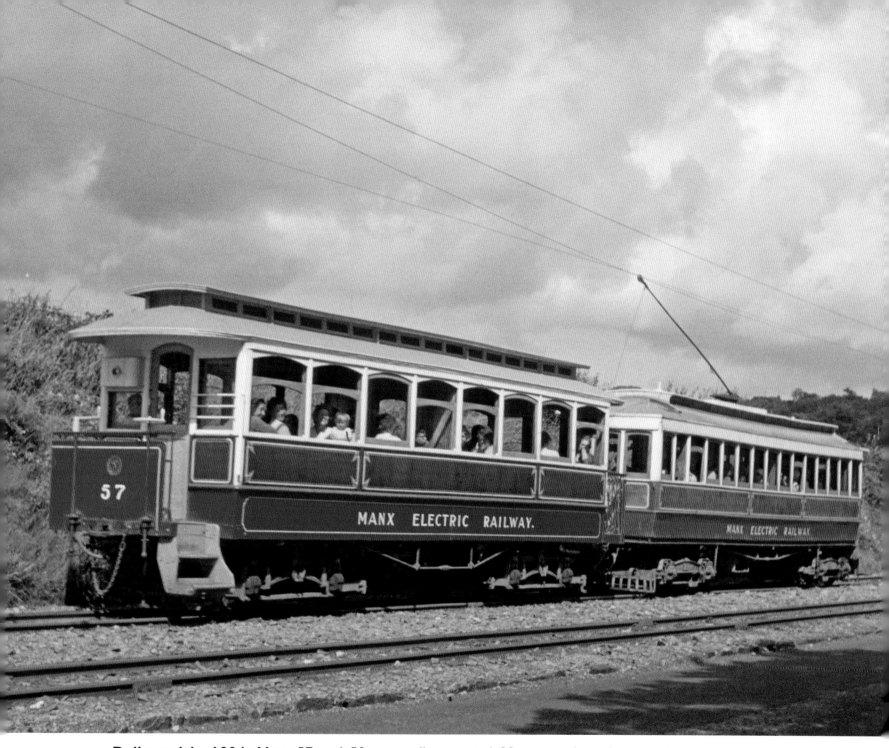

Delivered in 1904, Nos. 57 and 58 are well-appointed 32-seat trailers designed for winter operation. They have unvestibuled ER&TC bodies, Brill 27Cx bogies and air wheel, hand wheel, scotch and emergency brakes. In this fine portrait, No. 57 ascends the shallow incline from Groudle Glen towards Eskadale on a warm summer's day in June 1964. This elegant trailer is still active. (*F.W. Ivey*)

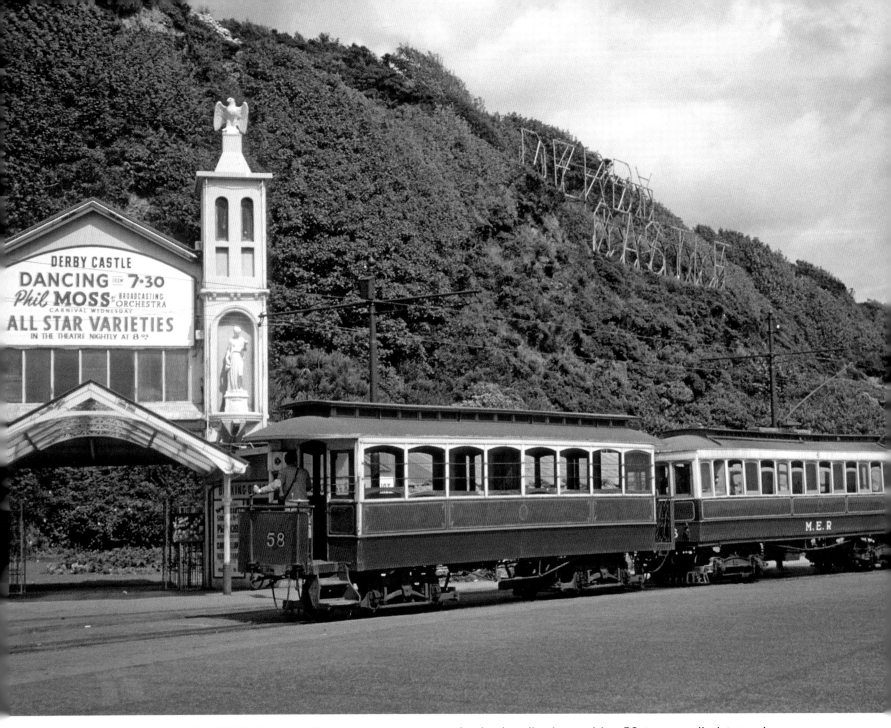

In July 1956, the conductor prepares to apply the handbrake as No. 58 is propelled into the terminal stub at Derby Castle. On the left is the ornate entrance into the former entertainment complex and high up on the rock face the large 'Derby Castle' sign would be illuminated at night. The trailer is in the post-war economy livery with grey roof and clerestory, heavy shaded fleet numerals and no company name on the rocker panel. It still sees use today. (*John McCann/Online Transport Archive*)

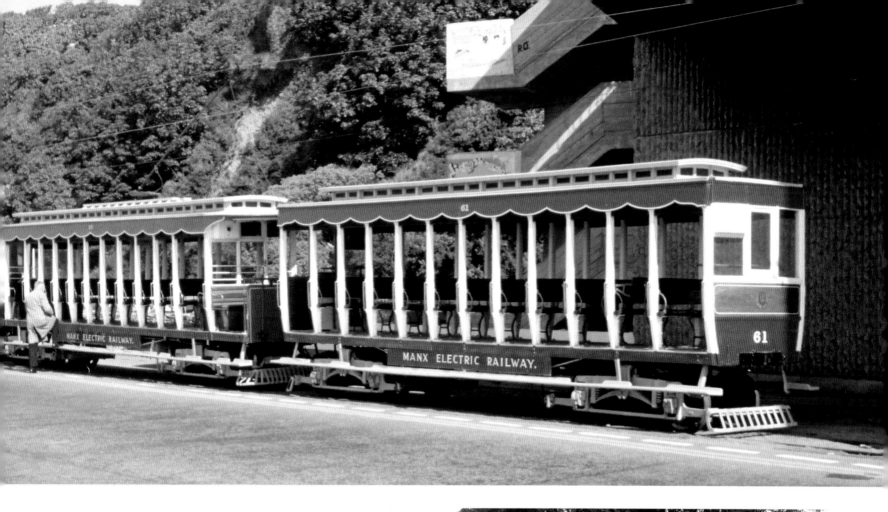

Delivered from the United Electric Car Company (successors to EC&TW), Nos. 61 and 62 are on Brill 27Cx bogies and fitted with hand wheel and scotch brakes although these were later removed. For many years they were usually coupled to power cars Nos. 32 and 33 which formed part of the same order. In the first view, No. 61 is at the rear of a queue of cars waiting to enter Derby Castle. Alongside is the surviving section of Summerland which has since been demolished. In the second scene, No. 62 waits to be coupled up to No. 33 at Laxey on 27 August 1966. Both went into store in 2008 but 62 has since been returned to traffic. (*Nicholas Britton; A. S. Clayton/Online Transport Archive*)

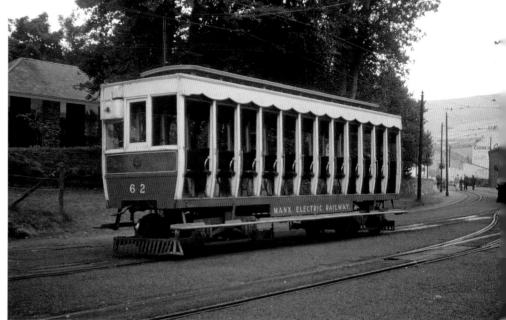

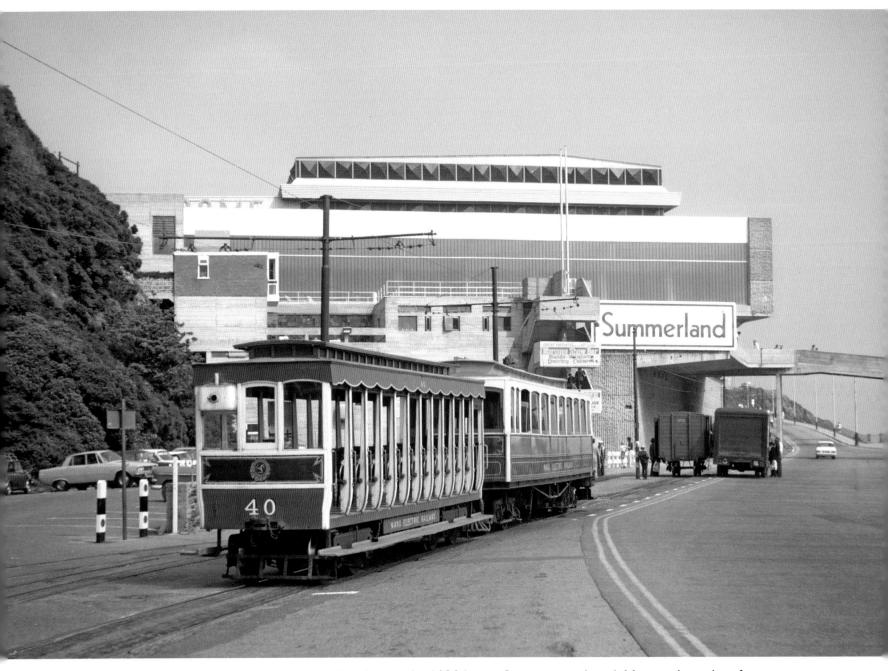

Only three of the seven trailers lost in the 1930 Laxey fire were replaced. Mounted on plate frame trucks, Nos. 40, 41 and 44 have English Electric bodies virtually identical to those supplied in 1904. Despite being heavier overall, they are still active and are regularly coupled to an enclosed power car. Summerland dominates the first scene taken in August 1972. Wagon No. 16 is being unloaded in the background whilst No. 40 waits to enter the terminal stub. In the second view (opposite), No. 41 was photographed during a mid-route crew change in August 1975. This time-honoured tradition enabled staff from Ramsey depot to return to base at the end of their shift or else on the last working of the day, the changeover taking place where ever the cars chanced to meet. (*Brian Patton; Richard Lomas/Online Transport Archive*)

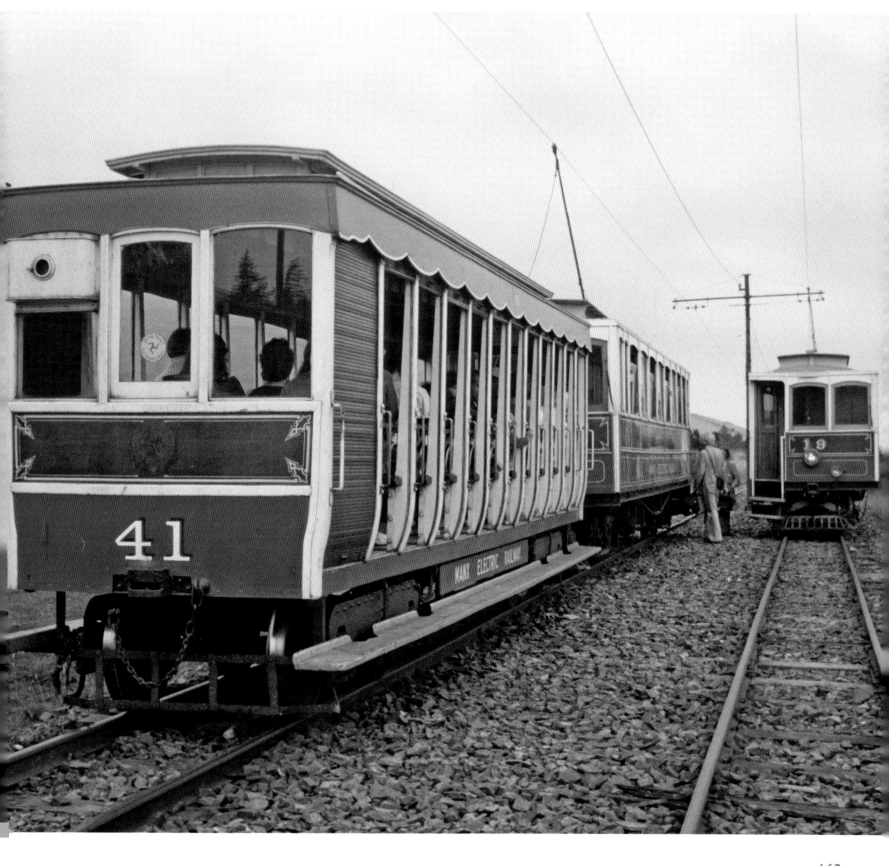

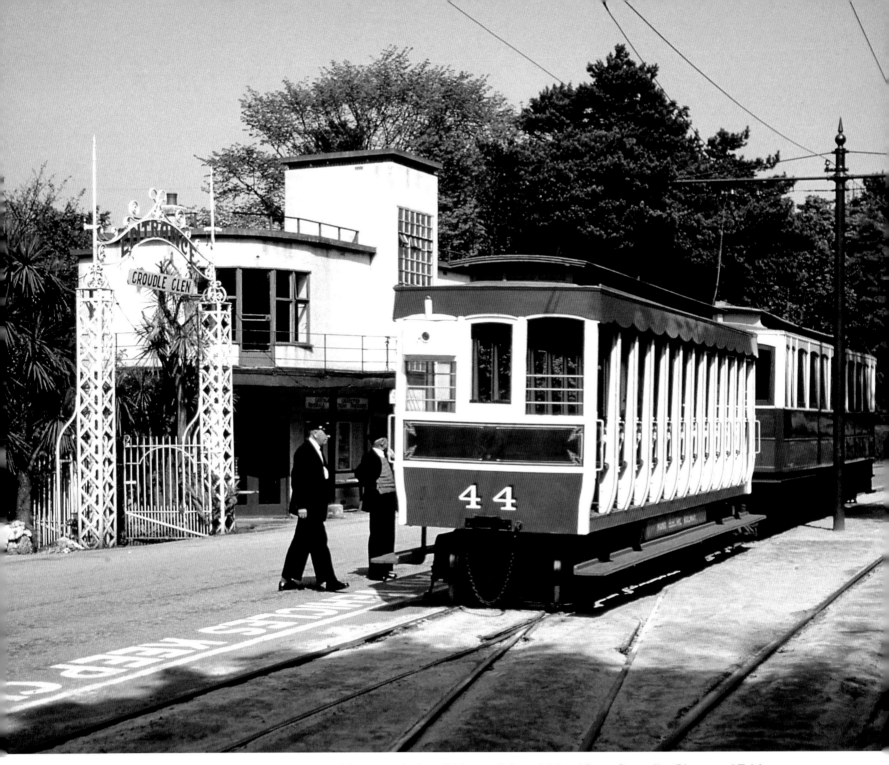

In this period scene, No. 44 is coupled to 'Winter Saloon' No. 19 at Groudle Glen on 17 May 1959. In the background is the ornate entrance to the popular attraction. All the staff are in traditional uniform. This was the 1893 original terminus and for many years 'specials' terminated here, just a ten-minute ride from Douglas. (*Jim Copland, courtesy Malcolm King*)

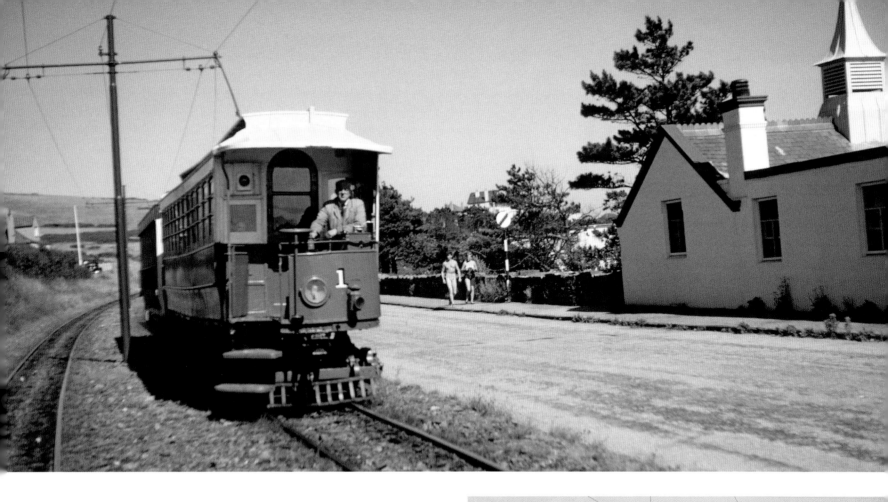

Soon after the ailing MER was nationalised in 1957, power cars 1, 20, 21, 22, 26, 27, 29, 32 and 33 and trailers 50, 61 and 62 appeared in a new green and white livery, also carried by two SMR cars (see pages 193/4). After widespread criticism, they were soon repainted, the last to carry the derided paint scheme being SMR No. 4. The livery does little for No. 1 as it travels along the roadside reservation on King Edward Road, Onchan in July 1959, an area which has since witnessed a significant growth in new housing. Earlier the same year, No. 20 is seen at Ramsey. (*Donald Nevin; Marcus Eavis/Online Transport Archive*)

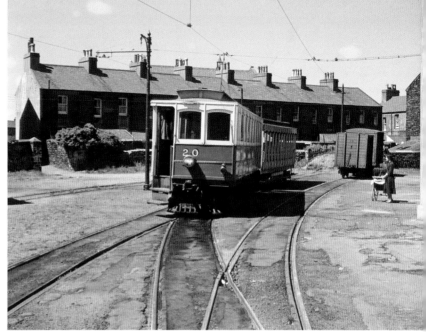

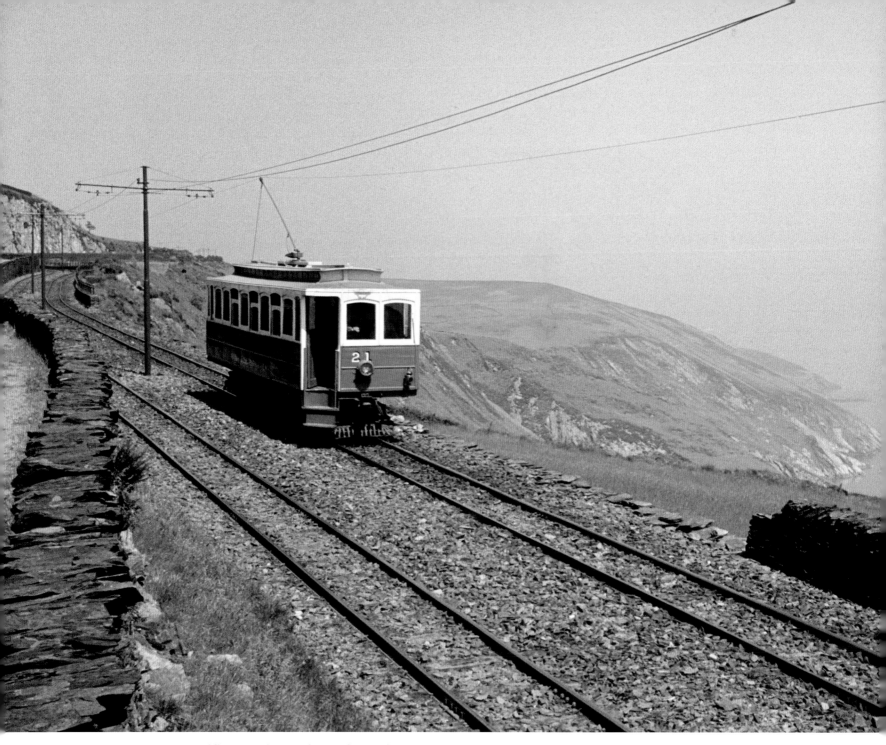

A magnificent view of No. 21 drifting down the cliff-side reservation at Ballaragh in late May 1959. This section, hovering on the edge of a significant drop, is liable to subsidence and rock falls. For example, in early 1967, a major breach led to special services being run from either side of the damage with passengers walking between temporary tram stations. (*Marcus Eavis/Online Transport Archive*)

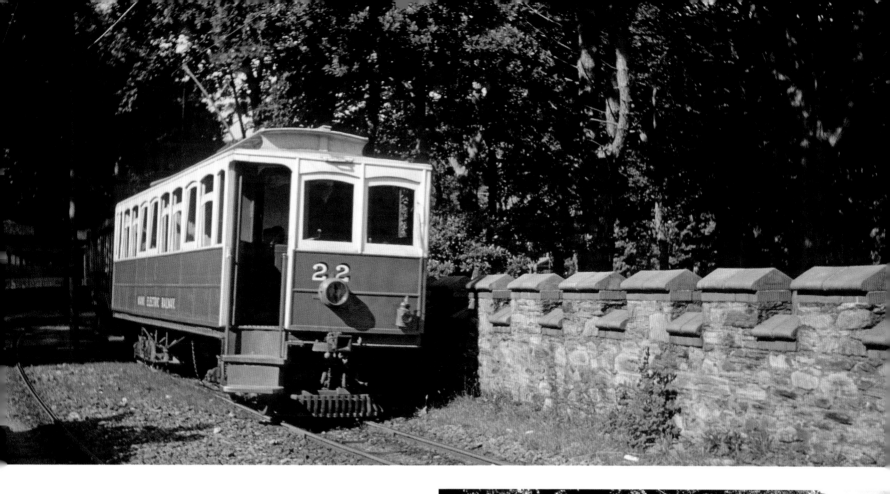

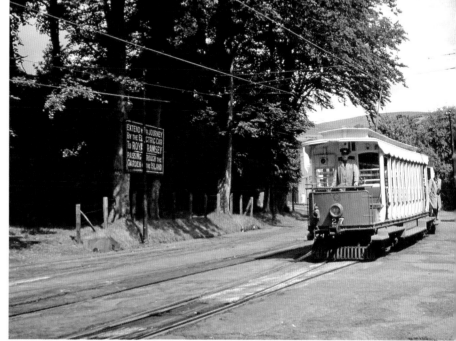

In late May 1959, No. 22 crosses Glen Roy viaduct whilst in the second view Nos. 27 and 41 prepare to leave Laxey with a train for Douglas on 19 July 1960. (*Les Folkard/ Online Transport Archive; Jim Copland, courtesy Malcolm King*)

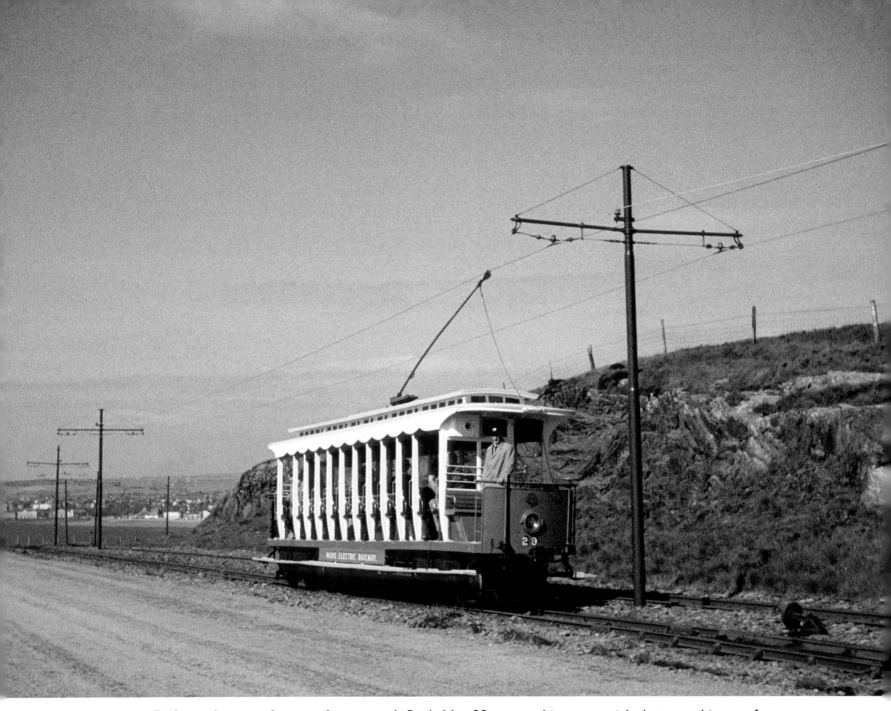

Before the regular service started, Rack No. 29 was making a special photographic run for members of the Light Railway Transport League and is seen posed on the crossover at Howstrake on 21 May 1961. This was then used by seasonal 'specials' shuttling to and from the nearby Holiday Camp. When the latter eventually closed, the MER lost another source of revenue. Both the newest power cars received the new paint scheme and No. 32 is seen opposite with its regular trailer No. 61 shortly just after being out-shopped in 1958. *Phil Tatt/Online Transport Archive; Jim Copland, courtesy Malcolm King)*

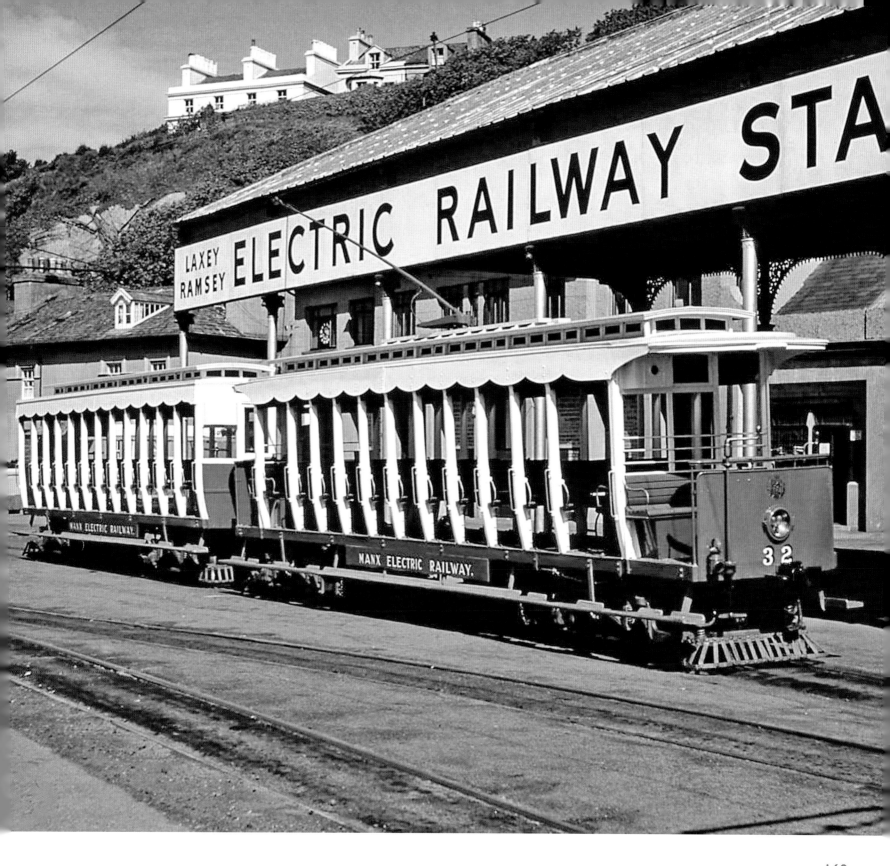

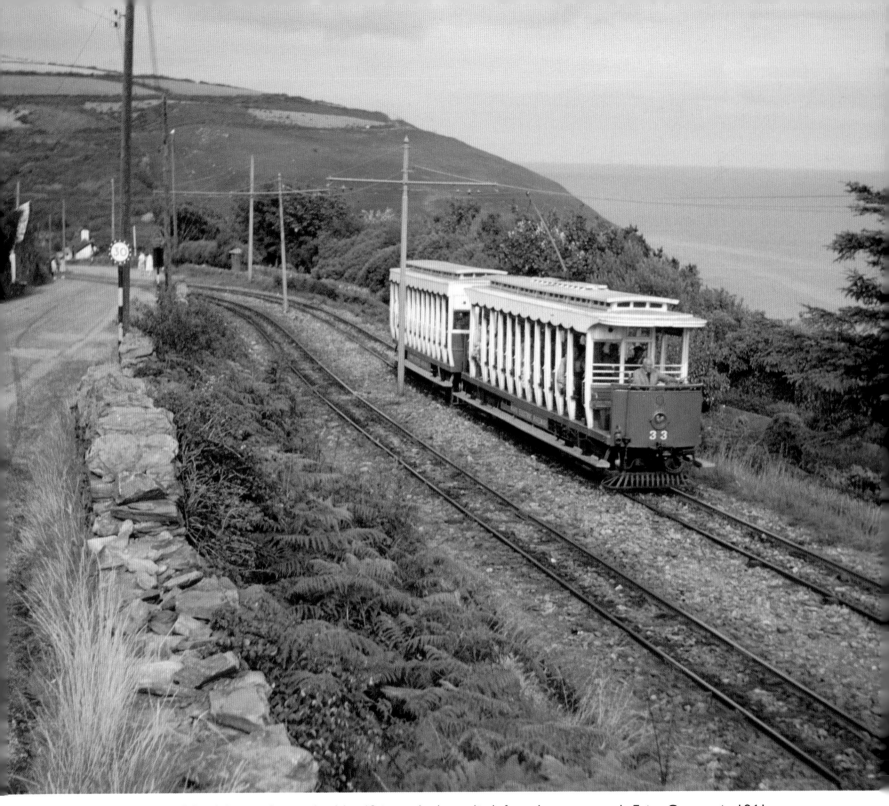

No. 33 with regular trailer No. 62 is on the long climb from Laxey towards Fairy Cottage in 1961. This view is now obliterated by tree growth. (*Les Folkard/Online Transport Archive*)

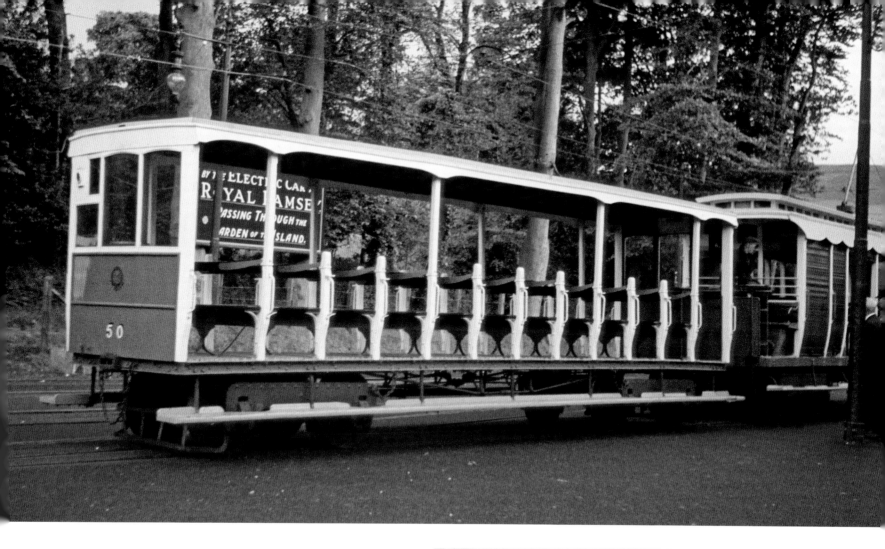

Seen at Laxey in Whitsun 1961, complete with small fleet numerals, No. 50 was the last trailer to run in the green livery. The second scene shows trailer No. 62 and power car No. 33 after they had been repainted into the green and white as part of the Tynwald Millennium celebrations in 1979. (*Phil Tatt/Online Transport Archive; R.L. Wilson/Online Transport Archive*)

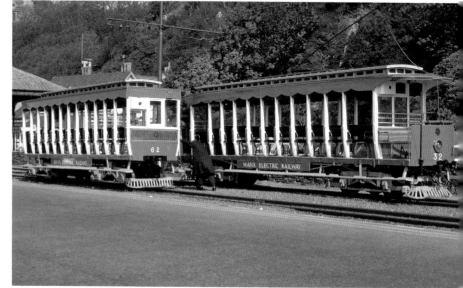

For many years, the MER fulfilled the role of a classic rural interurban, relying for some of its revenue on moving coal, stone, livestock, agricultural produce, general goods, parcels and mail. As a result, a range of different types of vans and wagons was acquired mostly from G.F. Milnes of Birkenhead. However the growth in road competitors gradually spelt the end for the once-profitable freight business. Livestock movements ended in the 1920s, stone in the mid-1940s, parcels with onward van delivery by the mid-1960s and Royal Mail collection, as detailed earlier, in 1975. As many freight vehicles were scrapped before the advent of colour photography, these next views provide only a flavour of the lost age of goods traffic. A year after the opening, six-ton open wagons (Nos. 1 and 2) and six ton vans (Nos. 3 and 4) were delivered by Milnes. No. 3 is seen heading through Ballaglass behind a 'Winter Saloon' in early May 1963. (*E.J. McWatt/Online Transport Archive*)

The following winter, the van was rebuilt without its short end platforms and is seen on 30 September 1975 being manhandled into Ramsey goods shed by Motorman Alan Radcliffe and Ramsey Station Master Norman Radcliffe. No. 3 has been in store since the late 1970s and awaits possible restoration. (*G.W. Price/Online Transport Archive*)

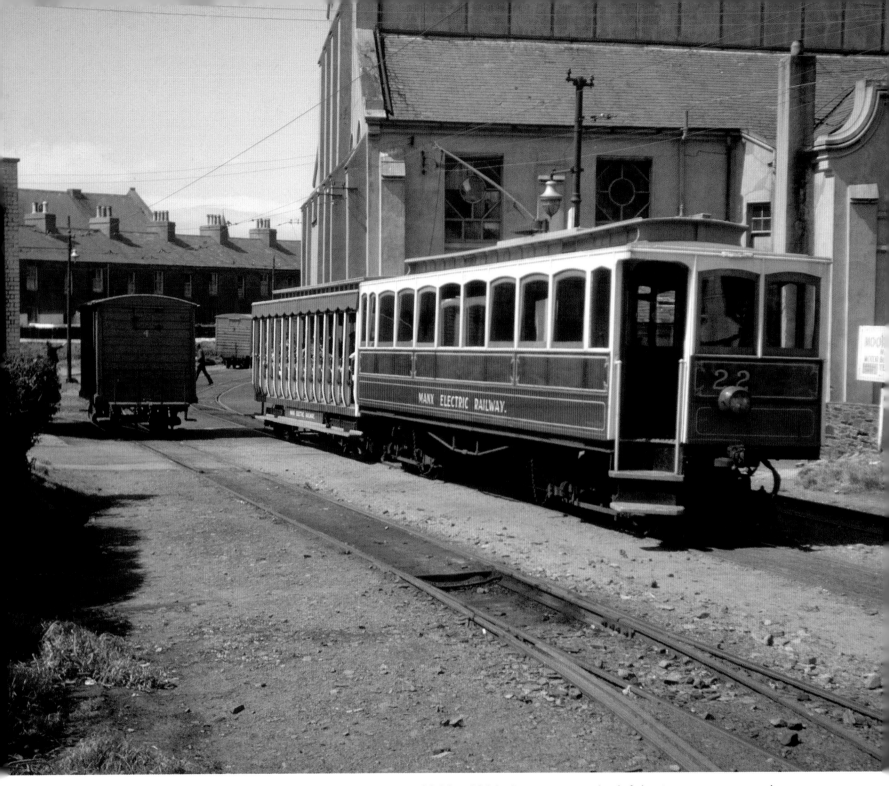

Van 4 was photographed at Ramsey on 20 May 1964, the points on the left having once accessed a cattle-loading bay. Placed in store in the mid-1980s, No. 4 is now restored as a 'Travelling Post Office'. (*R.L. Wilson/Online Transport Archive*)

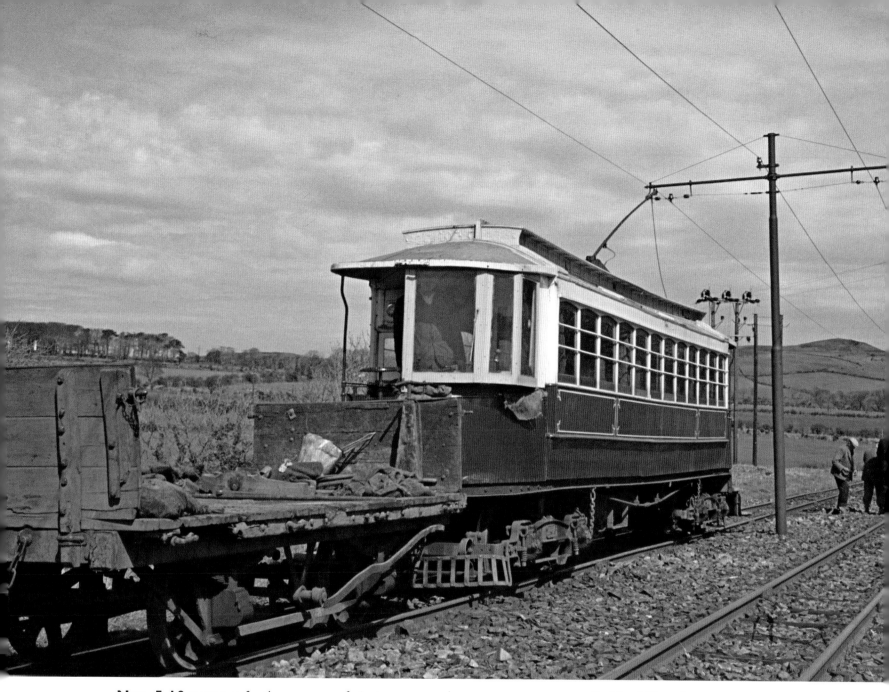

Nos. 5-10 were a further group of six-ton, general purpose wagons supplied by Milnes between 1895 and 1898. During the period covered by this book, the survivors were mainly used by the permanent way department. On 17 April 1964, wagon 8 is coupled to power car No. 1. They are wrong line working whilst carrying out maintenance near Ballajora. For most works duties, passenger cars were utilised so for much of the year, No. 1 was assigned to the permanent way department and No. 2 to the overhead line department. After this view was taken, No. 8 underwent several changes and was, for a time, fitted with a diesel generator concealed within a van body. It has since been restored to original condition. (*Brian Faragher/Online Transport Archive*)

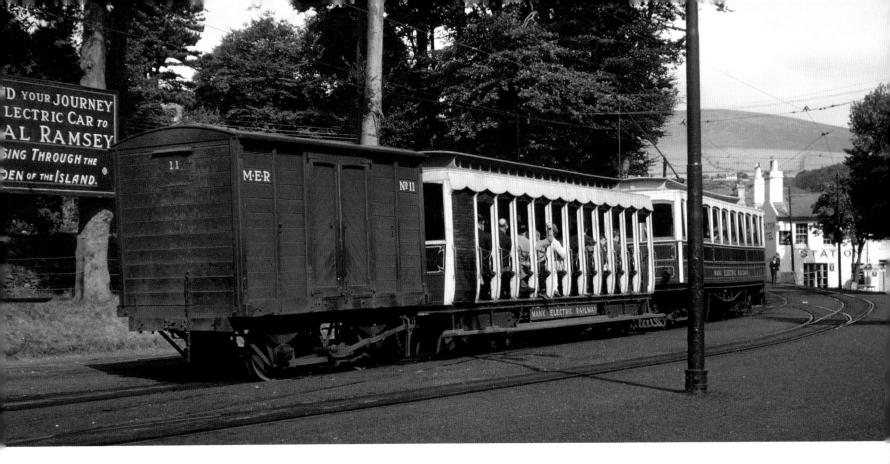

Two six-ton vans with small platforms were delivered from Milnes during 1898/9. No. 11 arrived in time for the inauguration of the Ramsey parcels service and was often seen attached to the rear of a through train. In the winter of 1957/8, its platforms were removed. In the first view at Laxey it is seen on 27 August 1966, by which time its longstanding grey livery had been superseded by olive green with white lettering. When withdrawn in 1997, this was the last active van in stock and was subsequently moved to the Jurby Transport Museum. It is now being restored. The second scene, which dates from 1962, shows No. 12 still with end platforms and upper body aperture. Following storm damage, it reappeared a short time later with a ridge-shaped roof. Then, in 1977, it was transformed into a mobile 'Poles and Wires' workshop with a roof-mounted platform and, as such, remained in traffic until withdrawn in 2008. It now awaits restoration. (A.S. Clayton/Online Transport Archive; E. J. McWatt/Online Transport Archive)

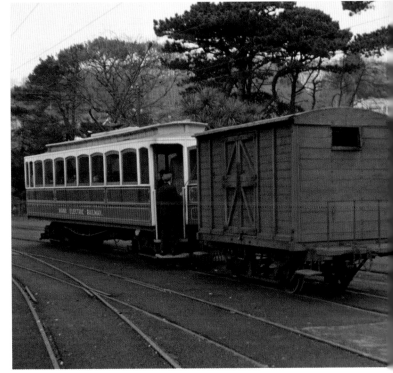

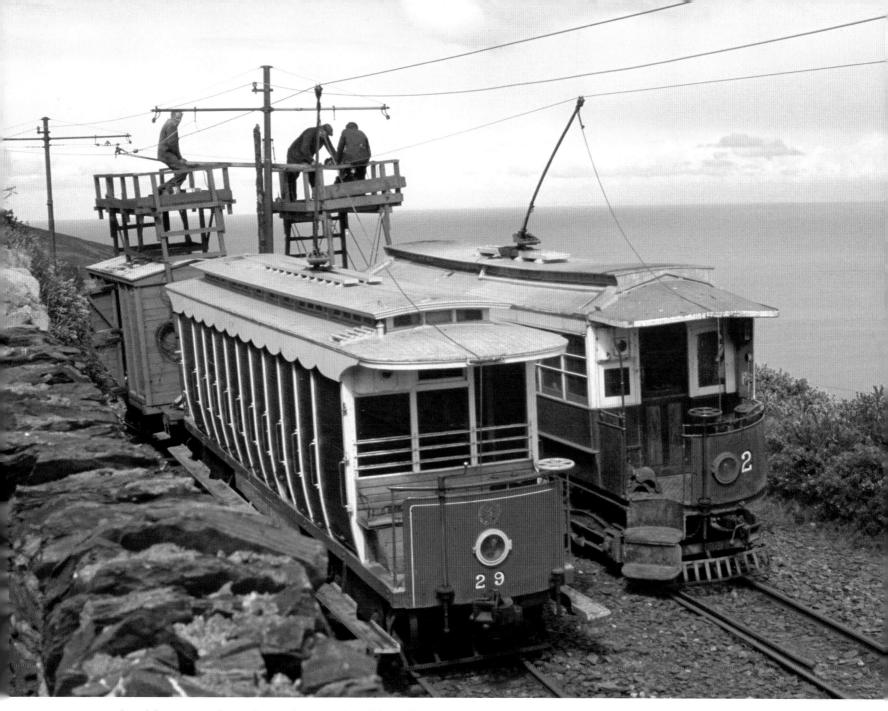

In this evocative view, the overhead line department are seen at work between Ballajora and Cornaa in May 1977, just weeks before the northern section was reopened. Rack No. 29 is coupled to 'Pole and Wires' van 12, whilst power car No. 2 is attached to tower wagon 2. The latter provided another example of the MER policy of adapt and use. After lying derelict for many years, wagon 10 was used as the base for this home-built tower wagon which was active from 1975 until 2000. After several years in store, 10 has been restored to original condition. (*Derek Bailey/Online Transport Archive*)

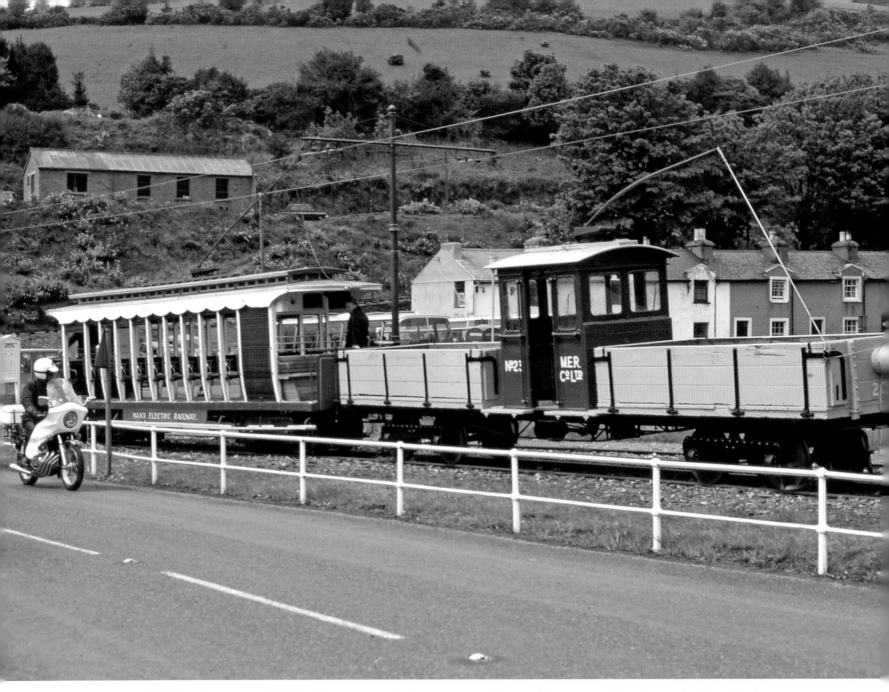

To haul wagons filled with stone and other commodities, a 12-ton steeple cab was built at Derby Castle in 1900 and given the number 23, the bogies being borrowed when needed from ratchet car No. 17. Following an accident, 23 was out of commission from 1914 until 1925 when the original centre cab was placed on a new frame flanked on either side by a six-ton wagon body, the bogies being borrowed from No. 33. In 1944, it was laid up again until restored for the Tynwald Millennium parade on 31 May 1979. Now, it is again out of use. (*R.L. Wilson/Online Transport Archive*)

Van No. 14 is seen here passing through Garwick Glen at the rear of a southbound train on 16 June 1964. This was one of a pair of five-ton vans (13/14) delivered by Milnes in 1904. Built originally to take holidaymakers' luggage, 14 was later used for general merchandise. When the once-busy Garwick Glen and hotel closed to the public in 1979, the rustic MER buildings were knocked down. Yet another source of revenue had gone. After years in store, the body of No. 14 was broken up in 2002. (*Cedric Greenwood*)

In 1908, the MER built five-ton van No. 15, which was scrapped after an accident in 1944, as well as 'Large Mail Van' No. 16, which still exists having been fully restored. In the view above, the latter is at the rear of a northbound working in June 1951, whilst in the image opposite, mail is transferred into a GPO van on 10 June 1957. In the 1920s, a limited stop 'Mail Express' had completed the Douglas-Ramsey run in under an hour, some 15 minutes quicker than the regular timetable. Van 16 last ran in the late 1970s. (W.J. Wyse/LRTA (London Area)/Online Transport Archive; John McCann/Online Transport Archive)

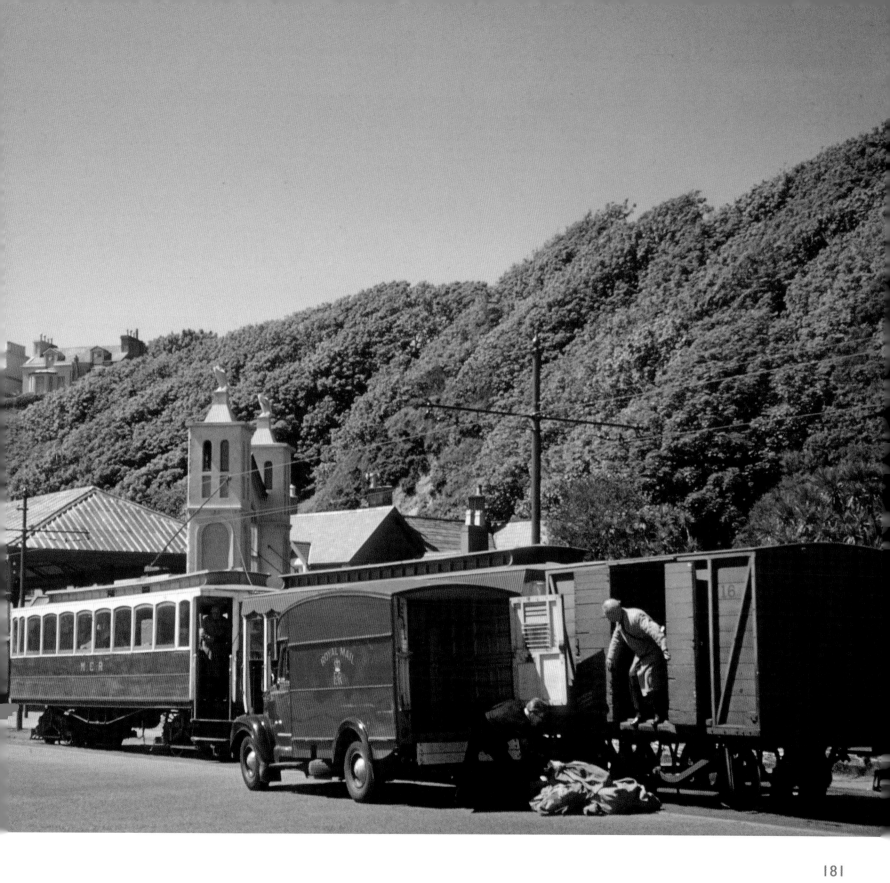

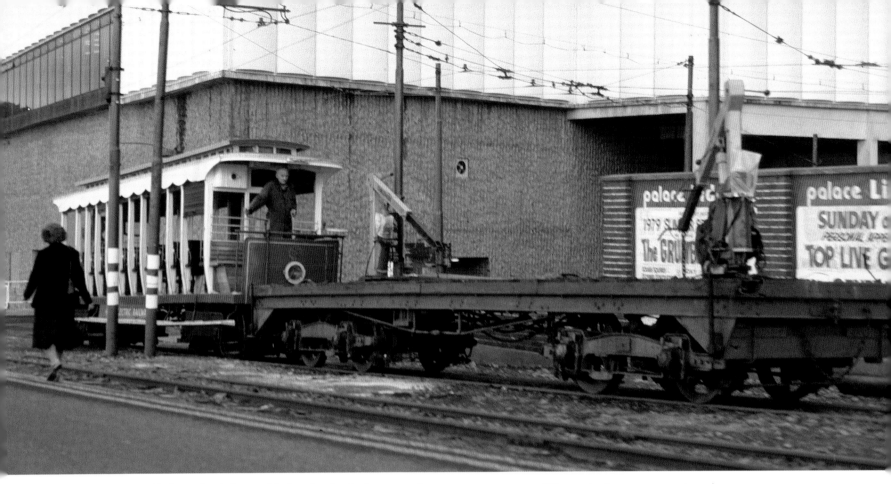

Other freight vehicles included more six-ton wagons, two 12-ton bulk stone carriers known as 'dreadnoughts' and a 'dreadnought stone wagon' built at Derby Castle in 1926. The latter enjoyed a varied history owing to the policy of reusing existing equipment. In 1942, it was mounted on Brush-built bogies salvaged from one of the Laxey fire victims. Then, in the early 1960s, it was transformed into a flat wagon which spent some years in store before being adapted in 1977 to carry two hydraulic cranes. The first view shows it with the cranes which between them could lift 1½ tons of rail. Later it would

be remodelled as a ballast wagon, with hoppers at each end, and today it can still be used as a flat wagon for carrying rails. Another radical transformation involved passenger trailer 52, which lost all its bodywork except for a dash at one end when it became a flat wagon in 1951. In this 1979 view in Laxey depot yard, it is on the de-motored trucks from Laxey fire victim No. 4. It survives today, having been fitted with a scissor lift in 2008 so it could replace an older design of tower wagon. Amazingly, when the roof was removed from No. 52 in 1951 it was put in store and then used years later during the rebuilding of sister trailer 51. A classic case of the MER's commitment to keeping anything and everything that could/might be used again! (*G.W. Price/Online Transport Archive; Nicholas Britton*)

After the original tower wagons were lost in the Laxey fire, two replacements emerged from Derby Castle in 1931. One of these is seen at Port Jack coupled to power car No. 2, which has a ladder slung along its side. (*W.J. Wyse/LRTA (London Area)/Online Transport Archive*)

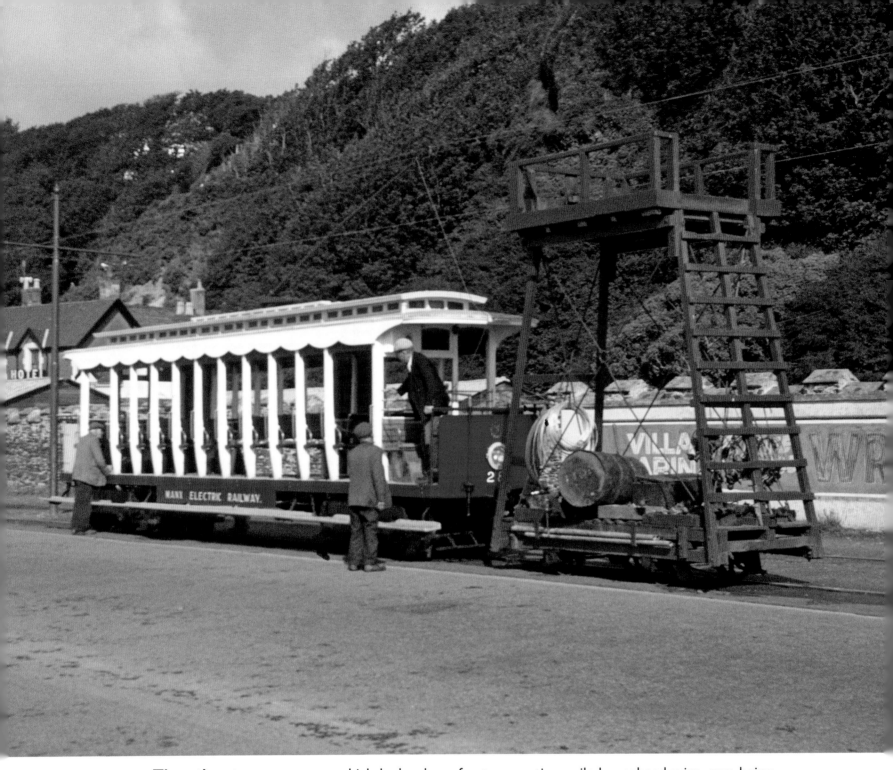

The other tower wagon, which had a drum for transporting coiled overhead wire, was being towed by 'Rack' 28 on 4 September 1967. For nearly 50 years, these tower wagons formed an essential part of the overhead line department until they were dismantled in 1979 owing to concerns over safety. (*John McCann/Online Transport Archive*)

In 1907, the MER established the island's first bus route, a seasonal service linking its isolated hotel and tearooms at Tholt-y-Will with Bungalow station on the SMR. The route was far from successful and only saw fitful operation. In 1939, the MER purchased two Bedford WLBs built in 1933 and, for a spell after the war, these provided a limited service until the end of the 1952 season. In this extremely rare view, one of these 20-seat forward entrance buses is seen outside the Bungalow Hotel in June 1951. During a brief revival in the late 1950s, the route was worked by two ex-Douglas Corporation Leyland Cubs. (*W.J. Wyse/LRTA (London Area)/Online Transport Archive*)

To handle the distribution of parcels and other goods at Douglas and Ramsey, various vans were owned including this Austin 152 which was photographed at Ramsey in May 1961. The illustration on the side was hand painted. (*Phil Tatt/Online Transport Archive*)

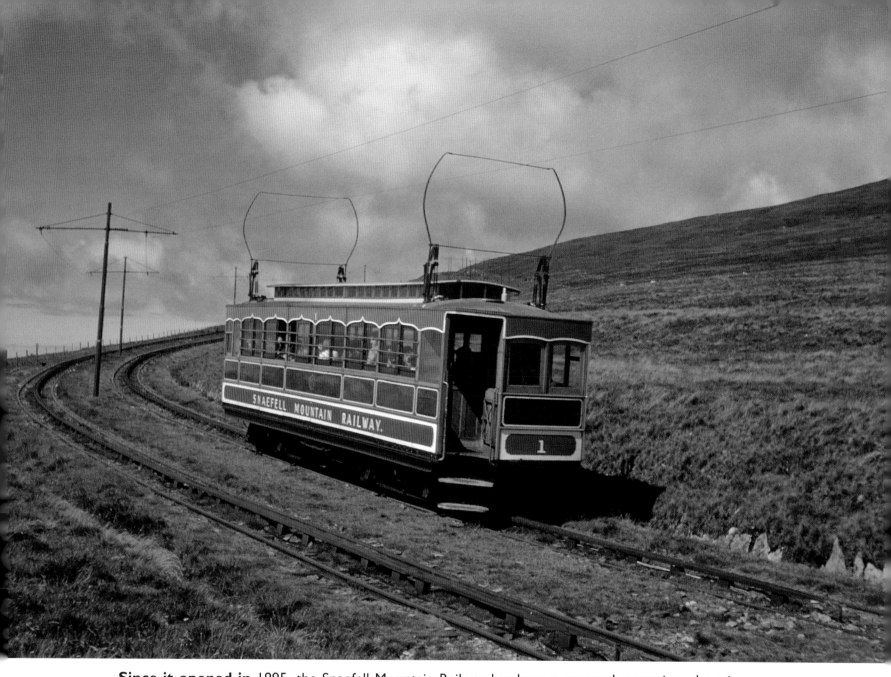

Since it opened in 1895, the Snaefell Mountain Railway has been a seasonal attraction, the trip from Laxey to the Summit taking 30 minutes. For most of the 4¾ mile journey, the 3ft-6in gauge line is on a steady 1:12 gradient, although in some places it can be as little as 1:42½. The six trams with bodies and trucks by G.F. Milnes and electrical equipment by Mather & Platt of Manchester were in virtually original condition until the late 1970s. On delivery, just the platform windows were glazed but sliding saloon windows and clerestory roofs were soon added. No. 1 is seen at Bungalow in July 1974 heading for the upper terminus which is 1992 feet above sea level. The two Hopkinson bow collectors help maintain contact with the overhead wire especially during stormy weather. (*Martin Jenkins/Online Transport Archive*)

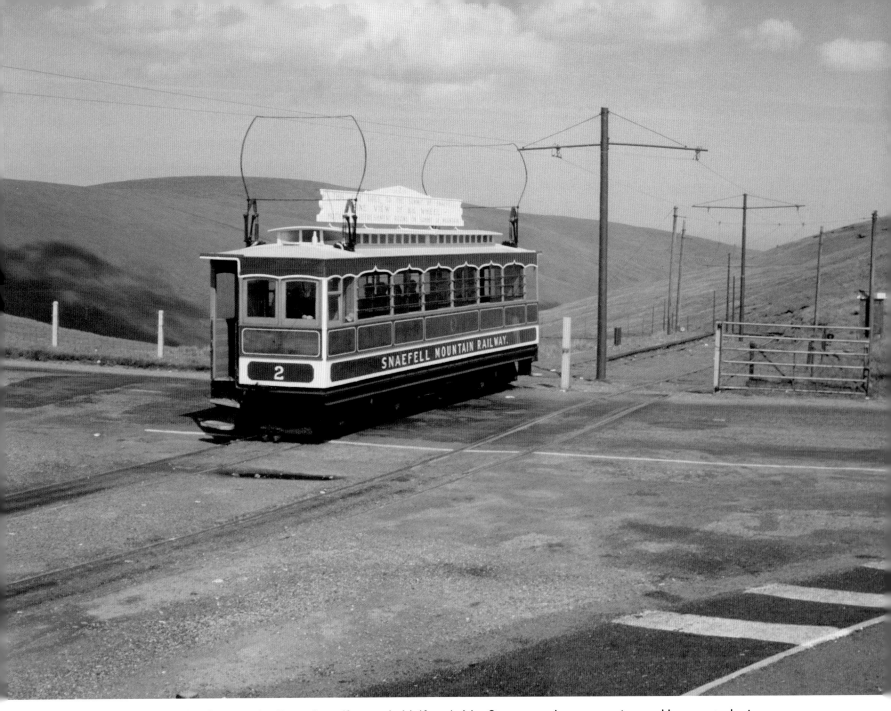

In this view at the Bungalow (formerly Halfway), No. 2 crosses the mountain road known to legions of motor cycle fans and riders, on 16 June 1963. On race days, trams from Laxey terminate just before this intersection, passengers accessing the race course by means of an overbridge. Bungalow is the only intermediate stop on the line. A hotel at this location was demolished in 1958, although the hotel at the summit is open during the season. In the late 1970s, all six cars were given new bogies built by London Transport and wheels, motors and control gear from cars purchased from Aachen. (*G.D. Smith/Online Transport Archive*)

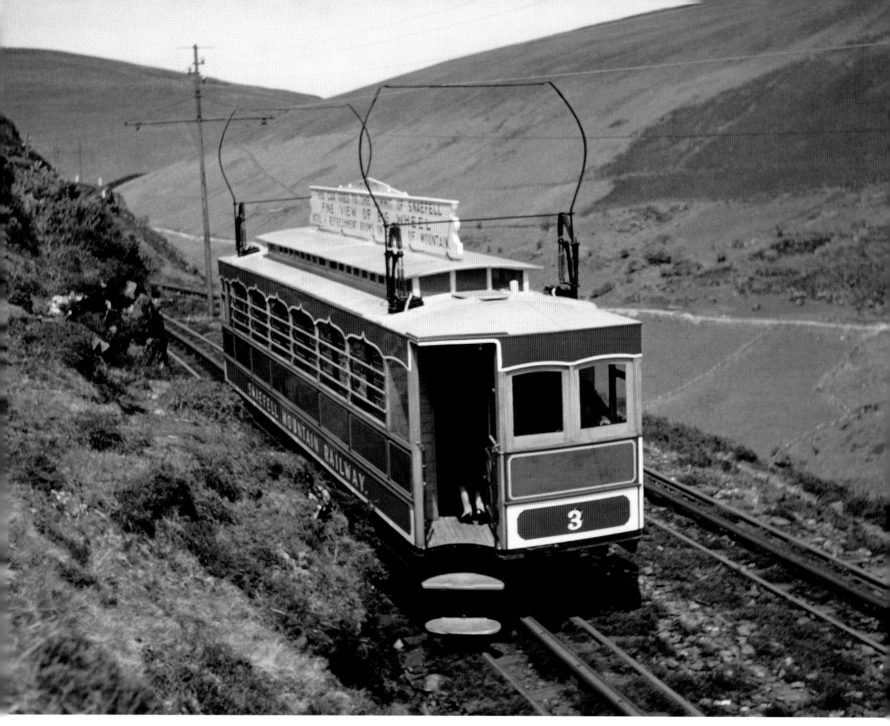

On 19 May 1956, No. 3 descends the southern slope of the valley between Bungalow and Laxey. On the opposite side is the road to the former mines at the foot of Snaefell. The line has always been right-hand running, the construction engineers believing a runaway car would be safer leaving the track close to the rock face as opposed to the less solid outer edge of the right of way. However, when unmanned No. 3 ran away in 2016, its body was wrecked. It is hoped to eventually construct a replica body. (*M.J. Lea/LRTA (London Area)/Online Transport Archive*)

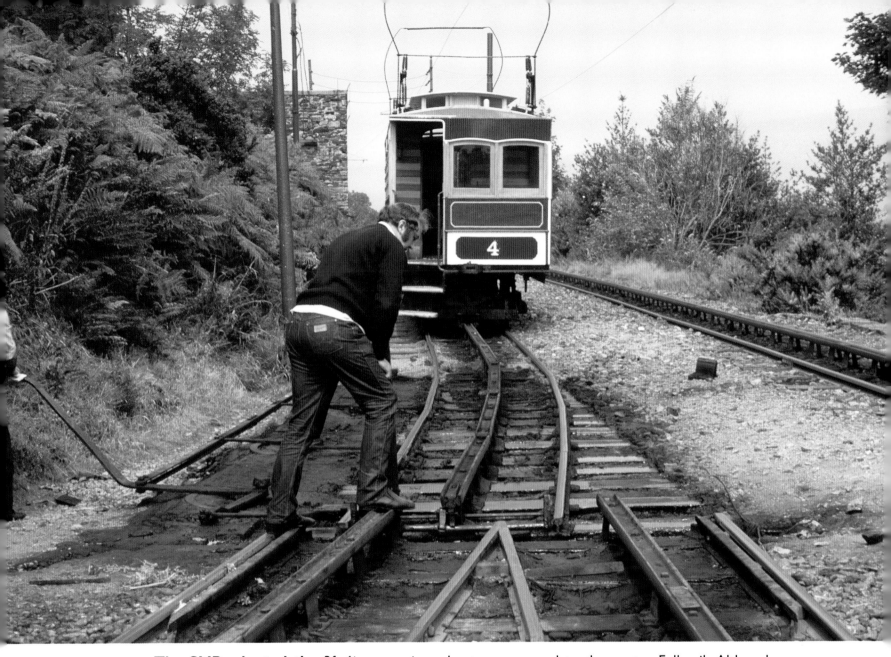

The SMR adopted the 3ft-6in gauge in order to accommodate the centre Fell rail. Although designed to provide additional propulsion on steam-hauled mountain railways, it was installed by the SMR as an additional safety device. During the descent, the rear brake is continuously engaged and monitored by the brakeman, who communicates with the motorman by a series of bell signals. At the same time, a pair of horizontally mounted wheels on the inner end of the bogies grip the Fell rail, making derailments virtually impossible. The brake in the front cab is for emergencies. The Fell system led to the installation of unusual points, one of which gave access to the depot. To provide continuous braking, all three rails had to move simultaneously so shifting them required a good deal of elbow grease as illustrated on 8 August 1976. More conventional points were installed in the mid-1980s. (*G.W. Price/Online Transport Archive*)

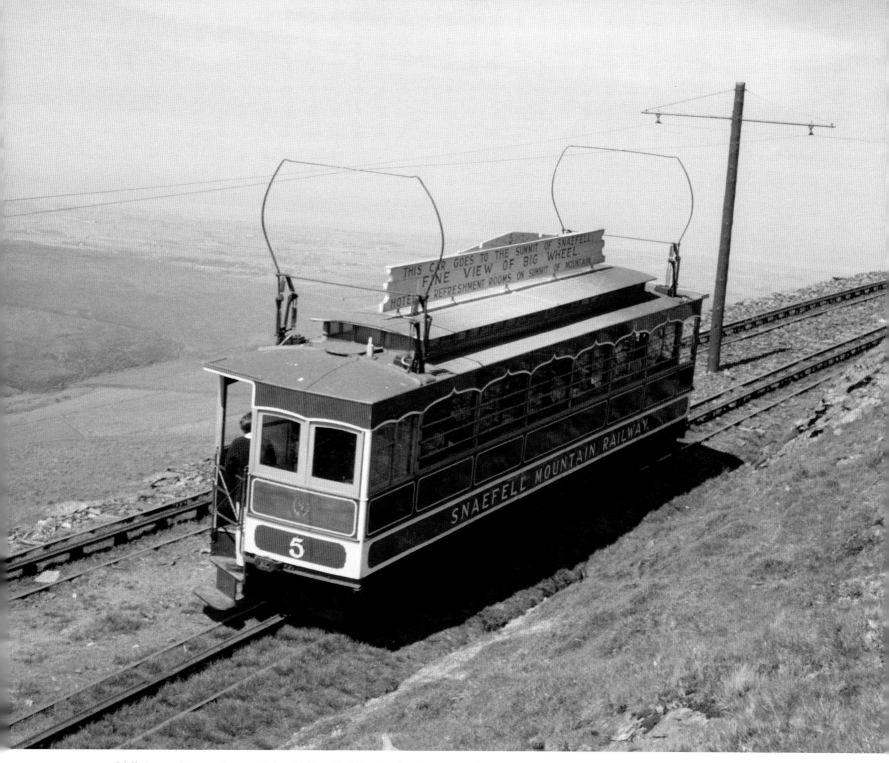

With a clear view of the Fell rail, No. 5 climbs towards the summit on 16 June 1963. Later, on 16 August 1970, the body was destroyed by fire but a replacement with flat roof and bus-style aluminium windows was built by H.D. Kinnin of Ramsey. Today, No. 5 can easily be recognised although the modern windows have been replaced. (*G.D. Smith/Online Transport Archive*)

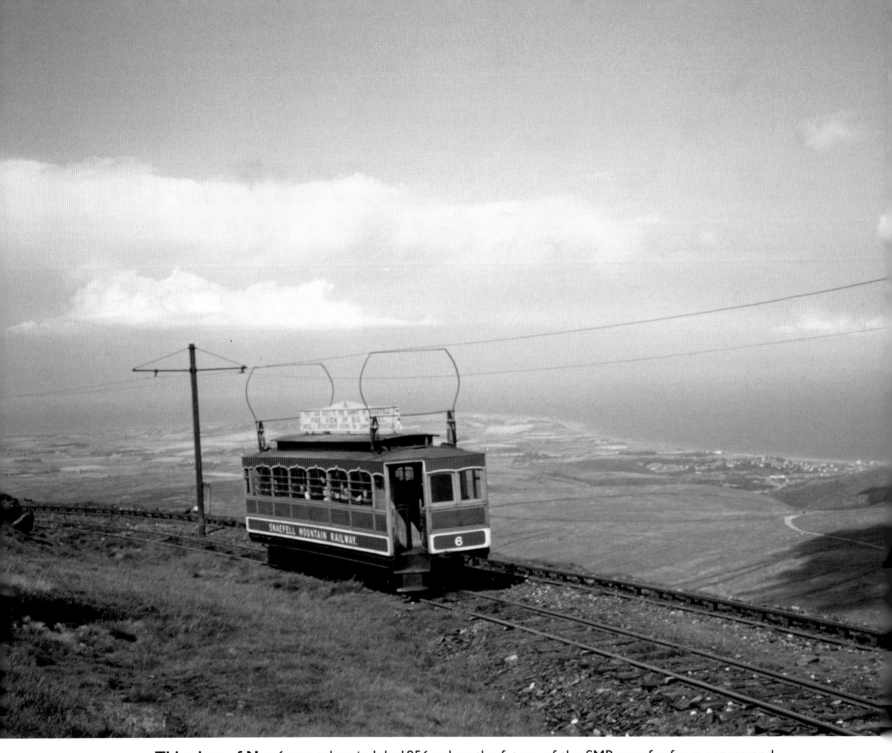

This view of No. 6 was taken in July 1956, when the future of the SMR was far from secure and much of the infrastructure, including the Fell rail, was in poor condition. The roof-mounted boards were all removed following the fire on No. 5 as it was feared their movement in high winds may have frayed certain cables. The car is on one of the short lengths of line laid without the Fell rail. (*John McCann/Online Transport Archive*)

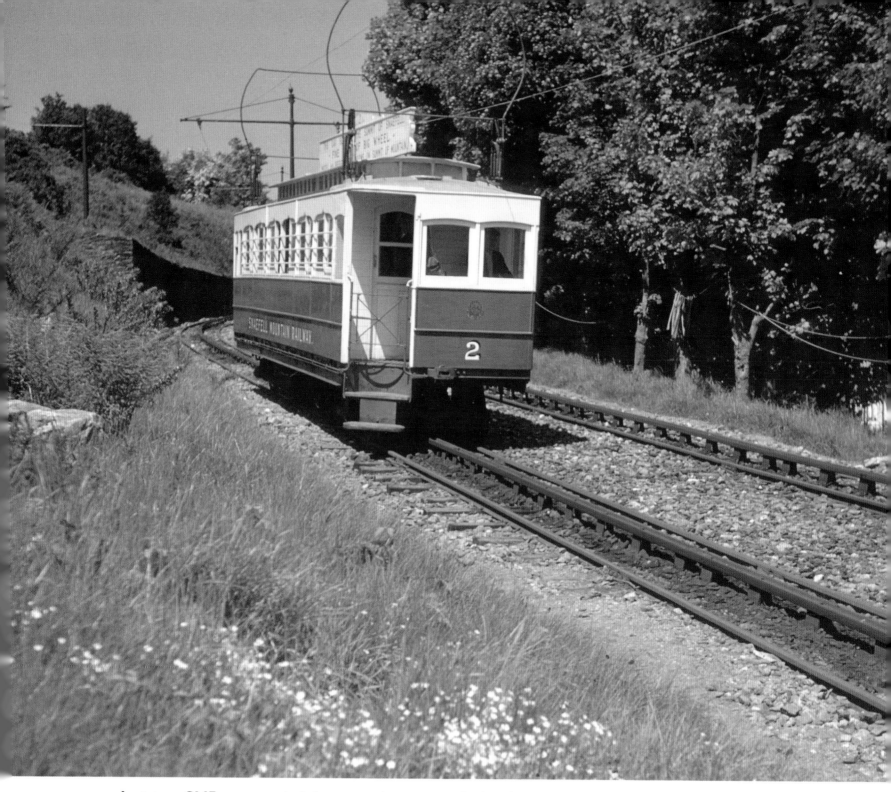

Just two SMR cars carried the unpopular green and white livery described earlier. Here, No. 2 is depicted on the final descent into Laxey in May 1961. (*W.J. Wyse/LRTA (London Area)/Online Transport Archive*)

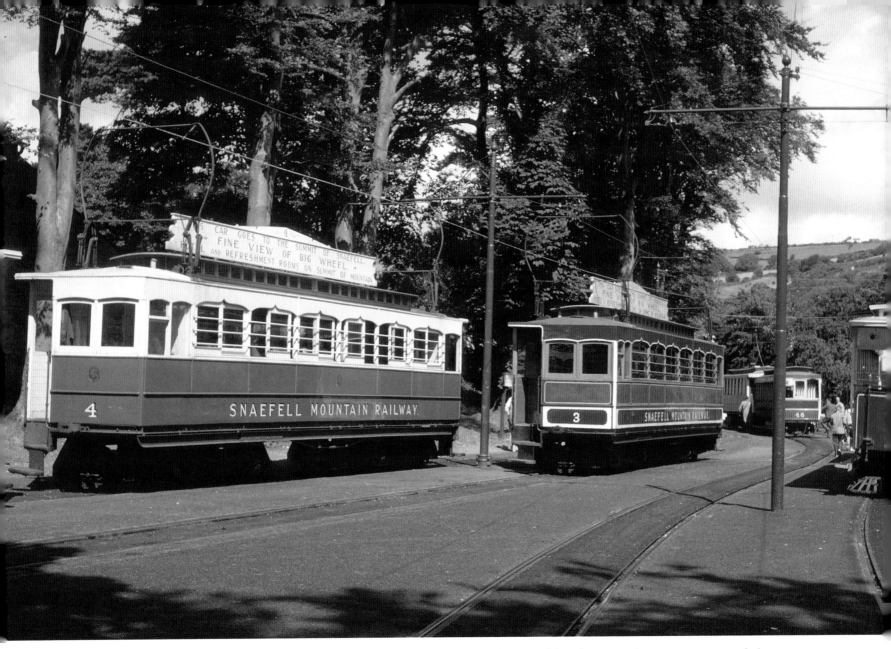

The spartan nature of the nationalised livery is evident as No. 4 awaits its next ascent of the mountain alongside No. 3 in traditional colours in June 1962. (*F.W. Ivey*)

The SMR had a relatively small works fleet, the most interesting vehicle being a six-ton open freight car known as *Maria*. Dating from 1896, it was basically a large wagon with drop sides and driving cabs at each end. Its prime purpose was to transport supplies to the hotels as well as coal to the original power station situated some three miles from Laxey. After this was converted into a substation in 1924, *Maria* was rarely used except during the Second World War, when it transported much needed peat from the mountain. Although officially withdrawn in the mid-1950s, the body was not broken up for some forty years. When needed, it used equipment from a passenger car, usually No 5. In the background is the overhead line vehicle and the small two-axle goods wagon built in 1895. The vehicles are on the site of the original Laxey terminus which was relocated in 1896 before finally being established at the present location in 1897/8. (*E.J. McWatt/Online Transport Archive*)

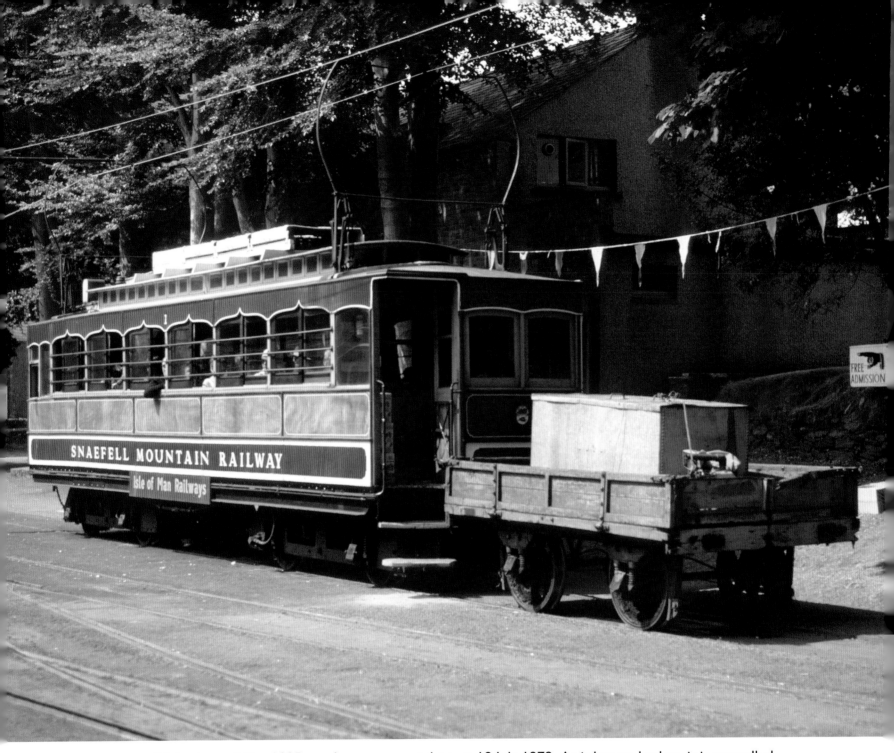

This view of the 1895 goods wagon was taken on 18 July 1979. As it has no brakes, it is propelled by a passenger car. Now, it is mostly used to transport materials to and from the summit hotel. Those working at the hotel usually travel up and down on the first and last cars of the day. By this time, No. 6 has been fitted with rheostatic braking and roof-mounted resistances, which were applied to all six cars during 1979-82. (*G.W. Morant/Online Transport Archive*)

A small 30hp four-wheel railcar built by D. Wickham of Ware was acquired by the Air Ministry (later the Civil Aviation Authority (CAA)) in 1951. The four-seater transported personnel to a radar station on the Summit especially during the winter when the overhead beyond Bungalow was dismantled to prevent unnecessary damage. It had its own shed on the north side of the depot. Seen on 19 May 1956 in its original RAF blue livery, it was equipped to operate on the Fell system and was powered by a Ford V8 petrol engine. When replaced by a new railcar in 1977, it was sold to the MER, where it remained for a number of years before being acquired for preservation in 2007. *(M.J. Lea/LRTA (London Area)/Online Transport Archive)*

In 1957, another, larger Wickham railcar arrived. This had an open space for carrying materials to maintain the radar aerials. It is seen at Laxey in its original dark blue livery in May 1961. Later repainted into CAA black and yellow, it served on the mountain until 1991. (*W.J. Wyse/LRTA (London Area)/Online Transport Archive*)

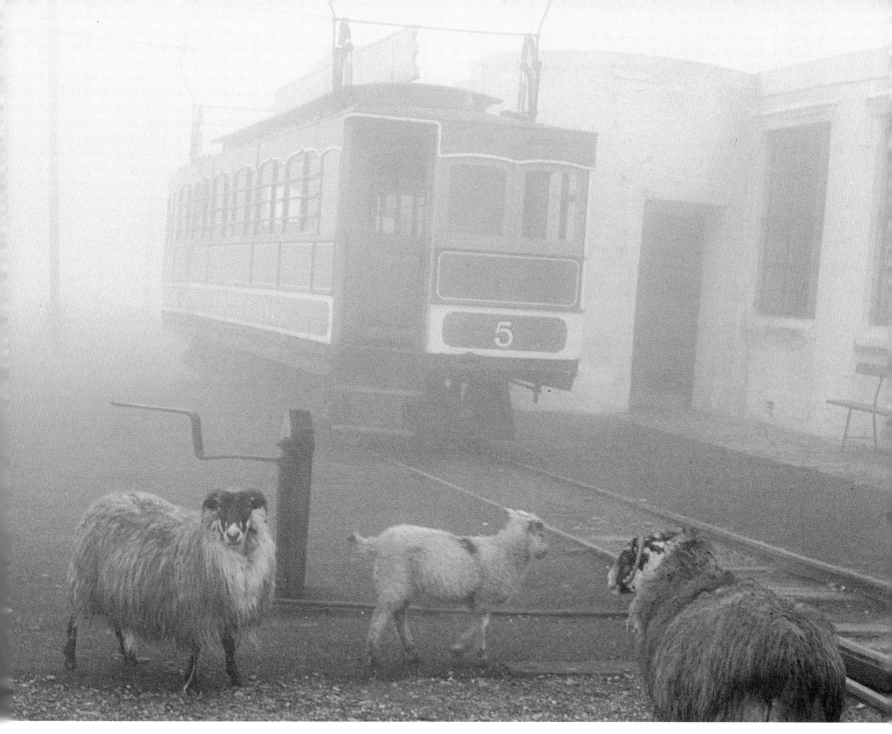

On clear days, the SMR affords excellent views of the famous Laxey Wheel, the rugged scenery flanking Laxey Glen and mountains in England, Ireland, Scotland and Wales from the summit itself. Add in the Kingdom of Mann and Heaven, and the claim is that 'Six Kingdoms' can be seen. However, on dull or overcast days the mountain is sometimes drenched by torrential rain or shrouded in mist – the legendary 'Manannan's Cloak', named after an ancient sea god. However, undeterred by the weather, the rich mix of vintage transport will continue to attract people to this magical island. (*F.W. Ivey*)

Bibliography

During their research, the authors consulted a range of magazines, timetables, pamphlets, newspaper cuttings, personal memoirs and record books as well as a number of publications, most notably:

CONSTANTINE, Harry, *Douglas Corporation Horse Trams*, Douglas Corporation, 1975.
DAVIES, Richard, *Buses of the Isle of Man 1945 - present day*, Lily Publications, 2009.
EDWARDS, Barry, *The Railways and Tramways of the Isle of Man*, OPC, 1993.
Fleet history of Operators of the Isle of Man, PSV Circle, 2017.
GOODWYN, Mike, *Manx Electric*, Platform 5, 1993.
GOODWYN, Mike, *Snaefell Mountain Railway*, MER Society, 1987
GRAY, Ted, *Railways and Tramways of the Isle of Man*, Past and Present Publishing, 2008.
HENDRY, Robert, *A Century of Manx Transport in Colour*, The Manx Experience, 1998.
HENDRY, Robert, *Rails in the Isle of Man*, Midland Publishing, 1993.
HOBBS, George, *Manx Electric Railway Past and Present*, Loaghtan Books, 2016.
Manx Electric Railway 1893-2013, LRTA, 2013.
PEARSON, F.K., *Snaefell Mountain Railway*, LRTL, 1956.
PEARSON, F.K., *The Manx Electric Railway*, LRTL, 1956.
PEARSON, Keith, *The Douglas Horse Tramway*, Adam Gordon, 1999.
PULLING, Chris, *Journey on the Manx Electric Railway*, Train Crazy Publishing, 2015.
WYSE, W.J. and JOYCE, J., *Isle of Man Album*, Ian Allan, 1968.

The Online Manx Electric Railway Encyclopaedia (manxelectricrailway.co.uk) and the Classic Manx Buses website (www.classicbuses.co.uk/+Manx.html) have helped with much up-to-date material.

Martin Jenkins
Walton-on-Thames

Charles Roberts
Upton, Wirral

September 2017